AUDIOPHOTOGRAPHY

A C.I.P. Catalogue record for this book is available from the Library of Congress.

ISBN 1-4020-2209-3 (HB)
ISBN 1-4020-2210-7 (e-book)

Published by Kluwer Academic Publishers,
P.O. Box 17, 3300 AA Dordrecht, The Netherlands.

Sold and distributed in North, Central and South America
by Kluwer Academic Publishers,
101 Philip Drive, Norwell, MA 02061, U.S.A.

In all other countries, sold and distributed
by Kluwer Academic Publishers,
P.O. Box 322, 3300 AH Dordrecht, The Netherlands.

Printed on acid-free paper

The views and opinions expressed herein are those of the author and do not necessarily state
or reflect those of Hewlett-Packard.

Printed in the Netherlands.

Dedication

For Julie

Contents

Contents

Preface

If you read the history of any new communication medium such as the cinema, television or radio, it always happens to be bound up with advances in some underlying technology. For example, cinema was born out of the rapid projection of a series of still images on a celluloid film strip. The difficulty of synchronizing sound recordings with the resulting moving images led to about 30 years of silent films - until such time as the technical problems were solved. In between the inventions, media seem to grow and develop at a slower pace, as content producers and consumers experiment with the most satisfactory and stimulating ways of communicating with each other. In the same example, silent film-makers eventually found ways of adding dialogue through scene titles and having music played during the projection of their films.

This book is about the next chapter in the history of photography, which is emerging from a relatively stable period into a chaos of new inventions. Photography as we know it is at the same point as the silent films of 1926. The transition from analog to digital photography is spawning many new ways of taking, manipulating and sharing photographs. It is also bringing photography and videography closer together by unifying sound, still and moving images in the same digital medium. As a psychologist working in the digital media industry, I find myself in the middle of this chaos, trying to make sense of it all on behalf of 'users', but also contributing to the technology itself to make it more 'use-ful'. My concern has been with the role of digital technology in domestic photography, where the producers and consumers of photos are ordinary people going about their lives. This defines the topic and scope of the book, but not quite its focus.

Rather than describing the many technical developments going on in the industry or the studies we have used within Hewlett Packard to test them, I have chosen to take a longer and more prescriptive view. I highlight a new media form that I think has great promise on the other side of the analog-digital divide. This form is simply the combination of sound and still image, which I refer to as the audiophoto. Although the audiophoto is simple in concept, it has many different uses in snapshot

photography, and the potential to transform a number of related practices. In fact, the coming of sound to photographs is analogous to the coming of sound to film. It adds a new dimension to the image which consumers may come to expect as a standard feature of the medium. So taking photographs *without* sounds in the future may be viewed in the same way as making a silent film today. To use another example, sound may be to digital photography what color was to analog photography: providing another dimension of selection and design.

Two observations have prompted me to write so boldly about only one of the possible future scenarios for digital photography. Both observations originated within a single small-scale trial of an audio-camera which families used to record sounds with their photographs. First, when we asked families to identify their favorite photos, audio-clips and audiophotos their selections were different for each type of recording. Audiophotos appeared to be a truly new medium with its own aesthetic properties. Second, in discussing their reactions to audiophotos, several families said they could get better effects as a novice than they could with home video. This was the first time it occurred to me that audiophotos could be *better* than video for the psychology and practice of domestic photography, even though both add a missing sound dimension to a visual memory. In an industry where more processing, data and features are promoted as more valuable, the notion that 'less is more' appealed to me.

By focussing on the medium and practice of audiophotography I aim to step outside the flux of today's technology for the central part of the book. This is a bit like trying to write about the medium of sound films in the era of the silent movie. My analysis is based on work with producers and consumers of the new medium, using the power of suggestion, conjecture and some laboratory magic to encourage them to explore its properties and values ahead of the enabling technology. In particular, I report the results of getting ordinary people to make up audiophoto material for comment and discussion. The book is therefore targeted primarily at an art and social science readership of people interested in the nature of domestic photography and how it might be transformed and enhanced through the use of sound. One of my aims is to inspire others to try out audiophotography for themselves, with whatever combination of technology is available to them today. To this end I include a large number of audiophotos generated by consumers throughout the book. All the sounds for these images can be played from the accompanying CD-ROM.

However, at the beginning and end of the book I talk about technology. Some technical history is necessary to motivate the enquiry, and put it into the context of an industry in transition. In addition, a consideration of playback methods and some recommendations for audiophoto technology are needed, to make full use of all the reported findings, and bring the practice of audiophotography a little nearer to a mass market. So the book is also for technologists interested in shaping the future of digital photography, and especially those who are willing to listen, both metaphorically and literally, to the voice of the consumer.

Acknowledgements

This work would not have been possible without the collaboration, support and advice of a large number of people, to whom I am extremely grateful.

All the studies reported here were carried out in collaboration with others. Judith Budd led the pilot study reported in Chapter 3. Ella Tallyn worked on the audiocamera trial reported in Chapter 4. Adam Drazin & Tony Clancy worked on the audio annotation trial reported in Chapters 5 and 6. Allan Kuchinsky, Celine Pering and Abbe Don collected the naturalistic photo sharing conversations used in Chapter 7, while Steven Ariss led their analysis. Nadja Linketscher, Maurizio Pilu and Tony Clany helped to collect the data on conversational photographs, also reported in Chapter 7. The prototype audiophoto albums and players discussed in Chapter 8 were created with Ella Tallyn, Tony Clancy, Guy Adams, Simon Poole, Phil Neaves, Andy Hunter, Rick Zampell and Brian Cripe. The Audiophoto desk described in Chapter 9 was created with Tony Clancy, John Robinson, Enrico Costanza and Paul Smith. Thanks also to Roger Tucker, Erik Geelhoed, Rachel Murphy, Jerry Walton, Jo Reid, Richard Hull, Dave Grosvenor, Phil Cheatle and Piet van Zee for advice on audiophoto technology and discussion of related concepts.

I would also like to acknowledge the cooperation, creativity and ideas of all the participants in the studies. Most of the example audiophotos in the book are from them, with the exception of Figures 1.3, 1.4, 9.4 and 9.6. For input to these I thank Joel Frohlich, Phil and Sheila Cheatle, Tony Clancy and Andreas Kelch.

The support of this work by HP Labs management and divisional customers has also been essential to its development. In this respect I would like to thank Phil Stenton, Dave Reynolds, John Taylor, Duncan Terry, Amy Battles and Rick Zampell for support of the early work. The later work was supported and encouraged by Huw Robson, John Meyer, Howard Taub, Brian Cripe, Bruce Cowger & Warren Greving. Special thanks to Huw Robson for releasing me from other duties and facilitating a sabbatical research period. Without him, this book would not have been written.

Hence the book itself was written while on part-time sabbatical, during 2002 and 2003, at the Helen Hamlyn Research Centre within the Royal College of Art (RCA). A number of individuals there and elsewhere helped with the writing process. I am particularly grateful to Jeremy Myerson and Giles Lane for help in planning the book, facilitating contact with other members of the college, and for comments on early drafts of the manuscript. Thanks to the many staff and students of the RCA for discussion of the work and its relation to other media forms. Thanks also to members of the library staff at the RCA, and to Jess Blower, Amanda Richardson and Debbie Duffety of HP Labs Bristol for extensive information and administrative support. I am also grateful to my good friend Julie Turner for discussion of the therapeutic value of photographs, and for pointing out relevant work in art therapy at a critical time in the research.

The following people kindly commented on early drafts of the book, including Abi Sellen, Ella Tallyn, Allan Kuchinsky, Steven Ariss, Adam Drazin, Piet van Zee and Richard Harper. Special thanks to Abi and Ella who reviewed the entire manuscript in detail. They both provided a rare blend of criticism and encouragement which I came to rely on as my primary feedback. Ella also helped with book production, including co-design and production of the accompanying CD-ROM. Thanks also to Don Norman and Ben Shneiderman who provided encouragement and advice regarding publishers, just when it was needed most. In this connection I would like to thank Robbert Van Berkelaer of Kluwer Academic Publishers for his faith in the project and his accommodation of various constraints on its completion.

Finally I must thank my family, Julie, Joel, Lily and Hugh, for humouring me so generously in my obsession with audiophotographs. They have themselves been recorded and played back many times over the last few years in sound and image, as unpaid participants in a larger unpublished experiment. They have also endured my writing with patience – asking how many pages I wrote each day and not laughing (or crying) when I told them.

Introduction

"Once invented and used, media affect us by shaping the type of interactions that take place through them. We cannot play certain roles unless the stages for those roles exist" (Meyrowitz1986, p329).

Think for a moment of your favourite sounds. Perhaps they include the sound of water in a brook or a fast flowing river, waves lapping on a beach, a dawn chorus of birdsong, the chatter of young children playing, or the hubbub in a busy restaurant. Sounds like these will have their own associations for you. Some sounds may have quite general associations while others may be linked to particular places, people or events. For example, I always associate the call of seagulls with holidays because that is when I have typically spent most time by the sea. On the other hand, the sound of rain on a window is now a distinctive sound of our current house where we have a conservatory with a glass roof. Your own house probably has its own distinctive sounds that will change with the passing of the days, nights and seasons. The meanings of certain sounds also change according to the context in which they are heard. To most children the sound of the school bell in the morning will feel very different to its sound at the end of the day. Similarly, the roar of a football crowd after the scoring of a goal will have very different associations depending on whether it was your team that scored.

The feelings and memories conjured up by sounds are an important part of the human experience. They demonstrate that people have very good memories for sounds as well as images. In addition to this natural-sound memory, people have an equally developed memory for music and spoken conversation. In fact, hearing certain pieces of music can be very evocative of the era in which you originally listened to them, while hearing and telling stories is one of the ways we remember and preserve the past. Taken together, these skills amount to a rather impressive capability to remember auditory stimulation of all kinds. Thus, it is curious that we don't record and playback more of this rich source of stimulation in life, as a way of supporting our own memories and sharing them with others. From this perspective you might imagine that the practice of recording *audiographs* would be quite as common as that of recording *photographs*, particularly since the technology for both kinds of activity has now been available for well over a hundred years. To be fair, some people do record sound clips of family life alongside their photographic records, but they are a small minority compared with the number of people who use a camera. Why is this?

One reason is that although sound clips are relatively easy to capture they are hard to handle and share. This is because recorded sound is a time-based medium, which until recently, had to be browsed and played back from a linear cassette tape. This involves either listening back to an entire tape over the same time as it took to record it, or hunting for sections of a tape blindly, with fast forward and rewind facilities. A more effective way of handling such a tape would be to create an index of individual sounds over time. However, this involves more work, time and discipline than most people can muster. Digital audio technology (such as MP3 players) promises to make this situation easier, by allowing users to record, access and share individual sound *tracks*. However, this has so far been limited to music recording and distribution, and shows no sign of creating a market for personal sound recording.

Another possible reason sound clips are not captured independently, is that they are already being captured on the soundtrack of home video. If so, then many of the benefits of sound may already be enjoyed by camcorder owners. While there is some truth in this, the type of sound recorded is usually limited to natural or *ambient* sound, and the proportion of people who record home video is still small, relative to the number of people who take photographs. Furthermore, the handling and sharing of conventional home video suffers from all the same problems as audiotape. Like audiotape, videotape is a linear time-based medium and has to be played back sequentially in real-time. As the body of un-indexed home video builds up, it becomes harder and harder to find and show particular clips. Evidence from our own internal studies of camcorder owners suggests that this is a real problem with home video, resulting in much home video never being watched again after it is captured. This may also begin to explain the low penetration of camcorders compared to cameras, as consumers chose to capture and share their memories in a more readily accessible form. Digital video technology (such digital camcorders) promises to make video clips more accessible, but the overhead of capturing moving images

with sound makes it very expensive compared to the cost of capturing sounds or images alone.

An alternative to standard digital audio and video recording brings us to the subject of this book. A low cost way of recording sounds with still images is provided by some digital cameras that allow users to record a sound clip with a photograph. This capability is extended on the PC where further sounds can be recorded or combined with photo collections to enhance their presentation in digital albums. These digital technologies provide new ways of handling sound clips *by* their corresponding images. Thus a photograph itself can become a handle on an associated piece of sound. It is this *audiophoto* combination, and the potential it represents for adding sound-memories to photography, that forms the subject of this book. I aim to show that audiophotos are a distinct and attractive new medium with their own psychological and aesthetic properties. As a way of embarking on this argument, let me play you a few.

AUDIOPHOTOS DEFINED

Audiophotos are simply photographs with associated sounds. However, the types of sounds and associations can be quite complex. Consider for example the audiophoto in Figure 1.1. It shows a market square in Krakov, Poland. At the time the photo was taken, a sound recording was made; capturing the ambient sounds of the square at that moment. These sounds can be heard in conjunction with the image on the CD-ROM accompanying this book. Simply insert the CD-ROM into the appropriate drive of your computer to launch an audiophoto album on your computer screen. Then select Figure 1.1 to hear the sounds play automatically. If you listen carefully you should be able to hear pigeons cooing and then taking off together, traffic noise and conversation, and finally a trumpet beginning to play.

This is perhaps the simplest kind of audiophoto. The sound and image were recorded at about the same time, and there is a direct one-to-one correspondence between them. Even so, the exact onset and offset of the sound in relation to the moment the photograph was taken can vary, and the duration of the sound clip now gives a certain length to the presentation of the image. In this audiophoto the sound clip is quite long (61 seconds) and contains the sound of the shutter operating as the photograph is taken (40 seconds in).

Imagine now the same photograph with other sounds. The photographer might add a voice commentary, or voiceover, explaining where the photograph was taken and what he or she was doing there. Polish music might be added to the photograph to give it more of an ethnic flavour. Finally, a fragment of conversation *about* the photograph might be recorded and attached to the image for future reference. All these additional recordings would have the same one-to-one correspondence to the photograph as the ambient sounds in Figure 1.1, but with a different kind of content, duration and sound effect in each case. Together with ambient sounds, they cover all the major types of sounds that might be combined with photographs.

Figure 1.1 Market square with ambient sounds

The boundaries between these four types of sound can be further blurred when music, voiceover or conversation is captured within the ambient recording itself. An example of this is shown in Figure 1.2. Here, two beach photos are associated with a single ambient sound track containing a live commentary and interview with a surfer. The commentary was recorded by a father watching his son trying to stand up on a surfboard. This example also shows another possible type of association between sounds and images, in which one sound clip corresponds to a sequence of images contained within it.

In short, audiophotos can differ in terms of the types of sounds and images they contain and the association between their component parts. By looking and listening to these examples you should have a feel for how audiophotos differ from both still photographs and video, in terms of the information they convey and the interaction you can have with them. On this last dimension, there is one more important point to make about the form audiophotos can take, and the effects of this on the way they are experienced.

If you have been looking at the audiophoto album on the CD-ROM you will have had a certain kind of playback experience around a screen. The album has been designed so that any audiophoto can be accessed directly from the home screen, and plays automatically on presentation. Audio playback can be paused or rewound to the beginning of the track with screen-based control buttons, but the next track won't play without you selecting another photograph. This allows you to playback audiophotos out of sequence, so that you can dip in and out of the CD-ROM as you are reading the book. Although this breaks up what might have been a more serial play-through of audiophotos in sequence, the experience is still somewhat presentation like. The photographs appear roughly one-at-a-time on a vertical screen and the sounds play at you until you stop them.

Figure 1-2 Surfing sequence with live voiceover

Trying to read the book with the CD-ROM playing may have given you a slightly different experience. Because the images are reproduced on the printed page *and* the screen you have a choice about which one to look at while its sound is playing. If you choose to look at the printed photograph in this situation, you are no longer watching a screen-based presentation but are reading a book with sound. In fact this activity might be better supported by instrumenting the book with audio technology. Imagine this book, or a photograph album, with stereo speakers on the inside of the front and back cover and a method of touching the photographs or pages to playback associated sounds. The experience you could have with this would be similar to the experience of looking at conventional printed photos, except that you would have the option of switching on and off the sounds at will. This possibility of playing back sound from a printed photograph, or *audioprint*, is something that is technically possible and would further distinguish audiophotos from video.

From these two forms of audiophoto playback it should be clear that there is a basic choice to be made between a paper and screen-based format, and that this choice dramatically affects the resulting interaction and experience with the content. The exact nature of this difference will depend largely on the complex interplay of hardware and software design decisions made in the screen-based implementation, and especially the extent to which they amount to a paper-like feel. The same kind of choice is inherent in the use of all digital photos, and there is an active debate in the industry about the future of printed photos when images can be viewed more quickly and cheaply on screens. (printed or projected)

AUDIOPHOTOS AS A NEW MEDIUM

I want to return briefly to the property of an audiophoto in representing the dual aspects of sound and visual memories. The sound and image components of an audiophoto are not simply audio-visual elements to be consumed separately. When they are consumed together, a single complex effect is produced. This is very similar

to what is going on in video where the total effect of combining moving images with sound is more than the sum of its parts. You can see this very clearly if you try to view an audiophoto or watch a piece of home video with the sound off, then listen to the same clip with your eyes closed, then view and listen together. As in the design of a film, it should be possible to create special audiophoto effects that are exclusive to that medium.Two examples of this are shown in Figures 1.3 and 1.4.

Figure 1.3 Object obscura

Figure 1.3 is a rather ambiguous image on its own. Its shape and meaning only become clear with the playback of its associated piece of ambient sound on the accompanying CD-ROM. Can you tell what it is? As a clue, the audio track contains the sound of someone approaching the central object and walking away again. In this example, the sound and image work together to 'picture' an object and communicate a simple activity that occurred around it during a long moment in time.

Figure 1.4 is an audiophoto of my son Joel when he was 4, riding on a train to the Natural History Museum in London. Like many four year olds he was fascinated by dinosaurs, and was looking forward to seeing the dinosaur exhibits at the

museum. In the picture he is singing into an earpiece of a portable cassette player which is playing one of his favourite tapes of the day; a collection of dinosaur songs. If you listen to the sound which accompanies this image, you will hear him singing along to the tape. Can you spot what is unusual about this? The sound lacks the background noise of the train and contains the musical backing to the singing. This is because I later re-recorded Joel singing the same song to the music playing on our hi-fi at home, so that the listener would be able to hear what Joel heard at the time. So the photo is taken from my perspective but the sound is taken from Joel's. As a unit this is extremely effective for me as a portrait of my son at the time. The addition of the sound helps to capture more of his personality and interests at that moment, than could have been captured with the image alone. Without the sounds the entire reference to dinosaurs and all that meant for Joel would have been missing. This shows that sound not only adds something to a classic photographic genre such as the portrait. Sound can entirely transform it *as* a genre. The same sorts of transformations are also possible for other photographic genres such as landscapes, devotional, still life, the human body, or surreal and abstract images.

Figure 1.4 Dinosaurs dinosaurs

UNDERSTANDING AUDIOPHOTOGRAPHY

The practice of creating and reviewing audiophotos of this kind might be referred to as *audiophotography*. As with traditional photography, this practice might be conducted on a professional or amateur basis, in a fine art or domestic context, and with a surrounding set of behaviours by its audience. Practitioners would work with a set of audiophoto technologies to create certain effects based on their

understanding of the aesthetics of the medium. This mix of practice, aesthetics and technologies in audiophotography is exactly what this book is about. The central focus will be on its operation in an amateur domestic context, although many of the findings may be relevant to its operation in other contexts. The central questions addressed in the book are:

- o How does the addition of sound affect the meaning and value of photographs?
- o What kinds of effects are produced by different combinations of sounds and images?
- o How might the addition of sound affect the ordinary practices of taking and sharing photos?
- o What kind of technologies are required to support audiophotography?

The question of relevant technologies begins to connect this book to others in the Computer Supported Cooperative Work series of which it is a part. Digital camera technology is important to audiophotography of course, but so also is technology for the communication and sharing of photographs. I have referred to this elsewhere as groupware for photographs or *photoware* (Frohlich, Kuchinsky, Pering, Don & Ariss 2001). By looking at a new kind of photograph for sharing I will be examining requirements for photoware from a different point of view. Instead of considering how analogue or digital photographs are shared today, and how this might be improved, this investigation will focus on how audiophotos might affect photo sharing and what photo sharing is *for*. The emphasis here is on understanding the value of a new media type for expressing ourselves differently and therefore changing the form of interactions we can have with each other. Meyrowitz (1986) expresses this well in the opening quote of this chapter. He uses an architectural analogy to show how new media act like stage sets or props, allowing us to play out certain roles or try out certain behaviours that were not available before. In the rest of this book I will be looking at audiophotographs as a new kind of prop in the photographic landscape. Hence the book is more about photographs than photoware, but has many implications for photo sharing which will be discussed throughout and drawn together ar the end. Readers can approach the book from either perspective, photography or technology, taking what they will away from the overlap between them.

One problem with addressing these research questions is that audiophotography as a domestic practice doesn't yet exist. This makes it difficult to study. In addition, the potential technology that might support the capture, handling and sharing of audiophotos is in flux. Finally, although it is possible to look at the aesthetics of image-sound combinations used in contemporary art and mass media, this will not tell us how those combinations will work with domestic audiophoto material designed for a private audience of family and friends. Given these conditions you might wonder how it is possible to say anything at all about audiophotography, let alone write a full-length book on the subject.

Surprisingly enough, this is a common problem when conducting user research on new technology (e.g. Ireland & Johnson 1995). The aim of the research is usually to identify opportunities for new technology in meeting unmet user needs or values.

This can be done ahead of the technology, by studying current day practice in some domain of interest and obtaining attitudes and reactions to future practice ideas. This part of the research process involves the gathering of early requirements and needs. Subsequent parts of the process involve working with designers and engineers to generate prototypes of the kinds of technologies that would appear to meet the identified requirements. By introducing the design concepts and then the prototypes back into the domain of interest, it is possible to obtain further reactions and attitudes, and even to sample future practices for small periods of time. When this involves the creation of new media, the media themselves can be used and shown to others experimentally in order to gauge the way they seem to work. In this way, it is possible to work up a future scenario for technology and its uses which is not arbitrary or unrealistic, but faithful to an understanding of user needs and how to meet them.

The book is based on the results of this process, which I have carried out in the domestic photography domain with different colleagues, on and off, over the last 7 years. Audiophotography is just one of the future scenarios we derived. Chapter 2 covers the class of technologies, both past and present, that we have been considering in the design of audio-photo capture and use. Chapter 3 presents a review of previous research to understand the ordinary practice of taking and sharing photos, and how it might be enhanced by sound. Chapters 4 to 7 step through the aesthetics of different kinds of audiophoto content. Each is based on a separate investigation of the four basic types of sounds that can be used with photographs, including ambient sound, music, voiceover and conversation. In each investigation, we gave people the opportunity to record audiophoto material that formed the basis of further discussion and analysis. Chapter 8 addresses the question of audiophoto playback, and particularly the effects of paper versus screen-based technologies. Chapter 9 concludes with recommendations for audiophoto technology that would enable the future practices that people appear to desire.

While it is possible in this way to argue rationally about the potential value of a new medium, I am also aware of the need to give voice to the medium itself. The many example audiophotos in the book are therefore an integral part of its message, and will probably speak more powerfully than my prose. Hopefully the text and media together will give you a taste for doing audiophotography yourselves. And if enough of you are encouraged to try it, the technology will evolve to support it, and another chapter in the history of photography will have begun.

A brief history of sound & image media

"For the purpose of preserving the sayings, the voices, and the last words of the dying member of the family – as of great men – the phonograph will unquestionably outrank the photograph" (Edison 1878).

The idea of capturing sound memories and combining them with images may appear exotic when applied to photography. However, these notions have been evident in different forms from the very inception of the modern mass media. Furthermore, the technological elements for handling different kinds of sound and image data are all readily available today.

This chapter underscores these points by turning briefly to the history of three key technologies and media forms: the phonograph, the talking book and the cinema. These technologies highlight the use and value of sound, as well as the combinations of sounds and images that have been tried in the past. In each case I consider their relationship to audiophotos as defined in Chapter 1, and trace any relevant technical developments to the present day. The aim in doing this is to point to prior developments in audio-photo media design that set a precedent for this activity today, and to collect any lessons that can usefully be taken into the photographic domain throughout the rest of the book.

SOUND MEMORIES AND THE PHONOGRAPH

It is hard to imagine now how the first phonographic recordings must have sounded to the people of the day. It must have been something akin to the surprise of babies when they first encounter a radio or hi-fi. However, babies are used to the world being full of surprises, and are not in a position to judge the difference between a commonplace event and something that is new to the world. The capture and playback of a human voice from a box was completely new in 1877 when Thomas Alva Edison filed his patent for the 'Phonograph or Speaking Machine' and unvealed its operation to the public. Even the first demonstration of the telephone by Alexander Graham Bell two years earlier had not prepared people for the idea that a voice could be separated from its speaker in time as well as space. The typical reaction upon first hearing a phonographic recording was shock, amazement and fear (Brady 1999). People simply couldn't understand how the full richness of human speech or music could be captured and reproduced from as simple an apparatus as a needle and a cylinder wrapped in tin foil. Consequently when the phonograph was first demonstrated to the National Academy of Sciences in 1878, several members of the audience fainted (Conot 1979:109). Early newspaper accounts of the phonograph referred to wizardry and magic, as in this opening from the Harper's Weekly in March of 1878:

> *"If it were not that the days of belief in witchcraft are long since past, witch-hunters such as those who figured so conspicuously in the early history of our country would now find a rich harvest of victims in the Tribune Building. Here are located two marvels of a marvellous age. The telephone, which created such a sensation a short time ago by demonstrating the possibility of transmitting vocal sounds by telegraph, is now eclipsed by a new wonder called the phonograph. This little instrument records the utterance of the human voice, and like a faithless confidante repeats every secret confided to it whenever requested to do so" (Read & Welch 1959, p21).*

Edison himself appeared to be shocked by the success of his own invention. The central idea came to him almost by accident when he was trying to relay morse code recorded on paper to another electrical circuit. He found that by turning the paper quickly the device he was using gave off a humming sound "resembling that of human talk heard indistinctly" (Edison 1878). Although he immediately saw the potential of this arrangement for recording speech he was still amazed at the fidelity of his own voice reciting 'Mary had a little lamb' on the first phonographic prototype built by John Kruesi in his laboratory:

> *"I was never so taken aback in my life – I was always afraid of things that worked first time" (Read & Welch 1959, p18).*

Many of these reactions were similar to those experienced on first seeing a photograph in 1839. In particular, people appeared to be amazed at the *accuracy* with which a scene could be captured and represented, compared with a painting. This is conveyed eloquently in Edgar Allen Poe's account of the daguerreotype in 1840:

> *"Perhaps, if we imagine the distinctness with which an object is reflected in a positively perfect mirror, we come as near the reality as by any other means. For, in truth, the Daguerreotyped plate is infinitely (we use the term advisedly) is infinitely more accurate in its representation than any painting by human hands" (Poe 1840 reprinted in Trachtenberg 1980, p38).*

This ability of both photographs and phonographs to accurately capture and reproduce sights and sounds of the past, lends both media a sentimental value, in addition to the practical one of recording information. The sentimental value of *photographs* is well-documented in writings on photography. For example, Hirsch (1997) points out that the family album serves both as a lively reminder of people and events for the current generation, but also as their tribute and eulogy for future gen̶... well known is that the same sentimental character of *sound record̶...* ̶.e of the first things noted by early commentators. For example, in ̶he first pu̶̶lication introducing the phonograph, an editor of Scientific American 1877 wrote this:

> *"It has been said that Science is never sensational; that it is intellectual, not emotional; but certainly nothing that can be conceived would be more likely to create the profoundest sensations, to arouse the liveliest of human emotions, than once more to hear the familiar voices of the dead. Yet Science now announces that this is possible, and can be done. That the voices of those who departed before the invention of the wonderful apparatus described in the letter given below are forever stilled is too obvious a truth; but whoever has spoken into the mouthpiece of the phonograph, and whose words are recorded by it, has the assurance that his speech may be reproduced audibly in his own tones long after he himself has turned to dust. The possibility is simply startling. A strip of paper travels through a little machine, the sounds of the latter are magnified, and our grandchildren or posterity centuries hence hear us plainly as if we were present. Speech has become, as it were, immortal" (Johnson 1877).*

In May of 1878, Edison's own views on the uses of the phonograph were spelt out in an article by his Public Relations officer, Edward Johnson. Foremost among these was the idea of the *phonographic family album* or 'family record'. This was proposed as an auditory version of the photo album, which would go beyond the mere visual depiction of family members to reflect their underlying views and beliefs, and project their very presence into a room (see the opening quote to this chapter).

Edison's National Phonograph Company continued to promote what might be called *domestic phonography* until at least 1900. In a promotional book they targeted family use of the phonograph in the home parlour. Fictional scenarios were used to show how voice recordings could at some times help with the mourning of a dead child, and at other times provide light-hearted fun and entertainment ('The Phonograph' 1900). In relation to the latter use, phonograph parties were suggested in which family and friends could record or listen to stories and songs together, and

play voice guessing games. Meanwhile, the public were buying increasing numbers of pre-recorded wax cylinders compared to blank cylinders, as music consumption became the dominant use of the phonograph. This trend was followed and reinforced by Emile Berliner in 1895 with the introduction of disc records. His gramophone was designed for playing pre-recorded music on mass-produced records and lacked recording capablities. Edison continued to market blank cylinder phonographs for home and business markets, as well as eventually manufacturing his own diamond disc phonogram in 1912, in competition with the gramophone.

Although the recording of personal sound memories has never taken off in the home, the recording of cultural memories and rituals has become a cornerstone of the ethnographic method as used in anthropology and other social sciences (Brady 1999). This practice was also anticipated and encouraged by Edison who proposed recording the speeches and utterances of great men. He recognised that these would be of key historical and cultural value in years to come:

"It will henceforth be possible to preserve for future generations the voices as well as the words of our Washingtons, our Lincolns, our Gladstones, etc and to have them give us their present 'greatest effort' in every town and hamlet in the country" (Edison 1878).

Edison and his associates also began to collect recordings from contemporary leaders and figures at every opportunity. The lack of a national repository for such recordings meant that their exact scope and whereabouts is unclear. However Read & Welch (1959, p47) tell a fantastic story of the discovery of a box of old cylinders by Miss Kathleen Blank in 1953, then a secretary at the Edison Museum at West Orange. The box was in a cupboard in the Edison Library behind a bed on which Edison occasionally used to take a nap. It contained original cylinder recordings of a range of eminent people speaking around the turn of the 20th century, including Leo Tolstoy, John Wanamaker, President Diaz of Mexico and Thomas Gladstone. Other recordings from eminent visitors to the Edison Laboratory have since been discovered, including those by Robert Browning, Alfred Lord Tennyson, Sir Henry Irving, Sir Arthur Sullivan, Count von Bismark and the emperor Franz Josef of Austria. Other collectors report recording the voices of Florence Nightingale, Napoleon Bonapart, Phineas Barnum and so on (Hough 1910).

At the same time that Edison was recording voices of the great, social scientists were beginning to take phonographs with them on their field trips to faraway peoples and places in order to capture native folk songs, languages and stories. The subjects of these recordings were not great or famous visitors, but rather ordinary members of their communities speaking or singing about their lives and beliefs in a domestic setting. Nevertheless these 'natives' furnished the scientists with detailed insights into other societies and customs, and generated recordings that were equally priceless in their own way to those obtained from the rich and famous. A pioneer in the use of sound recording for this purpose was Jesse Walter Fewkes who first used a phonograph to record the music and language of Passamaquoddy Indians in 1890 (Brady 1999). A great number of cylinder recordings were made of American Indian life at around that time by anthropologists who realised that it was under threat from

white domination. Figure 2.1 represents a typical scene and recording of this kind by
Frances Densmore, another well known ethnographer/recordist.

*Figure 2.1 An ethnographic recording being made by Frances Densmore
around 1914. Figure 4.1 in Brady (1999, p92).*

Over time, the number of eminent and ethnographic cylinder recordings grew
very large. This led to the need for one or more national sound archives, noted by
Hough as early as 1910. Apart from the Edison museum and the establishment of a
phonogram archive in Vienna, Austria, around 1925, there were few attempts to
bring together different kinds of early sound recordings in other countries. Read &
Welch, writing in 1959, mention that the Library of Congress in Washington D.C.
was a place to which music companies and researchers tended to send recordings for
safe keeping. The Library extended its role of sound archiving by eventually hosting
a large number of cylinder recordings belonging to the Bureau of American
Ethnology and related agencies. During the 1970's, the director of the American
Folklife Centre at the Library of Congress noted an upsurge in the number of
requests for cylinder recordings by members of the public, especially those with an
Indian heritage:

> *"Like a wildfire, the passion for searching out, embracing and
> elaborating upon one's roots spread through the United States during
> the Bi-centennial era. Nowhere has this renewed passion and concern
> been more visible than with American Indians, and the Folk Archive
> found itself the recipient of an increasing number of inquiries from
> Indian tribes, organizations and individuals about those early cylinder
> recordings. To the scholars they provided fascinating documents for the*

study of cultural history; but for the sprirtual heirs of the traditions the
cylinders documented, the recordings had the greater intimacy of being
'somebody's grandfather'" (Jabbour 1984, p7).

In response to this demand, and with the support of the Smithsonian Institution, Jabbour set up the Federal Cylinder project in 1979. The aim of the project was to organise, catalog, preserve and disseminate the contents of the cylinders (Brady 1999:5). Erika Brady was a technical consultant and researcher on the project, and recalls the closing phase of the cylinder project in 1983 when archival tapes of Omaha Indian recordings from 1901 were taken back to a modern Omaha reservation. The effects of the tapes on the Omaha people were summed up by a member of the tribe as follows:

"I didn't know what to expect when the songs on the cylinders came
back. After a year or so now it has affected people in different ways. For
some of the older singers and older people that remember those songs, it
is renewing, it brightens them up, because it supports what they have
been saying and standing for all along. During the last pow-wow the
singers started singing song that no one had heard before. It was like a
supernatural or spiritual gift that had been given back to the people
again" (cited in Brady 1999, p121).

Although this event is extraordinary in many ways, as an example of the use of sound memories, it does reinforce the power of verbal sound recordings for cultural memory and identification. Furthermore, the interest in cultural and personal history has increased if anything in recent years, with the advent of computerised geneological records and family history software. Given these two observations it is not hard to see that the time may have come to reconsider the possibility of domestic sound recording – particularly if it can be done as part of an established practice of taking photos.

SOUND AND THE PRINTED IMAGE

Since the earliest days of photography, commercial photographs have been printed alongside textual captions and writings that place the image in some wider context (Barthes 1977). Domestic photographs followed the same convention, as people began to handwrite brief labels on the back of their prints or alongside them in paper photo albums. The idea of recording these labels as voice comments that can be played back from the paper itself seems at first sight to be very advanced, even to modern ears. However, the germ of this idea can be seen in another of Edison's predictions about the use of the phonograph. Furthermore, its evolution into a variety of talking book technologies means that the development of printed audiophotos (or *audioprints*) is just around the corner.

In reflecting on his first tin foil phonograph in 1878 Edison noted that the foil on which the sound indentations were recorded could be taken off the cylinder after recording, folded up and transferred to another phonograph for replay. In the context of dictating business letters, Edison realised that the foil itself could be put in an

envelope and mailed to its recipient, eradicating the need to transcribe the message onto paper to send as a conventional letter. This led to a proposal for a 'phonogram'; a physical voice-mail message based on a kind of audio-paper. This is explained in the quote below.

> *"The practical application of this form of phonograph for communications is very simple. A sheet of foil is placed in the phonograph, the clockwork set in motion, and the matter dictated into the mouthpiece without other effort than when dictating to a stenographer. It is then removed, placed in a suitable form of envelope, and sent through the ordinary channels to the correspondent for whom designed. He, placing it upon the phonograph, starts his clock-work and listens to what his correspondent has to say. Inasmuch as it gives the tone of voice of his correspondent, it is identified. As it may be filed away with other letters, and at any subsequent time reproduced, it is a perfect record. As two sheets of tin foil have been indented with the same facility as a single sheet, the "writer" may thus keep a duplicate of his communication. As the principle of a business house or his partners now dictate the important business communication to clerks, to be written out, they are required to do no more by the phonographic method, and do thereby dispense with the clerk, and maintain perfect privacy in their communications" (Edison 1878).*

With the benefit of hindsight we know now that the transmission of voicemail in this way never took off. However, the *electronic* transmission of voice messages directly through the telephone network certainly did take off, to realise many of the functional benefits outlined by Edison above. It is surprising that Edison overlooked this method of voice messaging in his many predicted uses of the phonograph, particularly since he was the first to combine the phonograph with the telephone in his 'Carbon Telephone'. This was used to demonstrate the recording of live telephone conversations rather than to record and transmit voice messages.

The failure of audio-paper as embodied in the foil phonogram was due largely to its inefficiency of transmission. It inherited all the shortcomings of 'snail-mail' compared to email, since the physical foil sheet still had to be placed in an envelope, stamped at extra cost, and transported with a corresponding delay. In contrast, an email or conventional voicemail message can be delivered almost instantaneously at negligible cost and effort. However, a secondary reason for the failure of the phonogram, when viewed from the perspective of audio-paper, is that it failed to exploit what paper is generally used for; namely printing. The foil material carried only sound information and was therefore used like a sheet of surrogate *blank* paper. This meant that it offered nothing over and above an electronic recording of the message, which could eventually be transmitted more efficiently. If Edison had been able to print on his foil sheets, the audio message could have been used to complement the visible information, providing something a straight voicemail message could not do. Furthermore, if the printing process had supported the reproduction of photographic images, then printed audiophotos or *audioprints* could have been produced.

Since the audio recording industry turned quickly away from Edison's foil sheets to solid wax cylinders, following the Bell-Tainter patent of 1886, these possibilities for printed audio paper remained unexplored for many years. However, they emerged again in the form of a printed 'Talking book' developed by a consortium of Japanese companies working in collaboration with the Tokyo Institute of Technology in 1959. Professor Yasushi Hoshino who was in charge of the project, describes its motivation as follows:

> *"Newspapers, magazines and other printed matter are for the purposes of conveying ideas by visual means – by word and pictures. Sometimes these serve their purposes well but at other times they are not so effective. The sentences in a foreign language text-book, for instance, are not conveyed to us in sound. A score does not play music for us. If books and newspapers could convey in sound what is described in the printed images in their pages their power of expression would be enormously expanded" (Hoshino 1959, p57).*

The innovation behind the talking book was to apply something akin to magnetic tape to the reverse side of a piece of A4 paper. Sound could be encoded in the coated paper, or 'synchrosheet', and played back on a 'synchroreader' device which looked like a flatbed scanner (see Figure 2.2). A magnetic reading and writing head would pass underneath the sheet while the user was reading the printed material from above. As with the early phonograph, the technology could be used both for recording and playing back sounds, and synchrosheets could be erased and re-used at will. This led to suggestions for voice-notetaking uses with pre-printed material or blank pages, as well as for the consumption of pre-recorded sounds from books. In a brilliant variation, personal recordings on one sheet could be copied onto a duplicate transfer sheet with an iron (Hoshino 1959, p59).

At the end of the Talking book article, Hoshino cites three Japanese printing companies who were working at the time toward commercialisation of synchrosheet paper. One of these, the Toppan Printing Company, is cited in a footnote as producing a musical Christmas card that was received too late for publication in the article. Ironically, it is this minor use of the technology that became one of its few commercial successes. Even this was achieved initially through an inferior implementation. The bigger ideas of an audiopaper medium to revolutionise reading remain unrealised.

Figure 2.2 Synchroreader prototype by Cannon Camera Company
(Figures 3 and 4 in Hoshino 1959).

Figure 2.3 shows a postcard of a seaside scene in Illfracombe, England. But this is no ordinary postcard. If you look carefully at the image you will see a hole in the middle and the faint grooves of a disc record imprinted over its centre. When placed on a turntable it can be played as a record to reproduce a song called 'The witch-doctor'. These kinds of postcards were popular in the 1960's and can be found in postcard collections of that period. They utilise the same concept shown in Figure 2.2 of a turntable interacting with a piece of paper containing a sound encoding on its surface, However, this time the encoding is on the front side of the printed paper in phonographic form, and requires rotation of the paper past a fixed reading head rather than vice versa. This means that the image spins while the sound is playing so that the two media cannot be consumed concurrently. A similar problem was inherent in vinyl records that were marketed with images printed on their surface in the early 1970s. This led some artists to release printed records with more abstract images on them. These formed psychedelic patterns while the record was being played. Both these technologies can be seen as early forms of commercial audioprints.

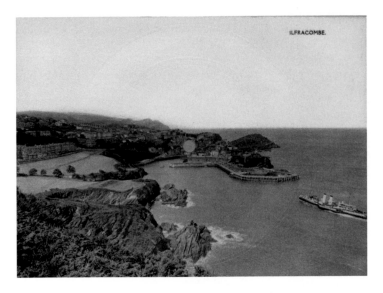

Figure 2.3 A singing postcard.

More modern versions of the audio-enhanced card or image-enhanced record now utilise digital technology. For example, greeting cards with pre-recorded messages can now be bought in most card stores. These incorporate voice chips such as those found in mobile phones and talking toys, and playback a sound clip lasting between 10 and 30 seconds. Recordable versions are also available to allow you to personalise a pre-printed card. These can even be ordered over the internet to personalise cards, and a range of other gifts including pillows, toys, flowers and photos. Printed audiophoto products now include self-playing audiophoto cards, audio-enabled photo frames, and audio photo albums.

While these audioprint products allow for the annotation of photographs and other printed matter by voice, they are generally niche gift items and have never made it to the mass market as extensions of domestic photography. Significantly, they have never been connected to developments in digital photography which allow people to capture or attach sounds to digital photographs. Instead it is becoming more common to create and consume audiophotos on screen. For example, it is now common to send or receive multimedia *e-cards* over the internet from websites which support the combination of pre-designed images, sounds and animations. Furthermore, a number of digital photo websites are beginning to support sound annotation and playback.

Turning to another form of audioprints, records have always been sold with printed record covers defining the style and type of music. Such packaging has been preserved across a number of media transformations from disc to tape to audio CD. The latter are often sold with small booklets providing a combination of lyrics and photographs. These contain the same sort of information that used to be depicted on

the larger surface area of a vinyl album cover, sleeve or insert. This type of music packaging can be seen as a form of audioprint material, insofar as the printed matter contains photos that are designed to be read in conjunction with the music, albeit in a loose and fluid way.

Again there are a number of screen-based alternatives to print being introduced with digital music. A simple example can be seen in the visualisation of sound patterns in various media players while a music track is playing. Also, modern audio CDs are sometimes released in a format which can also be played in a CD-ROM drive to show accompanying video, graphic and multimedia material on a PC screen. In addition, the introduction of the MP3 format for digital music encoding has led to an explosion of artist and distributor websites from which users can download music files. Many of these are linked to internet radio stations which stream digital music to a PC alongside promotional information displayed about the artists. In these contexts, images and sounds are presented together in more or less integrated forms. In the most tightly integrated cases, users can click on an audiophoto of an album cover to hear a sample track. While this may be adequate for music browsing there is evidence that *purchasing* music by downloading it is unsatisfactory for users. It leaves them without any kind of physical or printed packaging by which to index it. A recent study suggests that consumers need something tangible to hold on to as a way of managing their music, and recommends that graphic packaging be preserved as a token and interface to the music (Brown, Geelhoed & Sellen 2001).

Finally, the fate of the talking book has been similar to that of the talking card. The conventional silent form persists as the dominant media type. A separate market for audio-only books co-exists alongside the conventional market, in the same way that voice messaging co-exists alongside greeting cards. In between printed *or* audio books there are a number of talking book products for children based on audio chip storage. Typically these comprise a hardback picture book with an electronic block attached to one edge of the binding. Children press buttons on the block labelled with icons appearing on the printed pages. These cause the playback of voices and sound effects designed to enhance the story. In a recent development of this technology called the LeapPad, a double-page digitizer is built into base of a separate book player, and a variety of booklets can be placed open on the base. As long as the user inserts the right audio cartridge into the player and remembers to touch the right page number icon down the side of each page, the entire surface of each page becomes available to touch with a pen wand in order to invoke sounds. Figure 2.4 gives an example of this by showing a music page from the introductory LeapPad book. The associated sounds are generated by touching different instruments in an orchestra in order to decompose a tune. The experience is similar to interacting with a PC-based talking book on a CD-ROM, except that it is delivered from a printed page held in a portable device.

*Figure 2.4 A LeapPad page allowing music to play from
a variety of paper instruments.
Pages 3 and 4 from Marggraff (1999.)*

In conclusion, we can see from this history that audiopaper and audioprints are relatively old ideas with many modern manifestations. As with the original tin foil phonograms, a competing implementation exists for almost all of them, in the form of computer software that can display images and sounds together on a screen-based device. However, unlike the phonogram, many audioprint products are considerably cheaper than their virtual counterparts and offer different kinds of experiences. In some cases, these experiences may even be worth paying a premium for, as in the sending of a recordable greeting card rather than an 'e-card'. Selection or design of a solution is not a matter of technological supremacy but of consumer preference and choice.

SOUND AND THE MOVING IMAGE

Whereas printed images have always been presented with textual explanations, moving images have always co-existed with sounds. Film sound design is highly relevant to audiophotography because it shows that a great variety of image and sound combinations are possible, along a continuum between still and moving images. Although most of this technology has been directed towards the development of public cinema, there has always been a sense that it could be used for enriching the ways in which people record multimedia memories in a domestic

context. By returning to the history of the cinema I hope to show that modern home video is not the only option for doing this.

The earliest image sequences were not photographs but paintings done on glass slides (c.f. Rossell 1998). These slides were used in *Magic Lantern* projectors that shone light through the slides to throw their image on a wall or screen. The earliest reports of painted slides date back to at least 1697 when the physicist Erhard Weigel made slides of goats butting and a bear attacking a man. Action of this kind was initially shown by changing slides mechanically in quick succession, or by the use of levers that moved or rotated one slide against another. In the early 1840s, Henry Childe introduced the technique of dissolving views from double or triple lanterns capable of blending one image into another. This led to a range of sophisticated animation effects. For example, a classic set of dissolving slides that could be purchased commercially at the time, depicted a pastoral scene showing a mill next to a pond and woodlands. The scene slowly changed from autumn to winter to spring, and included subtle effects such as the turning of the millwheel, snow falling, a family hurrying by, and a group of swans feeding in the water.

What is significant from an audiophoto point of view is that these kinds of images and animations came to be used by professional magic lanternists in illustrated talks. These talks were a form of visual storytelling in which the lanternist would essentially narrate a story whilst operating the Lantern. Rossell (1998) gives an indication of the content of some of these talks by citing the work of a famous travelling lanternist called Paul Hoffman. Hoffman travelled around the captitals of central Europe giving talks on topics such as 'Polar expeditions from 1845 to 1859', 'A trip through central Africa', and 'Earthquakes, volcanoes and the destruction of Pompeii'. He also designed some slide sets to go with music: as in his series of illustrated operas by Wagner.

The next step forward in Magic Lantern technology came with the invention of the *Choreutoscope* by Beale in 1866. This essentially switched the slide changing mechanism for a rotating disc with successive images painted around it. This allowed projected images to be changed much faster by spinning the disk. The use of a stroboscopic disk was borrowed from a child's toy called the *Phenakistoscope* invented 34 years earlier by Stampfer in Austria (1832) and Plateau in Belgium (1833). The toy comprised a spinning disk, held on a stick, with images painted on one side of the disk and slits cut into its inner circle. This would be held up to a mirror, spun around, and the images viewed in the mirror through the slits. If the disk was spun fast enough, the individual images were seen to merge into each other and their subject was seen to move. This illusion of true motion occurred when more than about 16 images were viewed each second. By combining this illusion with Magic Lantern technology in the Choreutoscope, Beale (and later Brown) considerably enhanced the impact of Magic Lantern shows and opened up the way for the rapid projection of photographic images later.

Around the time that Childe introduced the dissolving view Lantern, Daguerre (1839) announced his invention of the daguerrotype as a method of fixing photographic images on a metal plate. The improvement of this method on glass plates by Archer shortly afterwards suddenly aligned photography with Magic

Lantern technology. The use of photographic slides in cameras simultaneously provided photographers with a new method of sharing photographs with large groups of people, through the Magic Lantern, and opened up a new source of ultra-realistic slides for lanternists. Frederick and William Langenheim of Philadelphia were quick to spot this potential and offered their glass *Hyalotype* slides for sale in 1849. Sales were subsequently boosted by the introduction of a brighter and more sensitive magic lantern called the *Sciopticon* by Lorenzo Marcy, also of Philadelphia. By 1878 the market for photographic slides was established. These tended to be sold in slide sets of 15 to 125 slides, on topics ranging from travel and education to drama and song. The more dramatic sets were comprised of 'life model' slides showing actors posed against stage settings. These were designed to enact a story as a sequence of scenes. Such photographic materials eventually overtook the use of painted slides in magic lantern shows at the end of the 1800s, and were again used in the context of a spoken or musical performance.

Given these developments in animation and photographic slide projection, it was only a matter of time before true motion animation came to photography. Time and the small problem of taking 16 photos a second. This required further innovation in camera technology and began with the capture of time series photographs by the 'chronophotographers'. The first chronophotographers were scientists trying to capture moving subjects. Three of the best know scientists of this kind were Pierre Janssen, Eadweard Muybridge and Etienne-Jules Marey. Between 1874 and 1892 they took photographs of solar eclipses, trotting horses, and other animal and human movements. Each photographer developed different techniques for capturing these photographs. For example, Janssen used a large cylindrical apparatus with a revolving glass plate to record images of the sun every second. Muybridge used a row of twelve individual cameras spanning a 30 foot distance to capture the trot and gallop of a horse. The camera shutters were operated by the action of the horses hooves as they broke trip wires stretching across the track. Marey developed a photographic rifle with a spinning glass plate to take serial photographs of animals, gymnasts and dancers, at 12 exposures a second. However, the real breakthrough in chronophotography, as well as in photography proper, came not from the scientists but from the businessman George Eastman.

Working with conventional photographer William Walker, Eastman devised the first successful roll-film system to replace glass plates in cameras. This was announced in 1885 and worked with paper film. By 1888 Eastman had brought this system to the mass market with the launch of his Kodak camera. This was sold pre-loaded with a 100-image roll of film, returned to the factory for processing, and sent back to the customer re-loaded and with a set of developed prints. Marey was quick to bring this innovation into chronophotography, also in 1888, when he developed the first motion picture camera with Eastman paper roll film. This moved the film continuously past a rotating disk shutter, clamping it momentarily to take an exposure every 20^{th} of a second. A year later, in 1889, Eastman introduced transparent celluloid film. Marey responded in 1890 by adapting his camera for this. He also improved the shutter mechanism with twin disks rotating at different speeds so as to achieve a frame rate of up to 100 images per second. Around the same time,

in 1888, Emile Reynaud had successfully adapted Magic Lantern technology to take a rapidly wound film strip up to 45-50 meters long containing 700 images. This meant that by 1890, all the composite inventions for reproducing true motion pictures with sound now existed, in the form of the phonograph, the motion picture camera and the film projector. However, their full combination in cinema was to take another 36 years and involved numerous experiments in audio and image design.

Two of the most relevant experiments for audiophotography were those by Demeny and Edison before the cinema experience coalesced into a form of public entertainment. Both men developed a form of short video clip that could be used for extending the time-frame of a photograph, rather than filming an extended activity.

Demeny was assistant to Marey in his physiology laboratory in the Bois de Boulogne, Paris. In 1881 he began to experiment with the application of chromophotography to speech therapy. Using Marey's celluloid film camera he took photos of himself speaking the phrase "Je vous aime". Like many of the photographers working with new cameras, Demeny designed a new Magic Lantern projector in 1892 to view his photos. This was called a *Phonoscope* and used a spinning glass disc to project his head and shoulder photographs. With this material, the Phonoscope generated a few rather intimate seconds of silent 'talking head' video. Demeny always intended to combine this with speech, recorded on a phonograph and played back in time to the projection - hence his choice of the name Phonoscope. Although he never succeeded in this, his Phonoscope company advertised the technology as being suitable for the taking of 'animated portraits' in a domestic context, as well as the production of public exhibits and scientific recordings. We can see this as one of the first recommendations for home video.

The same concept of short 'living photographs', was also at the heart of Edison's initial interest in motion pictures. Having perfected the phonograph for the purpose of recording sound memories in speech and song, it was natural for him to be interested in extending this to the capture of the entire audio-visual recording event. Hence, shortly after meeting Muybridge in his West Orange Laboratory in February of 1888, Edison set up a moving picture project under the supervision of William Dickson with the purpose of combining animated photographs with sound (c.f. Rossell 1998, Chapter 5). Given this background, it is not surprising that the resulting *Kinetoscope* viewers, patented in 1891, were all designed for individual viewing, and were therefore more suitable for a home or museum audience than a cinema crowd. Indeed the Kinetoscope was initially marketed as a peep-show, and often displayed short films of domestic scenes recorded on stage sets. The fact that all the early motion cameras, viewers and projectors of the time were static, expensive and used by professional photographers and entertainers, meant that this domestic use of video as an extension of photography was subsumed by a more public use of video as an extension of theatre. The living photograph was therefore lost until the 1920s and 30s when 16mm and 8mm non-flammable film cameras were sold into homes for the purpose of capturing family memories. And by then, the cinematic drama was more familiar than the living photograph as a model for home video.

While the battle raged to synchronise sound with moving images until 1928, a thriving silent movie business emerged in parallel. Interestingly, these movies were never silent (Cavalcanti 1939). Short film material was first shown around 1900 in fairgrounds where 'Barkers' attempted simultaneous narration or dialog in multiple voices. Written 'Intertitles' eventually replaced Barkers as films began to be shown in specialised cinema halls where their voices couldn't be heard clearly. These titles provided narrative continuity between scenes by explaining the context for the action to follow or hidden developments between the action. They also conveyed dialog between the actors on screen. At the same time, live music began to be played in cinemas to drown out the noise of the projectors and give the film emotional atmosphere. Specific themes evolved for particular characters or emotions. At first, this music was played by a single piano player. Eventually trios, quartets or orchestras were introduced as cinemas competed with each other to provide a more dramatic experience from the same visual material. An economical way of providing this kind of sound was to use a single organ that could emulate the music of multiple instruments. Organs became commonplace in cinemas of the 1920s and tended to remain in place even after the coming of sound films to provide intermission music between films. Many cinema organs were also specialised for the production of sound effects. These were done with labelled stops for noises like crying, sirens, crockery and trains.

By the time sound films were introduced at the end of the 1920s, there was already a well-established practice of sound production with film, although this was split between the film producers and the cinema owners. Film producers had to learn sound production lessons all over again as they assumed responsibility for the sound track. Initially they concentrated on speech rather than music or sound effects. This was because music and sound effects were already part of the silent film experience, whereas the big new feature of sound films was the integration of synchronised speech. Hence the earliest sound films became known as 'Talkies' and resembled filmed plays (Cavalcanti 1939). Audiences found these kinds of early sound films boring, since they made little use of action, narration, or music. Cavalcanti writing in 1939, summarises the lessons learned by film producers in the first decade of the Talkies:

> *"Summing up: film producers have learned in the course of the last ten years that use of speech must be economical, and be balanced with the other elements in the film, that the style employed by the dialogue writers must be literal, conversational, non-literary: that the delivery must be light, rapid and offhand, to match the quick movements of the action, and the cuts from speaker to speaker" (Cavalcanti 1939, p104).*

These lessons, together with further technical advances in sound and image editing, led to increasingly sophisticated ways of combining sound and moving images in the cinema. While space forbids a detailed treatment of these techniques here, it is important to stress the time and effort that goes into merging images and sounds from different sources in a modern movie. Action shot on set or location is usually captured simultaneously from multiple cameras and microphones. This allows the viewer's perspective on the action to be manipulated during editing, and

move between the eyes and ears of the principle characters or to some independent position. Images and sounds can even be deliberately moved out of synch' with each other to create slow motion or other effects. Additional recorded monolog can be inserted over the top of the action, to produce the effect of voiced thoughts or retrospective reflections, and natural sounds can be accentuated or added to create surprise, arouse curiosity or heighten tension. Musical backing is almost universally used to manipulate the mood and pace of a scene, yet in such a way that its presence often goes unnoticed.

This level of professional film editing and production can be contrasted with the amateur use of cinema technology in home movie-making. This activity took off within the mass market around 1980 with the introduction of 8mm camcorders and VHS videotape players. The home movie is closer in form to the early talkie than the modern sound film. It is filmed from a single perspective with a synchronised sound track containing ambient sounds, conversation or commentary. It lacks music and may be shown completely unedited. Any editing that is carried out typically involves a simple condensation of material by cutting out unwanted footage, rather than the mixing of multiple sound and image tracks or the dubbing of additional commentary. Finally, in comparison to an early talkie, home video lacks a coherent storyline, since it is shot as a real-time slice of life without a satisfactory beginning, middle or end.

One could argue from this account that home video is undergoing a similar history to that of the public cinema, starting with the use of silent film and unedited talkies. If so, then the next stage of development may come through digital video technology which offers to provide professional home video editing tools, or to automate some of the capture and editing processes so that the final results are more entertaining. While this is undoubtedly a trajectory with momentum, it is not the only future for the *sentimental* use of recorded images and sounds. This brings me back to the theme of the book, which is to argue for an alternative approach in which ordinary photographs are enhanced by a variety of sounds. Before considering how this might be done, let us draw together some of the lessons we have learned regarding the use of sound in other media and its combination with images.

LESSONS FOR AUDIOPHOTOGRAPHY

One of the most obvious lessons to emerge from this short history, is that *the development of content and technology for any new medium is intertwined*. Time and again we saw that the inventors of technology expected it to be used for one type of content or purpose and it ended up being used for another. For example, Edison thought his phonograph would be used for voice recording and it ended up being used mainly for music playback. In some cases the content was fine but the technology was lousy – as with voicemail stored on a foil phonogram. In other cases, the technology was fine but the content was lousy – as with early Talkies shown in the cinema. In all cases, an advance in new technology had to be matched by an advance in new content – as with the need to capture a series of chrono-

photographs to use in a true motion projector. The consumer's judgement of this content was also involved throughout the history of these new media. Perhaps this is why talking books have never taken off in the mass market, because the content has never been compelling enough to merit the extra cost and effort involved in adding sound to print.

So new media technologies must be developed with both devices and content in mind, and always with reference to the user's reactions to each. Applying this lesson to audiophotography suggests that different kinds of audiophotos should be developed in different forms, and tried out by consumers themselves. This is exactly the method used in the rest of the book to explore the value of particular types of sounds with photographs and identify the best methods of capture, editing and playback. Working with this distinction a little longer, let us consider the lessons for audiophoto content and audiophoto technology that might be tried out in this process.

LESSONS FOR AUDIOPHOTO CONTENT

Regarding audiophoto content, the lesson of the early phonograph is to call attention to *the power of recorded voices for capturing both personalities and memories*. All the early reactions to the phonograph were to the possibility of holding onto the recorded thoughts and stories of a speaker beyond their death. In one respect, the value of these recordings was seen to come quite simply from the content of what was said or sung, such that messages could be passed around the current generation or memories could be passed down to future generations. However, there was a also a sense that a more mystic power resided in the voice itself, such that by entombing a *manner* of speech or singing, a part of the personality and life of the speaker could be captured and reactivated at will. Both uses of sound became entwined in later practices of voice messaging and ethnographic interviewing, although Edison's predictions for domestic voice recording were never fully realised. By combining messages, stories and interviews with photographs we may well give this prediction another chance, and align photography with a growing interest in geneology and extended family history.

Another lesson for audiophoto content comes from the patchy attempts to develop talking books. *Sound and printed images must contain very different content* that complements each other in significant ways. A book or text which reads itself has not been a strong enough idea to sustain a mass market. In contrast, the forms of audio-paper which have survived all use sound to complement and extend the printed image or text. These include sound effects in children's books, personalised voice messages in commercial greeting cards, and pictures of a band or performer on a music album cover. This suggests that straight verbal descriptions of photographs may not add as much value as ambient sound effects, music or personal messages.

The history of the cinema also teaches us that moving images emerged from the projection of successive still images at high speeds, and that moving *and* still images have always been accompanied by sound – either inside or outside the image record.

The implication for audiophoto content is that *cinematic media forms can be both borrowed and unpicked to create a range of audiophoto forms* lying between photos and home video. In particular, the sound design techniques for modern films can be borrowed and applied to still photographs to merge combinations of ambient sound, music, dialogue and voiceover. True motion video images can be unpicked by slowing down the rate of capture and playback of still image frames. Together these techniques could create new kinds of slide shows and albums that bring photographs to life in different ways. This would mark a return to the very early idea of a living photograph, but in a variety of forms which go beyond the talking-head portraits of Dememy or the peep shows of Edison.

LESSONS FOR AUDIOPHOTO TECHNOLOGY

Regarding audiophoto technology, the main lesson from this review is *digital methods of imaging and printing now provide all the elements necessary to support the coming of sound to photography.* This is made possible as professional photographic and film-making equipment is re-packaged for a mass market of consumers interested in capturing, developing and sharing images faster than ever before. Thus, still image *capture* can now be supplemented by audio recording on digital cameras and camcorders. The same functionality is also beginning to emerge on handheld computers with camera attachments, and on the new class of camera-phones. Some of these devices also support the capture of multiple still images in *burst mode*; designed not for true motion playback but for slideshow effects and printing. Additional audio recording and audio-visual editing can now be done with digital photo album software and digital video software. The video tools are oriented towards the production of more professional looking home video sequences, but the photo tools are already beginning to use sound as a way of enhancing the presentation of photographs. These presentations will run on an increasing variety of screen-based devices in the future, including the PC, TV, telephones and handheld viewers – all of which support sound playback. But there is also a chance, suggested by the talking book technologies, that audiophotos could be played back from an equal variety of paper-based devices, including greeting cards, photo frames and albums.

In the next chapter we consider how these possibilities might impact the ordinary practices of domestic photography. We will then be in a position to explore them directly, by giving consumers the chance to make different kinds of audiophotos in screen and print-based forms. Ultimately it is the consumers own specifications and reactions to this material that we will take as the requirements for this technology, rather than speculation about what could be done technically.

Domestic photography & the role of sound

"The threading of public meanings through the private medium of family photography poses again and again the puzzle of the family album. Our understandings must shift from an 'inside' to an 'outside' perspective and back. Neither position has much to say to the other, but neither is enough by itself" (Holland 1991, p5).

In this chapter, we review the existing practice of domestic photography, in contrast to other forms of art and commercial photography. The aim of the review is quite fundamental. It is to understand how and why people take photos in a domestic context, what uses and functions they are put to, and what requirements and opportunities exist for change. The review culminates in a new framework for understanding domestic photography and a set of questions about the role of sound. These questions are then addressed in a series of studies reported in the rest of the book, and interpreted with reference to the framework. In this way, we begin to define how the combination of sounds and images developed in other media might work within the medium of photography.

Summarizing previous writings and studies on domestic photography is not easy. Writings on photography in general are characterised by disagreement. Squires (1990) makes this point rather forcefully in her introduction to a collection of readings in contemporary photography:

> *"Despite intermittent outpourings of verbiage about photography, consensus about its importance, function and effect has never been achieved" (p7).*

Furthermore, writings on domestic photography are much less common than writings on other forms of photography, such as art photography. This is surprising, given the scale of amateur photo taking in human affairs, especially in comparison with the scale of professional photo taking. Also, empirical studies of domestic photography are even rarer than writings in the area. Again Squires (1990) summarizes the situation concisely, when accounting for the lack of a chapter on domestic photography in her book:

> *"..A coherent methodology for considering photography as a cultural practice that cuts across all levels of society has yet to be articulated" (p13).*

Finally, associated literatures on memory, conversation and personality have largely overlooked the use of photographs in these domains, despite their relevance in everyday notions of what photographs are for. These connections are often expressed better in fiction than in non-fiction, as exemplified in the writings of Proust (1982).

In view of these limitations, I have chosen to steer a short course through a variety of literatures that throw light on domestic photography in different ways. I begin with some classic ideas about the structure and meaning of photographs in general and their contrast with film. I go on to review some commentaries on the content of domestic photographs and albums, and also consider the role of images in psychotherapy. These ideas then form the basis of a new framework for understanding domestic photography and the potential role of sound.

THE INTERPRETATION OF IMAGES

How do you read a photograph? This question goes to the heart of what photographs are, and is addressed powerfully by two significant figures of photographic writing; Roland Barthes and John Berger. Interestingly, both are commentators on photography rather than photographers themselves, and approach photography as another form of writing.

Barthes' analysis of photographs was based on a disenchantment with existing critiques and a determination to start afresh from his own personal experience. Using 'no more than a few photographs' and a form of personal introspection, he set about trying to understand photography from first principles (Barthes 1981, p8-9). Reflecting on the relationships between the people connected with a photograph, Bartes introduced distinctions between the *observer* (or author), the *spectator* (or consumer), and the *referent* (or subject) of a photograph. As he had little experience of taking photographs as an observer, he concentrated on the experience of being photographed as its referent, or viewing a photograph as its spectator. As a referent, Barthes pointed out the profound effect of knowing you are being photographed. The anxiety of this experience is tied to a concern to project your real self, and leads

to posing for the camera. This anxiety is increased by the knowledge that the photograph may outlive you, and travel unaccompanied into history.

As a spectator, Barthes pursued two lines of enquiry in his book. The first was from the impersonal stance of a spectator who has no memory or connection to the photograph being viewed. From this position, Barthes observes with honesty that many photographs fail to make any impression on him and appear banal. Those which do make an impression always seem to have two components: a *Studium*, or subject matter of interest, and a *Punctum*, or point of effect. The punctum is said to operate like an arrow that shoots out of the scene to pierce the consciousness. It is what is emotionally touching about a photograph and often comes from the most surprising elements. For example, Barthes describes being affected by the belt worn by a women in James Van der Zee's portrait of a black family in 1926. This belt was made from the rubber hose of a water pump and revealed something of the poverty of the family dressed otherwise in their Sunday best.

In a second line of enquiry, Barthes adopts the more personal stance of a Spectator with memories relating to the photographs he is viewing. He describes the experience of looking through photographs of his mother following her death, and looking for one that captures her personality as he remembers it. He eventually finds it in a photograph of her as a child of five, standing with her older brother in a glass conservatory or 'Winter Garden'. The punctum of this photo was the expression of gentleness in the girl's face, which for Barthes represented the essence of his mother's character throughout her life. Although, Barthes doesn't comment explicitly on the difference between the impersonal and personal stance of the spectator of a photograph, its importance is established by the way in which he treats these separately in his book. As we shall see later, the perception and discussion of a domestic photograph is profoundly affected by whether or not the viewer shares a memory of what or who is represented in it.

As if to underscore this point, John Berger comments on the ambiguity of a photograph he is passed by a friend (Berger 1982a). He has no other connection or information with this photo. The photograph is reproduced in Figure 3.1 and shows a man standing by a horse. Without further information the meaning of the photograph is entirely obscure. In fact Berger plays a game of inventing meanings by giving the photograph different captions (quoted from Berger 1982a, p86):

- The Last Mountie. (His smile becomes nostalgic.)
- The Man Who Set Fire to Farms (His smile becomes sinister.)
- Before the Trek of Two Thousand Miles. (His smile becomes a little apprehensive.)
- After the Trek of Two Thousand Miles. (His smile becomes modest...)

The only certain information about the photograph is carried in its *appearance*, which shows that this horse and man existed and were standing together in this way at some point in time. The fact that the photograph isolates this moment and pulls it out of the flow of time for consideration is its other major feature according to Berger. Understanding the photograph, and thus reducing its ambiguity, consists of both reading its appearances and placing it in a local history extending just before

and just after the photograph was taken. This amounts to reading the *story* of the photo:

> *"Meaning is discovered in what connects, and cannot exist without development. Without a story, without an unfolding, there is no meaning... When we find a photograph meaningful, we are lending it a past and a future" (Berger 1982a, p89).*

Figure 3.1 Man and horse. Figure from Berger (1982a, p85).

The historical placement of a photograph can be done through text associated with the image, as in the captions listed above. In fact, the relationship between image and text can work in two directions. Either the text can load the image with contextual information, as in a caption, or the image can illustrate text as in a figure (Barthes 1977, p25). Furthermore, the 'text' of a photo could include the spoken words that are said about it (Sekula 1982). However, the appearance of the photo itself can also provide clues to its history and meaning. Barthes (1977) lists a number of techniques such as the choice of pose of a subject, the arrangement of objects in the image and the blurring of movement, all of which convey additional

information about the context in which the image was taken. Berger refers to this effect as a coherence of appearances that takes place in particularly expressive images that point outside themselves to the events surrounding them. A final method of placing a photograph and aiding its interpretation is to present it in a sequence of images. This leads the viewer to read the story of each photo in the context of the images that come before and after it. For Berger, these latter, non-verbal, techniques for conveying multiple meanings out of sequences of appearances, are the essence of photography and the photographic language. He illustrates this powerfully in a collaboration with photographer Jean Mohr, in which the life of a peasant women is illustrated through 150 photographs (Berger & Mohr 1982, pp135-275). This work, entitled 'If each time..', mixes images from different times and places in the woman's life to create a shifting sense of what her experiences, activities and memories must have been like. The story of individual photos is illuminated by adjacent photographs, but another story of the woman's life also emerges at the level of the photo collection.

The use of photo sequences to tell a story brings us to the idea of a photo narrative and its contrast with film. Berger again provides some insight on this difference in his essay on Stories (Berger 1982b). He argues that photos are the opposite of films because they point backwards rather than forwards in time:

> *"Before a photograph you search for what was there. In a cinema you wait for what is to come next. All film narratives are, in this sense, adventures: they advance, they arrive...By contrast, if there is a narrative form intrinsic to still photography, it will search for what happened, as memories or reflections do. Memory itself is not made up of flashbacks, each one moving inexorably forward. Memory is a field where different times coexist"* (Berger 1982b, pp279-280).

The fact that still images point backwards in time and can be juxtaposed out of chronological order, makes them particularly suitable for supporting memory, according to Berger. When they do tell a story, it is often by association with the viewer's own memories or through a more tenuous and constructive process of interpretation, rather than through a literal depiction of time.

Many of these sentiments are echoed and extended by other writers on the differences between media. For example, Burgin (1982) notes that the pace of consuming photos is dictated by the viewer. Typically a photograph will hold a gaze for a limited period of time before it is displaced to another photograph by frustration or boredom. McLuhan (1964) describes all media as having a temperature corresponding to the amount of work the viewer has to do to interpret them. Hot media contain information of a higher definition than cold media. Photographs would therefore be cooler than film because they contain less information about the same event depicted through moving images with sound. Consequently they require more work on the part of the viewer to fill in the details of that event. Wollen (1989) compares photographs to ice and film to fire. Action is encased forever in the ice of a photograph, whereas it continuously unfolds in the incessant flickering of a film. Furthermore, photographs can depict three different aspects of time at a glance: states, processes or events. Wollen suggests that different

forms of photography may use and mix different combinations of time aspect to achieve different narrative effects. Finally, Metz (1990) lists a number of technical differences between photos and film. Photos have a smaller *lexis* or frame of reference, they are used for private reflection rather than for public entertainment, they make less use of off-frame space, and can become objects of fetish by virtue of their tangibility. Photographs must also communicate their meaning through a single form of static visual information. Film communicates through 'five more orders of perception': movement, plurality of image, phonic sound, non-phonic sound and music. All these technical differences work together to result in quite different viewing experiences.

In summary, there are good reasons to believe that photo and film sequences are fundamentally different, and work their effect on an audience in very different ways. While both convey visual appearances and tell stories, photos do so with limited information and over very different and discontinuous periods of time. In contrast, films use richer information to unfold time in distinct and coherent scenes. This suggests that a personal photo collection cannot be viewed, so to speak, as a sequence of index shots from the storyboard of life. It is probably more like a collection of moments from the passage of time, which serve to highlight particular events and general impressions in equal measure.

THE CONTENT AND USE OF FAMILY ALBUMS

The use of photos to depict life stories is most commonly done within the humble family album. Exactly how they are used to do this visually is indicated by a number of writers who have turned their attention to the domestic 'snapshot' or album as a photographic genre. These writers tend to be collectors, photographers or sociologists commenting on the content and function of the family album, rather than media theorists considering photographs in general.

For example, King (1986) provides a number of insightful observations on the content of family albums based on an analysis of his own collection of over 10,000 snapshots. The first and foremost observation is that snapshot photography is typified in many ways by poor photographic technique (see Figure 3.2). Instead of the careful composition and juxtaposition of images described in the previous section, King finds all kinds of visual oversights that make up the 'snapshot vernacular'. These include the following features:

- Tilted horizon – where the camera is not held steady
- Unconventional cropping – where part of the main subject is out of view
- Distant subject – where the main subject is too far away to see well
- Blurring – where the image is indistinct
- Poor lighting – where the image is under or overexposed
- Fingers –where the fingers of the camera user are over the lens
- Shadow – where the shadow of the photographer is in the picture
- Banality – where the reason for taking the picture is unclear

- Ambiguity – where the subject of the picture is unclear

Figure 3.2 An example of unconventional cropping in a snapshot. Figure 57 in King (1986, p50).

The fact that people choose to keep and display photographs containing these features is significant. It indicates that the meaning and value of such photographs remains intact for members of the family, despite a reduction in their 'readability' to outsiders. As long as the content is recognisable, it can serve its purpose in bringing back a memory of the event or person depicted – at least for those who were there at the time the photo was taken. In Barthes terms, members of a family are likely to be either the observers or the referents of family snapshots and therefore have a more priviledged insight into the meaning of the images than outside spectators. They therefore need less visual evidence of the story-of-the-image than spectators, and are often at hand to provide this story to spectators directly when the image is viewed outside the family context.

Further evidence for the role of other people in snapshot interpretation comes from an examination of their inclusion in snapshots themselves. Although King does

not comment on this himself, the presence of people in snapshots can be seen from the examples he includes in his book. In fact, there are 206 separate snapshots included altogether (excluding professional photographs and paintings) and 201 of these depict people within the scene. In most of these snapshots the people form the *main* subject of the image. Of the five photographs that don't show people, two are of cats (King 1986, Figures 204 and 208F), one includes the photographer's shadow falling across a road (King 1986, Figure 200), one is of a car with its door open (King 1986, Figure 192), and the other shows an empty highway (King 1986, Figure 158). If these examples are typical of snapshots in general, I suggest that the inclusion of people (or pets) could be used as a defining feature of a snapshot. Furthermore, from personal experience it seems that the people included in snapshots are usually family or friends of the person taking them. Indeed it would be highly unconventional to take photographs of strangers for a family album, and is usually disturbing to find that a stranger has accidentally become the main subject of a family photo. All this means that whenever a snapshot is taken, there is usually at least one other person depicted in the image to share it with later.

Similar conclusions emerge from another book on snapshots by Chalfen (1987). Chalfen is a social anthropologist who provides the most detailed insights to date on what he calls 'Kodak culture'. By examining over 200 photo collections and questioning American families about their photographic practices he is able to comment on the content and purpose of domestic photographs and albums. Again we find incidentally that the snapshots he includes as examples in his book contain images of people. In fact all the 20 snapshots shown, contain people. This time, Chalfen (1987) comments explicitly on the importance of knowing who these people are in snapshots:

> *"Anonymity is the exception and not the rule (p123)...In fact it is when people cannot recognize people in their pictures that they get thrown away – but this is not very common" (footnote 17 to Chapter 6, p186).*

Citing Berger's view that all photographs are visual statements, Chalfen *defines* domestic photography as a social activity involving 'home mode pictorial communication'. His analysis then centers around how images are used to communicate with family and friends. He finds that contrary to the advice of photographic guides and manuals, home photographers are reluctant to create visual stories or narratives with snapshots. Rather their photographs document key moments in life, whose significance is explained verbally in interaction:

> *"The narrative remains in the heads of the picturemakers and on-camera participants for verbal telling and re-telling during exhibition events" (Chalfen 1987, p70).*

In a recent up-date of Chalfen's approach, we examined the social character of digital as well as conventional photographic behaviours (Frohlich, Kuchinsky, Pering, Don & Ariss 2002). We found confirmation of the social nature of conventional photography, and an accentuation of this in digital photography. Hence, a primary motivation for doing digital photography was the ability to enhance the communication of images by transmitting them electronically. Technically this can be done asynchronously via email or the web, or synchronously

through video conferencing tools. Together these facilities are set to further extend the social component of photography by allowing *distant* family and friends to keep in touch more effectively through what we call 'photo-talk'.

One significant audience then for the family album is the family itself, who use it to capture and retain memories of themselves and their family life against a backdrop of passing time and failing memory for details. Another audience is the friends and relations of the family who will view the album as a more public document of their lives. This public aspect of the album has been noted by a number of authors who observe that albums rarely contain images of the more difficult times of family life such as those involving sickness or death (e.g. Hirsch 1997, Holland 1991). In addition to protecting individual family members from painful memories, the selective portrayal of positive events projects an idealised view of the family to others. King (1986) again describes the kind of events that are captured in snapshots and contribute to the positive character of albums. These include the following:

- Possessions
 - Homes
 - Cars
 - Others
- Achievements
 - Trophies
 - Awards
- Holidays
 - Days out
 - Times away
- Rites of passage
 - Weddings
 - Birth of children
 - Christenings

It is this dual role of the family album as private and public document that gives it its unique character. Holland (1991) refers to this as 'the puzzle of the family album', since it is used both to remember but also to forget, to capture private moments but then to display them as public statements, and to form personal memories of our lives but also collective memories of our times. This dual aspect of the family album is brought out in the opening quote to this chapter.

Another way of expressing this is to say that each family snapshot can be taken and viewed from two perspectives. Again using Barthes terms, it can be taken and viewed very personally as the observer or referent in the scene, as a way of capturing and recalling the past. Additionally, a snapshot can be taken and viewed *as if* one were a spectator, even by those originally involved in the scene. In this case the snapshot is used as a way of looking at oneself as an outsider, and presenting oneself to others. As the family album ages and passes to those without memories of the original events, the snapshots retain a residual value. They reflect what a true spectator is *meant* to see of the original participants. In this sense, all domestic photographs can be seen as communications to oneself and communications to others.

THE THERAPEUTIC NATURE OF PHOTOS

The dual character of snapshots as communications to oneself and others has been dramatically explored by photographer Jo Spence. Tiring of what she saw as the insincerity of the family album, she broke with convention to produce more honest pictures and stories of her life (Spence 1987). This involved creating a photographic record of her personal battle with breast cancer and using childhood photographs of herself in later therapy sessions. In an extension of the use of existing photos in therapy, she also collaborated with fellow photographer Rosy Martin, to create new portraits of herself and Martin acting out a series of childhood characters and emotions. One of these photographs is shown in Figure 3.3 and shows Spence as she remembers her 'Early mother'. In all these cases, the photographs are created to foster self-knowledge or insight, in the context of showing and discussing them with others.

The therapeutic value of photos revealed in Spence's work has long been recognised and used by psychotherapists in a variety of *photo therapy* techniques. Indeed, these stretch back to at least 1856 when the English physician Dr Hugh Diamond noted the beneficial effects of showing mental patients pictures of themselves (Stewart 1979, p41). More recently, the use of existing family snapshots and instant Polaroid photography has become common in the treatment of groups as varied as disabled or antisocial children (e.g. Wolf 1976), anxious middle-aged adults (e.g. Akeret 1973) and isolated elderly people (e.g. Zwick 1978). Stewart (1979, p42-43) lists the kind of photo therapy techniques that are used with such groups:

Projective – using any photograph in which the client or therapist has an interest, as discussion-generating or as material for interpretation.

Family album – one of the most frequently used sources, it often gets at early childhood experiences and relationships which the client is otherwise unable to recall, generally because they have been repressed.

Photographs of the client – these enable the client to begin to explore feelings about self and relationships with objects and people.

Photographs by the client – a method in which the client indicates things of value, interest or concern.

Self-portraits – photographs of the client by the client. Although the most difficult for most clients, this approach leads directly to feelings about self – the essence of photo therapy.

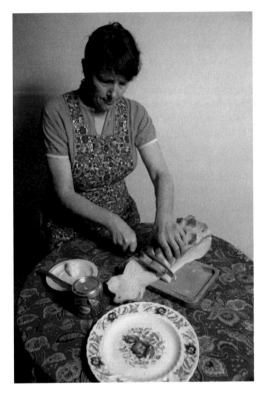

Figure 3.3 A therapeutic photograph of the subject pretending to be
her own mother as she remembers her
(Figure x in Spence 1987, p 189).

The use of photos in therapy can also be supplemented by the use of more artistic techniques in arranging, decorating and combining photos. This leads to a kind of *photo art therapy* in which photographic artefacts are created as a focus of attention and discussion. For example, Fryrear & Corbit (1992) describe the creation and use of a self-portrait box in which each side of the box contains images representing different characteristics of the self. The inside surfaces represent the Private Physical Self, Social Self, Family Self, Occupational Self, Emotional Self, and Spiritual Self. The outside surfaces represent the Public versions of the same dimensions. Each surface can be composed of individual photographs, or of a collage enhanced with sketches. In other exercises, Fryrear and Corbit (1992) encourage the creation of posters with cut-out photographic characters stuck onto painted scenes or textured backgrounds.

There appear to be two main reasons why photographs, and indeed images in general, are so effective in a therapeutic context. First, the act of taking, selecting

and presenting photos about oneself may help to express images and feelings which could not be described consciously in words. In this sense, art and photography may function like dreams and word association to reveal thoughts, memories and motivations that lie hidden or repressed in the subconscious (c.f. Jung 1916). The image is therefore another language in which to express yourself, and can come to symbolise or even embody important emotions. Schaverian (1991) refers to this embodiment as the 'life *in* the image', and suggests that clients can exhibit a *transference* of emotions to and from the images they create. On a more mundane level, the creation of photographic images is easier than drawing or painting for most people, and may involve aesthetic and social skills that are beneficial in their own right. For example, emotionally disturbed adolescents have been found to benefit from practising amateur photography because it gave structure and purpose to a set of social interactions that drew them out of themselves and resulted in tangible success (Cosden & Reynolds 1982).

A second reason photographs are valuable in therapy situations is that they form a focus for subsequent therapeutic conversations between the client and the therapist. In fact, images are a point of joint reference and reflection for both the client and the therapist in a three-way interaction, as shown in Figure 3.4. Schaverian (1991) refers to this arrangement as the 'life *of* the image', since the image becomes the subject of numerous interactions and conversations over time, all of which serve to progressively alter the client's and therapist's interpretation of the image. Most significantly for photographs, the original memories triggered by the image in the client will come to be supplemented by memories of conversations about the image with the therapist as time goes on. Shaverian also suggests that therapists can exhibit something of the same transference of emotions to and from the image as the client does (*countertransference*). This is the basis of experiencing and demonstrating true empathy with the client.

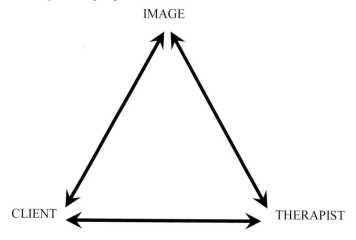

Figure 3.4 Interactions around an image used for art therapy

All this is directly relevant to the life and function of domestic photos. Not only is the context for domestic photography similar to that shown in Figure 3.4, the underlying work of the photo is the same. By calling to mind a fragment of the past, a photograph strengthens memory and also helps people to view themselves, or their lives, from an 'outside' perspective. This outside perspective is reinforced when the photograph contains the person as a subject in the image, and when it is discussed with another person who wasn't present at the time the photograph was taken. Viewing oneself from the outside is an integral part of developing a self-image, and the content of that image is influenced by memories of one's personal past. The connection between what has been called *autobiographical memory* and personality is a complex one, but it is generally acknowledged that both are closely related and act to influence each other. This means that personal memories can suggest personality attributes that people come to believe about themselves, and that certain beliefs can colour the memories themselves. These connections are indicated in the following definition of autobiographical memory:

> *"The defining characteristic of autobiographical memory is its relationship to the self: The remembered events are of personal significance and are the building blocks from which the self is constructed. Paradoxically, the self is both the experiencer and the product of the experiences" (Cohen 1996, p147).*

A further connection between memory and self-image is suggested by recent work on storytelling in conversation. Strange as it seems, what we remember about ourselves is affected by how we discuss and describe events to others. At a very basic level, people help each other to reconstruct memories of events they shared together in a form of collective remembering (Middleton & Edwards 1990). At a deeper level, the way someone comes to tell a story about something that happened to them, stabilises after several tellings and becomes the way they interpret the event themselves in the future (Pasupathi 2001). This leads to the possibility that people can change the way they remember something by talking about it in a biased way (Tversky & Marsh 2000).

Photographs then can be used to selectively remember personal events and display a particular self-image, as in the domestic photo album. Alternatively, photographs can remind people of suppressed events and extend that self-image, as in the photo therapy portfolio. In both cases, conversation around the photo is an integral part of the process of remembering, understanding and presenting oneself. It also serves to cement and maintain relationships between those involved, and with others not present at the time of capture. In the next section, we bring together these ideas into a single model of domestic photography. This is then used to consider the role of sound.

A NEW FRAMEWORK FOR DOMESTIC PHOTOGRAPHY

Figure 3.5 presents a new model of domestic photography inspired by the above review. I will refer to this from now on as *the diamond framework* because of its

shape. It is based on a re-definition of Barthes (1981) terms for the principle characters involved in photography, and a recognition of the kind of therapeutic interactions that can go on between them, as described by Schaverian (1991) and indicated in Figure 3.4. To make this re-definition clear, I have changed Barthes' terms as follows. The image corresponds to any *photograph* taken in a domestic context for consumption by a private audience. The referent corresponds to the *subject* of the image, which in domestic photography usually comprises another person or persons. The observer corresponds to the *photographer*, who is also used as shorthand for any other observer of the scene at the time the picture is taken. The spectator corresponds to an *audience* for the photograph, but does not share a memory of the scene it depicts. For any photographic encounter, there can be multiple photographs and more than one person in each human role in the system.

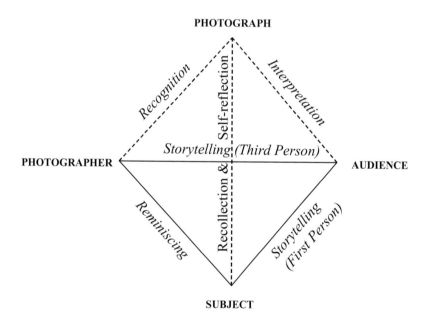

Figure 3.5 The diamond framework for domestic photography

This framework allows us to distinguish between a number of lines of communication between the photograph and the people who interact with it. Half these lines, shown dashed, represent *solitary* interactions between various people and the photograph itself. The other lines, shown solid, represent *social* interactions between the photographer(s), the subject(s) and the audience(s). In a photographic context, all these social interactions also involve the photograph as an equal participant. This means that each simple interaction involves a triangular three-way communication similar to that shown in Figure 3.4. The equal division of solitary

and social interactions with a photograph, represented in the framework nicely captures the dual role of the domestic photo as a private and a public document. Viewing the private interaction of individuals with a photograph as a two-way communication also acknowledges the active transference of meaning and emotion that can take place between them.

Stepping through the six classes of interaction represented in Figure 3.5 reveals all the different forms of 'home mode communication' discussed more generally by Chalfen (1987). Each of these involves a different method of reading the meaning or story of the photograph.

1. Recognition

Private review of the photograph by the photographer involves recognition of the scene and its moment of capture. Usually the information in the Photograph will be enough to trigger this recognition and all the associated memories that go with it. However, this information may become less effective as the time between the capture event and review of the photograph increases. Difficulties in recognising the scene may also be experienced if the timing, framing or perspective of the photograph is unusual or obscure.

2. Recollection and self-reflection

Private review of a photograph by the subject involves a similar process. This is because both the photographer and the subject share a memory of the scene in the photograph. However, this memory is triggered more by recollection than recognition in the subject, since he or she was a participant in the scene at the moment the photograph was taken, and cannot therefore share the photographer's perspective of it. This may make it even harder for the photograph to trigger a memory of the scene in the subject over time. An additional process of self-reflection is also at work in this interaction. Whether or not the subject remembers the scene they are looking at, the photograph provides incontrovertible evidence that they were there (assuming they can recognise themselves in the image). As a photograph of them, it provides the kind of outside view of the self that has proved so powerful in therapy settings, and may trigger other reactions than simple memory of the scene.

3. Interpretation

Unlike the previous cases of private review, the consideration of a photograph by an audience involves classic photographic interpretation. Since an audience, by definition, does not have a memory for the scene in the photograph, they must try to read the meaning or story of the photograph from the image alone. All the subtleties of photographic composition become important to this task, but will probably lead to a number of possible interpretations of the kind listed by Berger for Figure 3.1. Setting the photograph next to other photographs may provide further clues to the sequence of events around it, as may the attachment of interpretive writings or comments. These attachments become increasingly important over time, and especially with the handing down of photographs to relatives with the death of the photographer.

4. Storytelling (3rd Person)

One social context for sharing photographs is when they are shown live by the photographer to an audience. Here the photographer is able to explain the photograph in a storytelling activity. Because the photographer is external to the scene this storytelling is likely to be in the third person, using the words *he*, *she* or *they* to refer to the actors in the scene. Storytelling could take place live in conversation, or through the attachment of interpretive comments or writings to the photograph.

5. Storytelling (1st Person)

The sharing of a photograph between its subject and an audience is similar to the above situation. It also involves elaboration of the meaning of the photograph by the subject in live conversation. This time, the storytelling is likely to be in the first person, using the word *I* or *we* to refer to the actors in the scene. A finding of previous research suggests that this interaction is tailored both to the interests of the recipient and to the self-image of the subject or photographer. It is the ambiguity of the photograph that allows for the telling of multiple stories in different ways.

6. Reminiscing

A special class of interactions apply to the sharing of a photograph by the photographer and its subject. This is quite different to the explanation of a photograph to an audience. Here, both photographer and subject share the memory of the event represented in the photograph, albeit from different perspectives. This leads to a kind of reminiscing conversation in which both parties are likely to use the photograph to remember and re-live the event. This also provides an opportunity for the photographer and subject to exchange their own interpretations of the event itself. For the photographer there is an additional opportunity to comment on the appearance or behaviour of the subject in the photograph.

Further meanings and memories accrue to photographs shared with others over time. Each time a photograph is shared with someone else, (as in activities 4, 5 or 6 above), the interpretation of that photograph can change through what is said in the interaction. And at the end of the interaction the participants are left with additional memories of the interaction itself. These new developments are likely to spill over into private reflection of the photograph, (as in activities 1, 2 or 3 above), so that the way photographers, subjects or audiences view a photograph is a little different on each occasion. External changes in the relationship between these three people will also affect subsequent readings of the photograph. In the most dramatic case, the meaning of a photograph containing a subject will change for a photographer or audience, when that subject dies.

THE ROLE OF SOUND

Having reviewed the existing use of images in domestic photography we are now in a better position to explore the potential use of sound. In fact, each of the six basic activities with photographs identified in the diamond framework could potentially be enhanced by sound. Taking into account the four types of sound identified in Chapters 1 and 2 (ambient, music, voiceover and conversation) we might now ask *'Which type of sound enhances which type of photographic activity and why?'*

As a way of approaching this question, we asked consumers directly about the role of sound in photography in an unpublished pilot study early in our investigations. This study was carried out by Judith Budd and myself in 1996. Four groups of individuals clustered by age and gender were interviewed about their current and future use of images. As part of the discussions, groups were asked for their reactions to the idea of associating sounds, text, handwriting and short video clips with photographs, and of reviewing photos on a variety of screen-based devices. Of all the additional media that were suggested, participants were most enthusiastic about sound. This is because sound was considered to have a number of different uses, and at least one of these uses appealed to every group.

For example, ambient sound was thought likely to enhance the personal memory of an event, particularly when the natural sounds of the event were distinctive. Participants also included ambient conversation in this category and were excited by the possibility of capturing the voices of loved ones on a photograph of them. Music was discussed in both positive and negative ways. Several people referred to 'elevator music' in the context of criticizing the concept of adding music to photographs. However, some people warmed to the idea as they thought about attaching music of the time or place. The value of voiceover was seen to lie in the recording of a brief voice message that would be sent to others with the associated photos. The idea of recording the conversation about photographs themselves was not discussed.

Some additional findings from these discussions concerned reactions to viewing photographs on screens rather than on paper. These findings also affect the potential role of sound because of their implications for consuming audiophotos. Essentially there were many negative comments expressed about viewing photos on the PC, TV, on a wall or even on a handheld tablet. Objections varied by device, but a common perception was that all this technology was not only expensive and likely to exclude certain people from the experience of sharing photos, but was also impersonal compared to photographic prints. Screen displayed photos reminded people of slide shows, which were considered boring. In contrast, prints or physical albums were associated with more intimate conversation, and were something everyone wanted to preserve.

Finally, many of the participants in these discussions pointed out the similarity of audiophotos to video. Some argued that audiophotos were a poor form of video. Interestingly, when these people were asked later for their views on short digital video clips, they were ambivalent. In contrast with still images, video clips were said to capture more of the moment but at the expense of being difficult to record, handle and share. Short video clips were seen as potentially better than conventional video

in this respect, but not as good as photographs for capturing the essence of a moment in time.

The same ambivalence about video compared to still images was a major finding of another study by Chalfen (1998). Chalfen (1998) interviewed 30 teenagers about their views on photos and video. Most agreed that video was a more realistic record of the past and better for re-living the event than photos. Paradoxically, this was also seen as its major weakness compared to photos, since video was too literal a record to leave room for thinking and talking about the past. It was as if the teenagers wanted to do more mental work to reconstruct their memory of the event, rather than remain passive viewers of the event itself. In this sense, Chalfen found that 'less is better' (p174). The implication for audiophotos is that, as a halfway-house between photos and video, they have the potential to be better than photos *and* video. An audiophotograph could be a more realistic record of the past than a photo, but also leave more room for reflection and conversation than a video clip.

These findings give us some confidence that sound may have a positive role to play in domestic photography. However, they are based on people's own speculations about the role of sound with photographs, rather than on any experience of creating and reviewing audiophotos themselves. Furthermore, these speculations do not cover the value of each type of sound for each type of interaction in the diamond framework of Figure 3.5.

In the rest of this book I report subsequent work to explore the role of sound more systematically by giving people the opportunity to record and review their own audiophotos. The role of each type of sound is assessed separately in Chapters 4, 5, 6 and 7, while the preferences for paper versus screen-based audiophotos are addressed in Chapter 8. The contrast between audiophotos and video clips is born in mind throughout, and the overall findings are drawn together in Chapter 9 where I reconsider the diamond framework and the prospects for a new practice of audiophotography.

Ambient photographs

"It definitely made you more aware of your sense of hearing and more aware of sounds… You had to think more about capturing the sound and taking a photo to go with it, rather than taking a photo and then the sound" (Debbie, audiocamera trial).

Sounds are an integral part of our physical environment and psychological experience. In the context of recording, ambient sounds are defined as those which happen spontaneously without being consciously created *for* the recording. These can be both natural and man-made. Natural sounds include the sounds of the elements such as water, wind and rain, and of animals such as birds, insects and mammals. Man-made sounds include the noises made by people themselves, such as footsteps, speech and music, and the sound of technology such as traffic, machinery and television. The balance of natural and man-made sounds changes as we move across geographic and cultural boundaries, between rural and urban areas, and into and out of buildings. Ambient sounds in general may be growing louder and more artificial over time, with corresponding losses in natural sounds (Schafer 1977). In fact, each part of the world can be considered to have a soundscape as dynamic and fragile as its landscape and wildlife, and equally in need of protection and management (Schafer 1976).

This chapter examines for the first time what kind of ambient sounds people would like to save with their photographs. It is based on an exercise in which families were given the ability to record sounds on a conventional camera. I report what kind of sounds were recorded and how they were associated with the images taken around the same time. I also examine the comments of participants as they explain why they took particular audiophotos, what they think of them, and how they would use them according to the diamond framework described in Chapter 3. These data give an initial insight into the role of ambient sounds in all the activities shown in the framework. They also provide an opportunity to test early speculations that ambient sounds may enhance memory for a photograph, and that ambient photographs may even be preferable to home video clips under some circumstances. But to put this study onto context, I begin with a brief review of related work.

RELATED WORK

In general, there is very little scientific work on the sentimental value of sound, and none which connects this to photographs. For example, social scientists have studied the physical and psychological properties of sound to understand how we hear and identify different sounds. However, they have failed to explore the personal meanings of sounds. At another level, members of the world soundscape movement, such as Schafer referenced above, have begun to classify and map geographic soundscapes, and campaign for an improvement in the quality of the sonic environment. While this work calls attention to certain general preferences for natural over man-made sounds, it seems to stop short of mapping personal preferences within a soundscape (Truax 1978).

In contrast, a number of artistic projects with sound have begun to do this, and reveal a rich set of meanings and preferences for particular kinds of sounds. In one such project, the sound artist and recordist Peter Cusack collected people's favourite sounds of London. His method was to invite proposals from members of the public and then go out and capture examples of these sounds for himself. Some of the resulting recordings were broadcast on a local radio-art station in 1998 and released on CD in 2001 (Cusack 2001). Favourite sounds of the city turn out to be highly ideosyncratic, and just as likely to include man-made sounds as natural sounds. The CD collection contains a number of natural sounds you might expect, such as a dawn chorus of blackbirds, a fountain, and the rise and fall of barges moored on the Thames. However, it also contains the less predictable sounds of underground trains, the bell of a London bus, Big Ben chiming and a street market packing up. Some sounds are extremely delicate and specific, such as the sound of a bicycle rolling over loose concrete slabs on a particular part of a canal towpath. Others are quite generic such as the sound of the turnstiles on entry to a football match or the sound of a coffee making machine. All these sounds are likely to have particular associations for the people proposing them, although these are not explored directly within the project. In a related piece, Cusack draws on his own memories of the Lea Valley in East London to create a collection of representative sounds (Cusack 2000).

This time he included spoken stories of the area told by locals, alongside familiar sounds of the place. These were recorded around the canal running through the valley, and include bird and frog calls, dogs barking, footsteps under railway arches, dripping water, gentle motor boat sounds and conversation outside a waterside pub. The sounds for both these projects are loosely associated with a series of images of London and the Lea Valley which are included in the audio CD booklets.

Another noteworthy project is the *Lost and Found Sound* programme on National Public Radio in the United States. This is produced by the Kitchen Sisters (Davia Nelson & Nikki Sylva) and Jay Allison, and features stories about sound recordings or sound-related memories phoned in by radio listeners. For example, a recent story concerned the Green Street Mortuary Band and its tradition of giving past residents of San Fransisco's Chinatown a musical send off. While these stories might be triggered by a single radio caller, some stories are based on a host of submissions on a particular theme. A dramatic example of this became the *Sonic Memorial Project*, in which listeners were invited to send in their sound memories of the World Trade Centre just after its destruction on September 11th 2001. This invitation resulted in a flood of stories and recordings relating to different personal memories of the buildings over time. Some callers described the sounds of the day itself, commenting on the silence which followed the collapse of the towers. Others noted the sounds of the buildings in use, such as the beat of the revolving entry doors, the creak of the walls in a high wind, or the sound of latino music played by the South American janitors in the evenings. A final group of callers described their memories of the original site of the centre where music would play from loudspeakers outside the electronics shops of 'Radio Row'.

These examples show that ambient sounds clearly trigger memories and stories of a location or event in much the same way that photographs do. The question that has not yet been answered by these projects is how such sounds might be captured alongside photographs, and integrated with the practice of domestic photography in all its forms. It is to this question that I now turn.

THE AUDIOCAMERA TRIAL

An audiocamera trial was organised to allow people to capture sounds with photographs. Ambient sounds could be captured around the time of taking each photograph, or other sounds could be consciously added later by recording into the audiocamera device. Four PC-owning families with children were given the opportunity to capture audiophotos with this camera on their summer holidays, and to review them at home before commenting on a range of new product options in what we call a 'feedback group'. In addition to discussing audiophoto usage, the families were specifically asked about the value of sound capture and its comparison with home video. The study was carried out in collaboration with Ella Tallyn.

Middle-income families with children living at home were chosen for the study because they happened to be the target market for early digital cameras. In our study, they comprised two families of five and two families of four. The parents and

all but four of the children used the unit and took part in the ensuing discussions. This meant that we had eight adults and six children as full participants. The participating children ranged in age from 11 to 16. Each family owned several point-and-shoot cameras and a multimedia home PC.

Families were given an audiocamera to use on their 1996 summer holiday. This unit comprised a Minolta compact camera combined with a slimline Lanier Dictaphone with an omnidirectional external microphone (see Figure 4-1). Each unit allowed users to record photographs and sounds in any combination, but did not allow them to associate the two at capture time. Individual sound recordings could be marked with a beep on the tape. Before the trial families were visited at home and given a written explanation of the trial process at this stage, together with instructions and guidance on how to operate the unit. After the trial families sent their photos to us for developing. We then revisited each family at home for a preview and editing session in which we

- discussed their experiences of using the capture units,
- observed and discussed their initial review of the printed photos alone and then in combination with their raw sound clips, and
- obtained their instructions regarding the arrangement and association of their best audiophotos for a holiday album.

Afterwards we edited their sound clips as instructed and supplied the family with a cassette tape copy for using at leisure with their prints. At the same time we used extracts from their best materials to make up audiophoto album demonstrations for the feedback group.

Figure 4.1 The audiocamera unit used in the trial

Two separate feedback groups were held for two families at a time in HP Labs Bristol. We structured the discussion to obtain their general impressions of the audiophoto medium, before asking them to summarise their private use of the edited

tape and prints. We then showed the families a number of ways of reviewing their audiophoto albums on screen and paper. These are explained further in Chapter 8, which examines the reactions and comments of families in this part of the study.

The rest of this chapter looks mainly at the findings of the first part of the trial in which families recorded ambient audiophotos, reviewed and commented on them, and selected favourites for an album. It begins by examining the kinds of audiophotos that were captured initially, before considering what families said about them.

AUDIOPHOTOS CAPTURED

A total of 261 photos and 158 sound clips were captured by families in the trial. Their structure and content reveals a lot about the attractiveness of ambient sounds and audiophotos. In particular, this set of audiophotos reflects the kinds of ambient sounds and images that participants thought they wanted to keep, before they had a chance to see the results later on. Although the set includes audiophotos which are later judged to be poor or ineffective, (as with any set of ordinary photos), it does not include sounds and images in which the photographers had no interest. The set as a whole therefore reflects the kind of image and sound associations that people may want to capture on an audiocamera.

Types

The different types of sound recorded are shown in Figure 4.2. This pie chart was generated by classifying each sound clip as containing one or more of the types of sound shown in the key. Hence, these are not mutually exclusive types of sound clips, but rather properties or components of all the clips recorded.

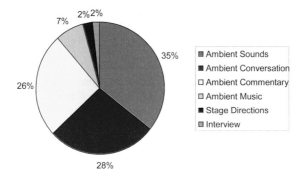

Figure 4.2 Types of sounds recorded on the audiocamera

The chart shows that the three most common properties of these recordings were *ambient sounds* of the environment in which a photo was taken, *ambient*

conversation taking place between participants in the scene, and *voiceover* spoken to the camera sometime after the photograph was taken. The chart also distinguishes *ambient music* from more natural environmental sounds, and three other types of deliberate speech recordings. These were *stage directions* spoken by the photographer to subjects in the scene (such as 'say cheese'), *interviews* between the photographer and the subjects, and *live commentary* designed to describe an event as it unfolds. These last three forms were less common but nonetheless important to the overall effect of the sound when they occurred.

Some of these types of sounds have already been shown in Chapter 1. Figure 1.1 shows a Polish square with the ambient sounds of birds and traffic, while Figure 1.2 shows a pair of surfing photos with live commentary describing the surfing event. Both these clips contain other kinds of sounds in the background. The Polish square clip contains the murmur of ambient conversation and finishes with some ambient music played by a trumpeter in the adjacent church. In addition, the surfing commentary contains the ambient sound of waves in the background and finishes with an interview with the surfer. The mix of different types of sounds in the same clip differs within the clip itself, and also between clips. An illustration of a different mix of sounds between clips is given in Figure 4.3.

(a) (b)

Figure 4.3 Different mixes of ambient music and ambient conversation in audiophotos containing both types of sound.

Figure 4.3 shows a pair of audiophotos of the same people, containing ambient music and ambient conversation. However, in Figure 4.3a the ambient music of the street band is more prominent than the background conversation. In Figure 4.3b the reverse is the case, since the hubbub of conversation in the restaurant is louder and precedes the faint introduction of background music half-way through the clip. Note also that the composition of the images in these photos also affects the salience of the music. Only the street café photo shows the source of the music in the image – behind the main subject. This also illustrates how the sound and image work together to create a combined audiophoto effect, since the music of Figure 4.3 serves to call attention to the band in the background of the image, changing the salience of its visual features.

Durations

Figure 4.4 shows a graph of the duration of sound clips recorded in the trial. Each bar in the graph represents the number of clips lying within each five second interval along the bottom. Hence, the first bar on the left shows that there were 22 clips between five and ten seconds long. Although the most popular duration was ten seconds, the average duration overall was 24 seconds, with about 95% of clips lasting under a minute.

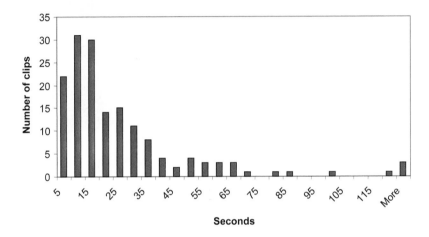

Figure 4-4 The duration of sound clips in the audiophoto set

The shortest clips were voiceovers which served only to attach a voice label to the photo. Examples include two second clips to say 'Sunny Zakopane' or 'A bendy bus', and were equivalent to the kind of label that might be handwritten on the back of a photo or on an album page. More extensive voiceovers varied in length from between five seconds and about 30 seconds depending on the subject matter.

Pure ambient sound clips were about ten seconds long. These included the sound of a horse and carriage (eight seconds), a tram (eight seconds), rain on a window (six seconds), the rattle of a toy car (eight seconds)., and the sound of a stream (13 seconds). Pure ambient conversation clips tended to be longer than this to allow for the closure of someone's turn or the completion of a phrase. For example, there were numerous conversations recorded around a table ranging from 18 to 38 seconds. In this respect, the clip represented in Figure 4.3b was a typical duration of 29 seconds.

The majority of clips were between 15 and 40 seconds and contained unfolding combinations of sounds. Those containing music and talk were not cut-off in mid-sentence or bar and tended to reach a natural closure. This may have extended their duration compared to a clip of ambient sounds that could be stopped at any point. The combination of different types of sounds often unfolded over time, making up a sound event. For example, Figure 4.5 shows two people jumping into a swimming

pool. The sound clip lasts for 29 seconds and moves through a sequence of sound types. These start with ambient conversation and a count-down to the jump, the ambient sound of their splash into the water, more ambient conversation in the form of exclamations, and a comment from the photographer which serves to label the photo.

Figure 4-5 A sequence of sound types in a sound event lasting 29 seconds.

The longest sound clips were music recordings made at a concert (four minutes 57 seconds), live commentary on an open-topped bus tour (three minutes 19 seconds) and a small number of sound-only recordings of conversations and comments, lasting one or two minutes. Although these were long in comparison to other clips recorded on the audiocamera, they are relatively short for recordings made on a dictaphone. This reveals the constraining influence of the camera on sound recording in the trial, and the fact that sound clips were almost always designed to go with corresponding images. It is to the nature of this correspondence that we now turn.

Associations

The capture of sound and image was completely unconstrained on the audiocamera unit, and our instructions encouraged participants in the trial to think about recording sounds and images out of sequence and adding sounds later. However, in practice, most sounds were recorded around the time of image capture, and in strict chronological order.

Recording seemed to begin from a variety of positions around each shutter depression on the camera, but could not be said to precede or follow it by any predictable duration. This meant that a lot of the sound and image associations were obvious even to us as spectators of the audiophotos, since the two media essentially

indexed the same event and proceeded in sequence across the recorded film and tapes. Any ambiguities were cleared up later in conversation with the families.

Figure 4.6 shows that about two thirds of sound clips were associated with a single image in the corpus. This association could usually be recognised by the sound of a single shutter click occurring within a sound clip, and by the connection between the content of images and sounds. Of the remaining one third of clips, most contained one or more sound clips for an *image sequence*. Finally, there were a small number of occasions in which participants attached several sounds to the same photograph.

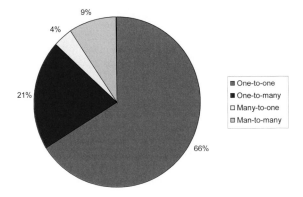

Figure 4.6 Audio:image association in the ambient photo set.

Simple sound to image associations are easy to visualise and comprise audiophotos like that shown in Figure 4.5. Other kinds are more difficult to visualise. Composite audiophotos with one sound for many images included action shots with a running commentary like the surfing images and sound of Figure 1.2. In fact the family took four surfing photos during a longer version of the sound clip. Other similar examples include a sequence of sailing photos with ambient sounds, and three photos of an obstacle race with 90 seconds of instructions and cheering sounds. The same form of audiophoto was also generated when people took 2 or 3 photos of a more static scene that was indexed by a single piece of ambient sound or voiceover. The Restaurant picture of Figure 4-3b was one of two photos taken at the time of that ambient sound. Other examples include the recording of a single voiceover for multiple photos of a beach.

Sometimes multiple sound clips were recorded for a single image. Figure 4.7 shows an example of this type of association. Here a comment was recorded first about a castle that was visited and photographed as shown. A further two audio clips followed, containing an interview between the photographer and other members of the family shouted between the bottom and top of the castle tower, and their joint conclusions when re-united at the bottom. These were rare because it was more usual for people to record multiple phases of an event live in a single recording, as in

Figure 4.5. Note also that the distinction between the sound clips in Figure 4.7 disappears at playback, because the clips have been joined together to play through as a single piece.

Figure 4.7 An audiophoto comprising three separate sound clips for the image shown.

Many-to-many sound and image associations are a variation of the other composite forms. An example is shown in Figure 4.8, which contains two ambient sound recordings for three street market photos. The photographer's intention here was usually to create a mood in multiple sound clips for a set of photos that might be viewed together like a collage, rather than to illustrate a sequence of photos to be viewed one at a time. This has been indicated by printing the images as a collage in the Figure. Technically these might be decomposed into simpler forms, but we preserve them here to indicate the behaviour of capturing an entire scene with looser collections of sounds and images.

Figure 4.8 An audiophoto collage of two sound clips for three images.

Silent photos

Because of the complexity of associations between sound and images in the collection, the 158 sound clips corresponded to many more than 158 of the 261 photos taken. Nevertheless, a residual set of 43 silent photos were left over when these associations had been taken into account. There was no particular theme to the content of these photos that might explain why they were left silent. However, a combination of technical features and comments by families explained why sound was not recorded on certain photos.

The majority of silent photos occurred amongst sets for which there was already sufficient ambient sound coverage. A good example of this was in one family's record of a trip to London. They took a variety of tourist photos with conversation, ambient sounds and some commentary from an open-topped bus, but six out of nine photos were technically silent. Another major reason for silent photos was sound equipment failure. This accounted for 11 out of 15 silent photos at the end of one family's film, after the microphone batteries had run out. This resulted in consequent disappointment since the family believed they were still capturing sounds with these

images. A batch of beach photos at the end of another family's photo set were also silent, due to salt water corrosion of the battery contacts in the dictaphone. Other reasons for not taking sound included the lack of any strong or distinctive sounds worth recording in certain environments, for example in the home, and the extra effort required to think about sound and control the dictaphone in combination with the camera. These factors will be discussed further below.

Solitary sound clips

In addition to photos without sounds there were also a number of sounds without photos recorded on the audiocamera. These might be called *audiographs*. Ten sound clips were recorded in this way during the main part of the trial, and a further six clips were captured by one family who asked to borrow the unit again afterwards.

As with silent photos, solitary sound clips were sometimes recorded at the end of sequences when the other medium had run out. For example, the teenage children of one family recorded a mock argument and a summary of the day at the end of one tape, after the film in their camera had finished. Other solitary clips were taken to record sounds that were considered attractive in their own right, such as street music and singing, or sounds that were difficult to capture with corresponding images, such as laughter. In one case, there was also a second take of an interview that was later rejected by the participants.

All these examples begin to indicate the value of sounds in extending what can be captured on a camera, and the way in which families quickly fell into the habit of recording sounds for this purpose. More direct evidence for the value of sound comes from how families reacted to their own audiophoto material, in terms of their preferences and comments.

REACTIONS TO THE AUDIOCAMERA AND AUDIOPHOTOS

Initial reactions

Many of the participants initial reactions were to the audiocamera unit itself and the experience of recording sounds with photos. The unit was generally too complicated to operate and slowed down the process of taking photos. This was annoying when participants were trying to capture something quickly, since they had to remember to switch on both the camera and the dictaphone, and decide when to start and stop the sound recording in relation to taking the photograph. As one mother put it:

"In some ways it was distracting and you tended to rush the photo" (Viv)

Most participants reported getting better at this with practice. Sometimes they would decide not to record sound with an image, while at other times they would take a picture to index a sound recorded earlier. With extended use, people appeared to treat the sound less as an adjunct to picture taking and more as a central or even primary medium to be captured with an image. This appeared to increase people's awareness and atunement to sounds in the environment, as indicated in the opening

quote of this chapter. Such attunement appeared to increase the importance of sound during playback as well as during the capture period:

> *"For me the sound initially augmented the visuals. But then as you run through it and you've got the sound going, the visual begins to augment the sound. You start with one, and become driven by one of the two media that are going on." (Paul)*

This awareness of sounds appeared to make adult participants self-conscious about the sounds and comments they were making in front of the audiocamera. Some participants mentioned not liking the sound of their own voice, or feeling stupid recording comments into 'thin air'. All this was less of a problem for children who either ignored the audiocamera unit entirely or enjoyed playing up to it. Self-consciousness appeared to diminish for adults over time as they got used to the presence of the audiocamera, and even began to play up to it occasionally for better effects. For example, the very next audiophoto following the restaurant scene in Figure 4.3b was of two adult members of the family singing silly lyrics to the 'The Yellow Rose of Texas' after the meal.

Another discovery made by participants using the audiocamera was that it raised privacy issues about the appropriateness of recording sound in certain situations. While it was fine to record sounds within a group of friends or family who knew they were being recorded, it was more of a problem with strangers. Such people would not expect a camera to record their conversation and might be offended to learn that it had been used to do so.

This problem is similar to that encountered with camcorders, except that camcorders are commonly known to record sound as well as moving images. Again, participants appeared to get used to this constraint by avoiding sound recording in delicate social situations, or other locations where it seemed inappropriate. For example, one family had visited the site of Austwitz concentration camp in Poland, and felt strongly that they didn't want to record any ambient sound there.

Despite some of the reservations expressed about the process of recording audiophotos, the families were intrigued to see the results for the first time. Their first listening was accompanied by a good deal of laughter and conversational banter, and was followed by a flood of comments to us about what they liked and disliked about the material. There was more consensus about the kinds of sounds they disliked most, with positive preferences for sounds and audiophotos being more idiosyncratic.

The sound of the camera shutter going off within a sound clip was unanimously judged to be annoying. Within a gentle ambient sound clip it destroyed the mood of the moment. Families asked for this sound to be edited out in the process of constructing an album of their best audiophotos. Similar intrusions sometimes occurred in the form of unexpected ambient sounds like traffic going past, or someone shouting in the background. For example, one clip of a distant steam train puffing past was spoiled by the sound of a relative yelling at a dog in the foreground. Other disliked sounds included wind noise on the microphone that tended to drown out other sounds, nondescript sounds whose source could not be recognised, and recordings that were not true to life. All these have their parallels in ordinary

photography where images can turn out to be masked by overexposure, to depict subjects too distant to recognise, or to contain colours that are not true to their source.

One surprise discovery was the relative unattractiveness of voiceovers to the people who had recorded them. Families who had recorded short voice labels or comments on their photos tended not to like these themselves at playback. They usually remembered the context of each photo, which after all was taken less than a month before, and felt that the comments were redundant.

In contrast, participants liked ambient sounds that were distinctive, uninterrupted and true to the actual sound as it was heard and remembered. If this sound also matched the content of an associated photo then it was usually perceived to work well as an audiophoto. A good example of this is shown in Figure 4.9, which shows a view of a horse and cart ride. The sound is a clear recording of the cart rattling down the road with the clip-clop of the horses hoofbeats in the foreground. While ambient commentary was also recorded on about a quarter of audiophotos, it was really these more distinctive types of natural sounds that delighted the families most, on listening to their audiophotos for the first time. Further evidence of this effect was provided through the selection of 'favourite' audiophotos for albums we made up for each of the four families after their initial review of material.

Figure 4-9 Distinctive sounds appear to make the best audiophotos

Favourites

In selecting about ten audiophotos for a favourites album, families explicitly revealed their preferences for sound and image combinations in the set. In the course of making this selection, individual family members also discussed the reasons for

their preferences, and sometimes volunteered their overall favourite audiophoto in the set.

In general, there was a preference for ambient sounds over other types. There was also a tendency to prefer more complex sound and image combinations in the favourite set. This suggests that looser or more complex associations may be considered more interesting or evocative than simple one sound one image associations. Nevertheless simple audiophotos made up the majority of favourite as well as non-favourite audiophotos.

In discussing their favourite audiophotos, families confirmed these overall preferences. They listed the following types of ambient sounds among their favourite recordings:

- Children's voices
- Crowds
- Rain
- Running water
- Chinking cups
- Street music
- Foreign language being spoken

These sounds turned up in various individual 'all-time' favourite audiophotos. Three of these are discussed here in order to illustrate their composition and explain why people found them so attractive. The first all-time favourite is shown in Figure 4.10 below.

Figure 4-10 All-time favourite audiophoto of Viv, depicting her husband and dog in the sea one summer evening, while she walked through the shallows.

Figure 4.10 was taken and selected by the mother of one family (Viv), and shows her husband and dog in the sea. A pure ambient soundtrack has captured the lapping of the water as Viv walks through the shallows. Although this is a simple one-to-one association of sound and image which contains little additional information in the sound channel, it was favoured because of the way the sound added to the mood of the photo and reminded Viv of the peace of that particular summer evening on a Devon beach. As spectators on this scene we can imagine something of the external atmosphere involved, but to Viv herself it appears to be her own internal feelings of the moment that are triggered by the sound and image. The fact that it was these very sounds she heard, from that particular perspective, is probably important to the effectiveness of the audiophoto in triggering this recollection, but it is the recollection itself that makes the audiophoto so special.

Another all-time favourite audiophoto is shown in Figure 4.11. This was singled out by the parents of Philip, shown on the far left of the photo, who recorded the associated voiceover describing where the photo was taken. The rest of the family found Philip's mistake at the end of the voiceover very funny, because he had rehearsed what he was going to say several times before making this recording. Philip's clear displeasure at the end of the clip added to this effect. Although this mixture of embarrassment and humour make the audiophoto appealing in its own right, its main value for the parents lies in the fact that it reveals something of Philip's personality that he might not want to reveal about himself, namely that he likes to get things exactly right. In this respect, the audiophoto operates as an enhanced self-portrait.

A final all-time favourite audiophoto is shown in Figure 4.12. This was chosen by Debbie, another mother in the trial. The figure shows a collection of photos of Debbie's friend and daughter, taken at her friend's house on a weekend visit. Her friend was learning to play the piano at the time, and the background sounds were recorded while she practiced over the weekend, as shown in one of the photos. These sounds end with Debbie wishing her daughter goodnight. This extract is an audiophoto collage of sounds and images. The images could be made to reveal themselves one-at-a-time at playback, or be viewed together as shown in the figure.

While the individual photos were taken at different times, Debbie chose to combine them with the music and conversation to create an impression of her friend's house. She used to live with her friend who often filled the house with the sound of her cello playing, and the sound of the piano reminded her of that. The inclusion of her daughter situates the photo in more contemporary times, in which Debbie has a new life with her own family. The selection of what sounds to record and how to combine them with images, opened up new creative possibilities for the families. This piece is an example of how some participants began to exploit these to good effect. Again the overall aim was to create something that operated as an effective reminder of thoughts and feelings of the moment, or revealed something of the character of the people in the photographs.

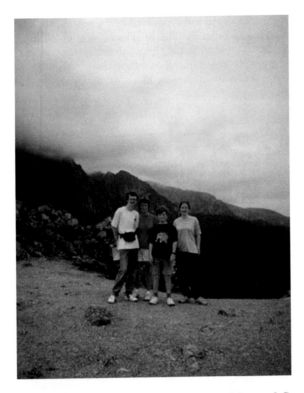

Figure 4-11 All-time favourite audiophoto of parents Mervyn & Sue, depicting their son Philip making a mistake in his commentary on their mountain climbing photo.

The value of ambient sound

The above discussions of favourite audiophotos begin to reveal some of the properties of ambient sound that participants valued most in the trial. For example, the ability of sound to add mood and humour to an image, and to foster increased creativity in photo taking, appeared to be key values of the medium. This was confirmed and extended in direct discussions of the value and attraction of audio.

The most common comment about the addition of ambient sound to photographs was that it *brings the photographs to life*. The notion of enlivening a still image through sound appeared to have a number of facets. Ambient sounds were seen to add a general mood or atmosphere to the scene, as in the market squares shown in Figures 1.1 and 4.8, the café and restaurant of Figure 4.3, or the seascape of Figure 4.10. In some cases, a sequence of events unfolds within these clips, lending a further impression of the life going on within them. This is particularly evident in Figure 1.1 where birds can be heard to take off and the trumpeter begins to play towards the end, or in Figure 4.5 where the frozen action of jumping into the

swimming pool is introduced and completed by the sound clip. The sound of voices in a clip also served to bring the human subjects of a photo to life, and to reveal something of their thoughts and feelings of the moment through the recorded conversations. By these means, the photos themselves were seen to inherit a kind of human agency, even without the inclusion of deliberately staged or annotated commentary. As one person put it:

"The photo speaks for itself" (Viv)

Figure 4.12 All-time favourite audiophoto of Debbie, depicting her friend learning to play the piano at home, on a weekend visit with her family.

In bringing a photo to life, sound also appeared to supply *additional stimulation to trigger people's memory* of the original events. This was shown by the fact that the families recalled and discussed the events in greater detail when looking at the photos with the sounds than without them. In fact the very act of listening to the associated sounds made the families look longer at each photo, and attend to the extra details of the event that were contained in the sounds. For example, sounds might be made by objects outside the frame of the photo, such as by a waterfall

behind the photographer in one beach scene. In other cases they contained repetitive or typical sounds of the location, such as the trumpet call in Figure 1.1 which was played in the square every day at one o'clock. For many of the participants these sounds seemed to trigger an existing sound-memory for events that might be just as salient as their visual-memory yet untouched by photographs alone. As one participant put it:

"I have an audio memory in my brain." (Debbie)

Some audiophotos were even taken for the audio memory alone. For example, one family reported taking the audiophoto in Figure 4.13 only for the sound of the marching band. Ordinarily, they wouldn't have taken a picture of a marching band at all. In this case the photo was used to index the sound, which acted as the primary cue for the family's memory of the scene.

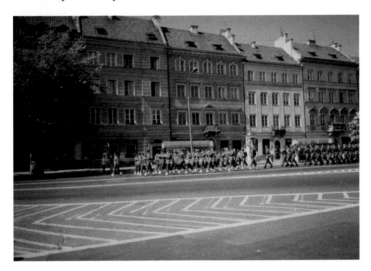

Figure 4.13 An audiophoto taken only because of the sound

Another major value of sound was *the element of humour* it often introduced. There was a noticeable increase in the amount of laughter experienced looking at the photos with sound rather than without them. Sometimes this was due to the strangeness of the sounds encountered in certain locations. For example, the music of Figure 4.13 was found by the same family to be playing down a salt mine visited later in the holiday. At other times the humour was strongly linked to the embarrassment of being caught saying something revealing, as in the private conversation between one of the teenage girls in the trial and her friend about which members of a pop band they liked the most. This is shown in Figure 4.14. The girls hated the audiophoto while the rest of the family loved it. This made for an interesting discussion at playback time.

Figure 4.14 An audiophoto recorded by two teenage girls

Such embarrassment also extended to the commentary and staging of audiophotos which went wrong in funny ways. The all-time favourite photo shown in Figure 4-11 is of this kind, where the son makes a mistake in his commentary on the mountain. Another example of a humorous 'mistake' was created by one father who tried hard to get his dog to bark for an audiophoto. The resulting picture of his dog is accompanied by increasingly desperate calls for her to bark, ending with some heavy panting as he holds the microphone to her snout. Hence, the general feeling was that:

> *"Its much more fun with the sound." (Thomas)*

> *"Its something that would prompt you to play around a bit and have more fun" (Paul)*

Two of the families did begin to play around with sound recording to exploit the humourous potential of sound deliberately. For example, the surfing sequence shown in Figure 1.2 was done as a spoof sporting commentary by one father for his son. This turned out to be especially funny to everyone except the son, because of the number of times it took him to catch the wave. The favourite photo shown in Figure 4.12 of a friend playing the piano was later sent to the friend as a joke. It contained her own playing, which she did not know was being recorded, preceded by a fast classical piano solo taken from Rachmaninov's Piano Concerto Number 3. Finally, the same father and son team as in Figure 1.2, created the audiophoto shown in Figure 4.15. This shows the father accidentally hitting his son several times, while putting up a windbreak on the beach. The ambiguity of the sound and image combination is exploited here to tell a false story-of-the-image. All these examples not only reinforce the humorous value of sound, they also show how sound

encouraged people to take more creative photographs and audio-photo combinations.

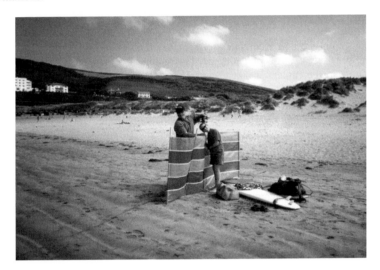

Figure 4.15 A joke audiophoto made by a father and son at the beach

Perhaps the most revealing finding about the overall value of sound was the disappointment that was expressed at any sound loss. Whatever the value, it was missed when taken away. This happened on about three occasions when the microphone batteries ran out within the trial period, and when the audiocamera unit was removed at the end of the trial. One family had got so used to the habit of recording natural sounds with their photographs they asked to borrow the unit again after the trial:

As a final indication of the value of ambient sound, we asked families directly if they would like to use an audiocamera again if they could. Twelve out of the 14 trial participants said yes. Most participants felt that that sound capture would be a good option on a camera, to use whenever there was some interesting sound going on in the background. An associated perception was that this might increase the overall use of the camera, because there would then be two kinds of events, visual and auditory, to trigger recording.

PRACTICE

It is clear from the trial that users of the audiocamera began to listen more attentively to sounds in their environment, and to watch for audio as well as photo opportunities. A number of difficulties in realising these opportunities were revealed by comments on the process of capturing, editing and reviewing audiophotos, and by

observing review behaviours. These are drawn together in this section to reveal the potential of the medium for transforming current practices, and to identify usage problems which need to be addressed by the enabling technology.

Capture

The prototype unit was generally considered to be too difficult to use, despite having very few controls and settings. The requirement to switch on the dictaphone separately to the camera meant that some people missed action shots or composed their photos badly. The consensus view was that an audiocamera should be as automatic as possible to preserve the point-and-shoot feel of a compact camera:

> *"There was too much to think about for a snap" (Debbie)*
>
> *"There's no time to fiddle around" (Sue)*

A number of people commented on the difficulty of anticipating the quality of the sound being recorded at capture time, based on a series of dissappointments on first hearing the results. People seem to make the same mistake with sound capture as they do with image capture, in assuming that whatever they can see or hear will be picked up faithfully by the recording equipment.

Participants also expressed a variety of opinions about the overall quality of sound playback. In general, the sound quality achieved on the prototype unit was adequate for most people, although our impression is that high fidelity stereo sound would accentuate the feeling of being taken back into the recorded scenes by the ambient sound clips. People tended to complain about sound quality when the recording diverged too far from the remembered sound of the source; such as when a boat engine was said to sound like a building site. We also found more tolerance for poor quality sound clips by members of the capture group who share the same memory of the recorded event. Presumably their memory helps with the interpretation of sounds which might be unintelligible to outsiders. From these effects it appears that the expectation for sound quality is the same as that for image quality. A relatively high baseline quality is expected by most users, but some users prefer higher quality recordings.

Editing

The fact that sound clips were recorded selectively around the time that photos were taken meant that the families did not need to cut out extensive portions of recorded sound or to significantly alter the order and association of sounds and photos. Most of the families' requirements for editing were expressed to us in terms of exceptions to a "keep everything" rule. For example, we were asked to take out the bits of sound where "nothing happened", such as when Thomas recorded his sister waking up, or when one couple waited for a cow to moo. Other bits of sound which were singled out for deletion were either interruptions to the clip, such as the sound of the camera shutter, or sources of embarrassment. However, as discussed above, it was often the embarrassments and mistakes in the sound tracks which added humour to the photographs and we found unaffected members of the family arguing to keep these in.

Arguments within the family about what sound or images should be kept or thrown away were common, and reflected a deeper issue about editing rights. Individual members of the family appeared to have different rights to editing depending on whether they personally took the audiophoto. Family members also had different opinions about the audiophotos depending on who they were going to be shown to outside the family. The situation was analogous to deciding which conventional photos should go into the family album. Nobody wanted to look foolish within the formal family record, and everybody wanted to show their own version of an event to personal friends.

Another important factor for editing was that participants began to record longer sound clips with practice. This was particularly noticeable with one family who used the unit for two cycles, shooting a 36 exposure film each time. On the first cycle they recorded about 21 minutes of unedited sound, whereas on the second cycle they recorded about 36 minutes. Both sets of sounds were edited down to about 17 minutes. This implies that families may be willing to do more sound capture and editing to achieve better effects over time.

Review

Most of the comments people made about the value of ambient sound were made in the context of thinking about its impact for them personally. To this extent, we can say that there was a positive perception of ambient photographs enhancing *private review* by photographers and subjects in the trial (see again Figure 3.5). Although we have not formally collected the feedback of a private audience on this material, readers might reflect on their own experience of these audiophotos in that role. Speaking for myself as a researcher reviewing the materials for the first time, the sounds added a good deal of context to each photo that helped me not only to interpret the photos more easily, but also to picture the mood, emotions or interpretations of the participants more effectively. I felt I was getting more of an insight into the character of the subjects of the photos with the sounds than without them. Spoken commentary was particularly effective in this respect, even though it was much less effective for the participants themselves.

Other comments made about the value of sharing audiophotos begin to extend these findings to the practice of *social review*. For example, several people felt that distant family and friends would appreciate a spoken voice message with a photo, either as an *audiophoto postcard* from the capture location, or as an *audiophoto reprint* upon return home. It was thought that a spoken voiceover on a photo would be perfect for this purpose:

> *"Sound (commentary) would be good if you aren't there to explain"* (Anna)

> *"Commentary would be good for sending to people who aren't there"* (Debbie)

There was some ambiguity about people's perception of how they would like to share ambient audiophotos directly with others. At one extreme, some participants spoke about wanting to make up a full-blown slide show of images and sounds to show to family and friends as a presentation. At the other extreme, several people

could foresee themselves showing the photos to others, such as a secretary at work, without the sounds, so as not to overcomplicate the process of sharing.

In fact this prediction came true within the methodology of the trial, since we left separate cassette tapes of sound clips with each family after the second home visits and before the feedback groups. At the feedback groups, some people reported showing their photos to others without playing the sounds. In between these extremes, the majority of people expressed a desire to selectively control or curtail the amount of sound that would play with each photo, so that they could adjust it for the audience at hand. As one participant explained:

> *"A choice of sound would be good. It depends on the subject matter and the audience" (Christine)*

The reasons for this ambiguity and sensitivity to the audience become clearer if we observe what happened when families began to share the audiophoto material within and between themselves. This happened on the second home visit when we gave families a chance to review their audiophotos together, and in the feedback groups when they were asked to show their audiophotos to another family. The first occasion represented a reminiscing situation in which photographers and subjects of the audiophotos interacted with each other. The second occasion represented a storytelling situation in which photographers and subjects interacted with an external audience.

By observing audio playback from a cassette tape in the home visits, we found that families automatically modified the way they handled and discussed the photos in order to accommodate the audio. They switched spontaneously from passing individual photos along the family group (without audio playback), to a process of one person turning over photos in the pack whilst others looked over their shoulder. This led to a more intimate group experience, with much laughter and conversation occurring over the rolling soundtrack.

However, this arrangement removed individual choice of how long to look at each photo. In fact, the photo holders tried hard to turn over the photos in pace with the sounds, to preserve the correspondence between image and audio. This sometimes caused the families to dwell on photos with long sound clips for longer than they wanted to, and to speed through photos without sounds too quickly. As one participant said:

> *"There is no time to linger over the photos when you are listening to the sounds at the tape pace (Philip)*

The same effect was observed in the feedback sessions later when families tried to show each other their favourite audiophotos from a pack of selected prints. Each print with sound had an audio track number written on the back, which could be played from a minidisc player connected to nearby speakers. Prints were turned over by a single member of the authoring family rather than passed around the group. Furthermore, photo holders tended to turn over the pack systematically and let the audio clips play through, rather than using the minidisc controls to pause the audio or randomly access audio clips out of sequence.

Whereas in the home visits this behaviour had led to a good deal of laughter and enjoyment, in the feedback session it led to frustration with the audio getting in the

way of conversation about the photos. Ambient sounds appeared to interfere with storytelling:

> *"Its very frustrating 'cos I want to tell Viv all about where we were and what we were doing but I can't do that with the water noise on" (Sue)*

Participants pointed out how different this felt to sharing audioprints within the family, when listening to the ambient sounds was more fun. Here, ambient sounds appeared to enhance reminiscing:

> *"If you do this with somebody else its quite different. 'Cos the first one we heard as a family was hilarious really wasn't it? We had Lucy with us, and she was covering her face, and the girls were so embarrassed at the sound of their voices, and it was actually real fun. But that wouldn't come over in an (outside) group..." (Viv)*

These findings show that introducing sound data into the existing activity of photo sharing dramatically affects its organisation and enjoyment. Ambient sounds seemed to enhance the experience of *reminiscing* with members of the original capture group, but potentially interfered with the experience of *storytelling* to others who weren't there at the time.

However, the extent to which sounds enhanced or interfered with photo sharing behaviours appeared to depend on the type of sound and its method of control. We noticed more frustration in families who recorded more voiceover with their photos. Ambient sounds and music appeared to be easier to talk over than forms of recorded speech. We also found that families were able to control the timing and pace of sound playback better on a PC album, where photo had to be clicked on before they began to play. The minidisc controls, although simple, were too much to think about in conversation where attention was focussed on the images and participants rather than the audio technology (see Chapter 8 for further details).

Comparisons between an audiocamera and a camcorder

To explore the issue of whether many of these values are provided better by video recording, we asked participants at the end of the trial whether they would prefer a camcorder or an audiocamera at the same price. Eleven out of 14 people preferred the audiocamera.

Since none of the families in the trial were camcorder owners, one might at first glance think that this result was due to the fact that they didn't understand the benefits of camcorders. However, all of the four families had experience of capturing and watching video or cine film, and were well aware of the costs as well as the benefits of camcorder use. Indeed they had deliberately chosen not to buy camcorders because of this. This suggests that their preference for the audiocamera reflected an informed judgement about its true benefits over and above a conventional camcorder. In discussing this preference, participants identified a number of benefits of audiophotos.

Several people in the trial said they just liked the aesthetic qualities of photographs better than those of video for capturing the mood of an event or moment. For them, enhancing the richness of a photograph with sound was

inherently more attractive than switching to what they see as a completely different (video) medium.

Another factor in the preference for an audiocamera was that it allowed the user to participate more fully in the scene being recorded. Some participants contrasted this with the lack of participation when using a camcorder:

> *"We don't go on holiday to create a film. We are much more instant people. We prefer to live life rather than record it" (Geoff)*

> *"One of the reasons we haven't got a video camera is that it is too intrusive and you end up not participating the event that you are in" (Mervyn)*

People reported using the audiocapture unit selectively, like a point-and-shoot camera. This enabled them to get back into the scene quickly after use. Furthermore sound recording could be left on with the user still participating in the scene itself, as shown in a number of audiophotos where the user's voice was in the sound clip. This is in stark contrast to video recording where the user is usually distanced from the scene for the entire duration of (longer) recording periods.

One family member commented that the audiophoto medium is easier to master than video for beginners. This is substantiated by any casual look at the families favourite audiophotos which are remarkably good for a first attempt at using the new medium.

> *"You need less skill and aptitude as a beginner to use this (audiocamera) than you would with a video. Video gives you more flexibility but aesthetically the results of the last audiophoto set were better than a first go at video." (Paul)*

The final appearance of video is critically dependent on the editing of raw video material, which is something camcorder users seldom get around to doing. In contrast we found that the editing requirements for audiophotos were very simple because of the way sound clips were recorded selectively around the time of image capture. Some trial participants recognised that this might be an advantage of audiophotos over home video, as long as sound editing and handling didn't turn into a big job:

> *"You had to be more thoughtful about what to select with the audiocamera. It's a one take opportunity.... With a camcorder you can take a chance and keep it running more." (Debbie)*

> *"Its different from a camcorder. You are looking for the moment" (Geoff)*

> *"Editing is the downfall of video for personal use. Would this be the same? I couldn't be bothered to edit each film we produce. Half the time we don't get round to putting photos in albums" (Paul & Viv)*

A final reason for the selection of an audiocamera in preference to a camcorder relates to the way the captured material is reviewed. All the trial participants without exception wanted to review audiophotos in the same interactive manner that they review ordinary photos - by discussing some audiophotos in more detail than others depending on the audience. While this was not always possible within the review

scenarios experienced in the trial, a number of people seemed to recognise that this would be an advantage for audiophotos over watching home video presentations which are notoriously boring to outsiders.

DISCUSSION

Although modest in scale, the audiocamera trial has revealed a good deal about the properties of ambient sound for memory and communication, and its role in domestic photography. In this section I draw together these lessons with reference to the diamond framework.

In general, we found that the families taking part in the trial adapted quickly to the use of a camera with sound, taking a large number of sound clips with their photographs in all kinds of contexts and forms. This device appeared to unleash a widespread interest in sound, as revealed in the art and radio projects mentioned at the beginning of the chapter. There was even evidence that this interest began to overtake picture taking. Hence the act of capturing sounds began as an adjunct to capturing pictures but soon became an equivalent or even primary task in the process of recording memories.

This transformation occurred as users became better attuned to the sonic properties of their environment, and the aesthetic properties of the combined medium. In reviewing this medium, families were delighted to discover that sounds brought many of the pictures to life, gave them mood and atmosphere, and provided additional information by which to interpret and remember the moment. This prompted them to think about how to improve the method of capture on the prototype unit, and the editing of sounds and associations afterwards, so as to consolidate and expand these values in more creative ways. This positive experience resulted in the majority of participants wanting to record audiophotos again, and led some people to regret the absence of the audiocamera when it was withdrawn.

Not all of these effects were due to the recording of pure ambient sounds taking place exactly as the photographs were taken. In fact a major finding of the trial was that ambient sounds are made up of multiple components lying before, during or after the images to which they relate. In fact, the ambient audiophotos contained music, conversation and commentary as well as environmental sounds, and comprised sound and image *sequences* that overlapped in different ways.

To the extent that these other sound types were recorded around the moment(s) of image capture, they remain part of the ambience of a scene or event and can still be distinguished from music or voiceover added later, and from the conversation about an image that occurs when it is shown to others. Nevertheless, the fact that these components occur or can be recorded as part of the ambient sound track adds to the complexity of its role in photography and to the expressiveness of the audiophoto medium itself. To understand this role and expressiveness better, it is useful to relate the study findings to the personal and social contexts for interacting with photographs, as shown in Figure 3.5.

The role of ambient sound in personal image review

Ambient sound was found to be beneficial for the personal *recall* and *recollection* of a scene or event by those involved in it. This confirms the expectation of people in our pilot study. Ambient sound has also been found to be useful for the *interpretation* of images by those not involved.

In the first case, participants told us directly that the recording and playback of ambient sounds with images improved their memory of the original event. In particular, natural sounds, ambient music and background conversation all served to capture more of the atmosphere of the time, and appeared to help people recover or remember their feelings of being there again. This was most clearly illustrated in the seascape audiophoto shown in Figure 4.10, where the simple sound of walking through shallow water helped to recreate the mood of an entire summer evening on holiday. Ambient sound undoubtedly provides more information about the scene that people may use to access their memory of it, but it is the *emotional* aspect of the sound that they appear to recognise and value most. This partly explains why voiceover was seen as less valuable than natural sound by the participants themselves. Although voiceover adds information about where and when the photograph was taken, it does little to mentally transport the participant back there, compared to ambient sounds of the moment.

Thus, ambient sound appeared to enhance memory by helping participants to emotionally re-live the event, rather than by furnishing details of the event to recollect cognitively. This effect is similar to that of *telepresence* in remote communication, where some systems and media are more effective in creating an illusion of being in a remote location than others (Lombard & Ditton 1997). Through photography, people can be transported to a previous time of their lives, and experience the illusion of being back at a particular location and moment. I will call this illusion *retropresence* to distinguish it from telepresence. Through audiophotography, the illusion of retropresence can be heightened by the use of ambient sounds, which literally surround you with the same auditory stimulation you experienced at the time. The same effect will be created by the ambient sound track of a video clip, although its literal depiction of movement through the moment may be less conducive to an overall sense of retropresence at the moment of review. This is an issue for future research.

In the second case, the interpretation of an unfamiliar scene was assisted by the playback of sound or comments providing additional contextual information. This could be seen in the reactions of families to each other's audiophotos, and in our own reactions to the trial materials as they arrived for editing and analysis. The images were easier to read with ambient sounds providing extra clues about the identity of people and objects in the scene, and comments providing a personal description of their significance. By definition, these audiophotos revealed more of the story-of-the-photo (Berger 1982a), either through the unfolding of sounds stretching beyond the moment of image capture, or directly through a voice comment. This made them highly suitable for sending to others who weren't there at the time, as observed by several participants in the trial. The same effects also enriched the depiction of people in the images. The inclusion of the voice of a

subject was found to be particularly revealing of their character, as in Figure 4.11. This is not surprising with hindsight, since the essence of someone's personality is likely to be conveyed at least as effectively by what they say or how they say it, as by what they look like.

The role of ambient sound in the social interaction

There were mixed effects of ambient sounds on the social interaction around images. As with personal review, these effects depended on *who* was involved.

In reminiscing conversations amongst themselves, families were observed to laugh more and generally enjoy the experience more with sound than without it. The element of humour was a key value of ambient sound noted by participants themselves, but it manifested itself most in social interaction where families could share the jokes and tease one another about how they sounded or what they had said.

In contrast, storytelling conversations between families were less fun. Indeed, people complained that they had difficulty talking over the background sounds and, in some cases, wanted to switch them off. People were trying to provide a live narrative commentary on their audiophotos, outside the sounds and commentary recorded with the images. These appeared to compete with each other, at least in the case of recorded speech. Hence ambient sound appeared to restrict rather than enhance the process of sharing photos with those outside the capture group, because it drew attention away from what the author and audience wanted to say about the image. The fact that the same sounds can be beneficial in one social setting and detrimental in another, is an important finding for audiophotography, to which we will return in later chapters.

In short, we have found that families take readily to the practice of recording ambient sounds with photographs , and produce audiophoto effects they prefer to conventional home video. This kind of audio adds considerably to what Schaverian (1991) calls the *life in the image*, by flooding the senses with some of the most distinctive sounds heard at the time of image capture. While music, commentary and conversation were all present in ambient sound to contribute to these effects, their contribution was usually secondary to that of environmental sound which was the most common type overall. In the next three chapters we consider each of these other kinds of sound in turn, as something added to the life of an image *after* it is captured. This will deepen our understanding of other kinds of audiophotos, before going on to consider the effect of screen and paper formats on the playback experience.

Musical photographs

"For me the voice captured the memory, the music captured the mood" (John, audio annotation trial).

In a recent survey of 29 funeral homes in the south west of England it was found that people are choosing more popular music to be played at funeral services (The West Briton 2002). Traditional hymns are being replaced by classic songs such as Elton John's *Candle in the wind* and Simon and Garfunkel's *Bridge over troubled waters*, or by contemporary hits such as *Angels* by Robbie Williams. At the top of the funeral charts calculated in the survey were pieces from Hollywood movies about bereavement and loss. Number one was Bette Midler's *Wind beneath my wings* from the film *Beaches* while number two was Celine Dion's theme from *Titanic, My heart will go on*. Outside the top ten were occasional choices for more light-hearted music such as *I'm the king of the swingers* from *The Jungle Book*, *Party Atmosphere* by Russ Abbot, and *Always look on the bright side of life* from the Monty Python film *The life of Brian*. The point of this story is that ordinary people are rather good at selecting music based on its personal meaning to them or to their close family, and using that music to create particular emotional and symbolic effects. Those familiar with any of the examples above will recognize symbolic connections with enduring love and the celebration of life in adversity, and these

meanings will be amplified when there is some personal association between the music and the person who has died. Indeed the funeral directors interviewed about the survey results, stated that people are turning to popular music to *personalise* the funeral service and make it relevant to their loved one who may not be familiar with church hymns and choruses.

This chapter explores whether people can do the same sort of thing with photographs. Perhaps music can be chosen to add personal meaning to a photograph and influence the kind of effect it has on oneself or others. For example, music associated with the time or place the photograph was taken might serve to enhance the memory of the event. These possibilities are examined here by encouraging consumers to annotate a small set of their own photographs with music from their own personal collections. However, before reporting the details of this study, we pause briefly to consider what is already known about this activity from previous studies or design practice.

RELATED WORK

Very little academic research on music has considered its sentimental value and use. Research questions have centred more on how we perceive and remember pure musical phrases (psychoacoustics), and on how musical tastes and styles differ across cultures and time (musicology). For the best insights into the personal value of music, we need to turn again to popular culture.

An experiment in personal music selection has been carried out through an ongoing BBC radio show called Desert Island Discs. The show celebrates its 6oth anniversary this year and must surely be the longest music-psychology study in history. The format for the half hour show is to invite a celebrity guest to choose eight records they would take with them to a desert island. The guests are interviewed about their lives in the context of the music selection, and always give a reason for each piece of music before it is played (in shortened form). Only three main interviewers have hosted the show over the years: Roy Plomley (1942-1985), Michael Parkinson (1986-1988) and Sue Lawley (1988- present). The very success of this format says something about the appeal of hearing about other people's choice of music as well as hearing the music itself. It also reveals the suitability of music as a vehicle for talking about the past.

In commentaries on the show, Roy Plomley and Sue Lawley discuss patterns in the choice of music across shows (Plomley 1975, 1982, Lawley 1990). The top 10 or 20 music choices appear to change over time, particularly as new popular music replaces old. Classical music selections are more stable and include well-known pieces such as Beethoven's *Ode to Joy* (Symphony No 9, last movement) and *Pastoral* Symphony (No 6), Mozart's *Clarinet Concerto* (second movement, Adagio), Dvorak's *New World Symphony* (largo), Elgar's *Pomp & Circumstance* (March No. 1), Brahm's *Violin Concerto* (last movement) and Rachmaninov's *Piano Concerto No. 2* (last movement). However, the reasons for choosing the very same piece of music can be quite different across people. Sometimes the music is chosen

for its connection with the past and ability to conjure up a happy memory. At other times, the music is chosen primarily for entertainment or because of a preference for a particular composer or performer. In all cases the choices are *personal* and idiosyncratic. They therefore reveal something about the personality of the guest that might otherwise have been difficult to elicit by direct interview alone.

These points can be illustrated by some music choices made by Brian May of the rock group Queen, speaking on the show during the week I was writing this chapter (broadcast on BBC Radio 4, Sunday 15th September 2002). His choices fell into three categories. Some tracks were chosen because of their aesthetic qualities and ability to lift his mood. These included:

- *Since you've been gone*, Rainbow – "This always gets me and lifts me"
- *Highway to Hell*, AC/DC – "This is pure rock. It clears you out and gets you back to basics".
- *We will rock you*, Queen – "It brings people together and makes them feel strong and uplifted".

It turned out that Brian had been subject to depression in the past, and wanted to use music to avoid this on his desert island.

Other tracks were chosen because of their association with important people in his life. These included:

- *Maybe baby*, Buddy Holly – "An early inspiration"
- *To know him is to love him*, Anita Dobson & Brian May – "My darling wife. I couldn't be without her".

Discussion of these two choices revealed a secret love of pop music in a quiet and conservative home setting, and the break up of a first marriage.

Finally, three tracks were chosen because of their nostalgic value. Each one reminded Brian of a different time in his life:

- *Saturn-Bringer of old age*, Planets Suite by Holst – "I wrote a monolog when I was a kid and used to perform to this"
- *Back on my feet again*, The Babies – "My driver used to play this as a pick-me-up on the car radio on the way back to the hotel after an all-night drinking session".
- *Tracks of my tears*, Smokey Robinson and the Miracles – "This took me all through my college days after a break-up with my girlfriend"

The meaning of each piece is indicated by its associated quote, and reveals something about Brian's past attitudes and behaviour. The Planets Suite movement relates to his love of astronomy, which he developed as a child and later studied at university. The monolog he wrote was about the night sky in winter. The Babys track refers to a period of excessive partying on tour with the band, while the Smokey Robinson track relates to his time at university. He played *Tracks of my tears* when getting over an important relationship with a girlfriend, and pretending to be OK when he was not. The lyrics of the chorus articulate this feeling exactly, and expressed for him something he couldn't put into words himself. This also prompted him to talk about his reason for wanting to write songs, as a way of connecting to people 'Heart to heart'.

Chorus:

Take a good look at my face

You'll see my smile looks out of place

If you look close its easy to trace

The tracks of my tears

These examples suggest that music has a variety of meanings and associations in one's life, and can be used privately to trigger memories and alter moods. Furthermore, the *discussion* of these meanings and associations seems to be revealing of personality. All this is relevant to the photographic context in which images serve a similar function. In this context it is interesting to reflect on what the associated images might be for Brian May's music selection. While the people selections could be linked to standard photographs of the performers, such as you might find on a CD cover, the nostalgic selections could not. It would be more meaningful to combine the *Saturn* music with a photograph of Brian as a child, or of the night sky, than with a picture of an orchestra performing the Planets Suite. Similarly a photograph of his driver or car would be best with *Back on my feet again*, while a photo of his long lost girlfriend or his smiling face at that time might be appropriate to *Tracks of my tears*.

Unfortunately, the format of this radio show does not support such speculation, and there is little scientific work on the connection between music and images. In a recent conference on *Musical Imagery*, the ability of people to hear and sing tunes in their heads was discussed and studied, as was the ability to read music or other visual symbols and hear inner sounds (Godoy & Jorgensen 2001). However, the ability to hear actual sounds and mentally picture a scene was not discussed in any detail, nor was the ability to look at an image and imagine the sounds or music that go with it (although see Mountain 2001 for an exception).

That people can do both these things is indicated by some of the findings in Chapter 4 of this book and by a book on music in modern art (Maur 1999). Hence, Maur (1999) shows that a number of famous painters and musicians were heavily influenced by each others work, taking inspiration from one medium and translating it into the other. For example, Kandinsky was inspired by Schoenberg's use of dissonant sounds to develop a more abstract form of cubist painting than had been done before. Furthermore, in Chapter 4 of this book, we saw that ambient sounds could either trigger a visual memory of an event or be recalled from a photograph of the event. The history of the cinema in Chapter 2 also alluded to the ability to set music to silent films. In fact some cinema pianists and organists of the time could improvise music which watching the film live. This is exactly the kind of thing that is done today over a longer timescale by film music composers. As this is such a relevant activity to the selection of music for still images, we will consider the film composers' skill as a final backdrop to our study.

Composers in general talk a lot about finding inspiration outside music for their compositions (Mountain 2001). They draw on analogies with human emotions, historical characters and stories, animals and landscapes. For film music composers,

these analogies are given visual form and pace through film footage. Note also that this footage is generated in relation to a screenplay and accompanied by ambient sounds and dialogue telling the story of the film. The process of producing such material takes time, and can be more or less integrated with the creation of the music. Hence we find that a perennial concern of film music composers is which comes first; the image or the music? This issue is discussed in a series of interviews with famous film composers, talking about their work (Russell & Young 2000). While it is more usual for a composer to be shown rough-cut footage as a stimulus for the music, some directors are open to discussion with the composer about the intention of a scene before it is shot or edited. For example, Elmer Bernstein was able to create a 'temp' score for Martin Scorsese, before editing ***The age of innocence***:

> *"Scorsese is one of those directors who will talk through the sequences and the way he would like the music. He said that listening to music is what made him want to become a director. For him the image and the music are inseparable. He finds it very difficult to edit a film cold, so he will tend to bring in the music as he's editing the film. In the case of The age of innocence, I wrote some themes for him which he liked and I then suggested we make a temp score based on these themes, so he was always working with what became the final score" (Bernsein quoted in Russell & Young 2000, p43).*

Nevertheless, one of the key skills developed by film composers is to look a sequence of images and imagine the kind of music that goes with it. For some film composers this can be an immediate experience:

> *"Whenever I see a film, a good film, I feel the orchestration right away" (Maurice Jarre quoted in Russell & Young 2000, p55).*

The intention of the music is usually to define and accentuate the *mood* of the scene or characters, and to assist the *narrative* flow of the film in telling the story. Individual characters may have separate themes associated with them, which communicate their own emotions to the audience. At other times, the music may cut against the (primary) emotions of the characters in the film, to communicate another (secondary) emotion to the audience – as in the warning of an unforeseen danger. These techniques have been shown to be effective both in influencing the emotional experience of the audience and their understanding and recollection of the film (e.g. Thayer & Levinson 1983, Boltz 2001). Finally, the music is only one of the sound elements in a modern film and must be combined with ambient sound, dialogue and voiceover. The control and balancing of these various elements is the job of the sound designer who must understand each contribution and fit them together in time to the visual events (Sonnenschein 2001).

Whether or not these kind of skills can be applied by ordinary people to domestic photographs remains to be seen in the rest of this chapter and book. However, we now know from this review that such skills can be acquired, and might be combined with already well-developed abilities to select music for personal and social effect. So let us put this to the test.

THE AUDIO ANNOTATION TRIAL

Using a methodology similar to the audiocamera trial in Chapter 4, we gave a small number of families the opportunity to annotate their photographs with music and voiceover recordings. The study was carried out with Adam Drazin and Tony Clancy, and was designed to provide insights on both musical and talking photographs. This chapter reports the findings on music annotation while Chapter 6 reports the findings on voice annotation.

The main difference between this study and the audio-camera trial is that participants were not given a technology prototype for an unsupervised trial period. Current methods of annotating photographs with digital music or sound recordings were considered too complex to use by untrained consumers or too simple to accommodate their requirements. Indeed, one aim of the study was to generate user requirements for such a system. Instead, we visited families at home to supervise their *choice* of music and photo combinations that we later digitized and assembled into audiophoto albums. We also took in audio equipment to record voiceover narrations for other photo content that we again digitised and assembled later. This exercise comprised a pseudo-trial period, after which there was a return visit by families to the Labs. At this feedback session, families reviewed and discussed electronic versions of the albums they had designed, in a variety of forms.

Participants

This approach was followed with eight households in the Bristol area. The households were all PC-owning families in which one member had a special interest in photography or music. This interest was measured through attendance at a photography, album making or music club.

These criteria were used to ensure some level of technological sophistication, together with a propensity to benefit from either voice or music annotation of photos. For example, people involved in photography and album making might be willing to consider using voice annotation with photographs. Alternatively, those with an interest in music might consider playing music from photographs as well as from records or CDs. We also hoped to assess the general appeal of these activities, by involving other members of the household, and looking at the reactions of photo enthusists to music and music enthusiasts to voiceover.

Home visits

Each of the eight households generated one musical and one talking photo album in the home visit, apart from one couple who generated a pair each on separate visits. There was usually one main contact and interviewee from each household, with partners or other family members present at about four of the visits. The first part of the home visit involved a general discussion about photo and music use in the home. This was designed to explore photo album making behaviours and the role of music in remembering the past. The concept of audio annotation of photos was introduced in the second part of the home visit for comment. Participants were then asked to select a set of photos to annotate with music, and a set to annotate with voice. We left this choice open as far as possible, to allow people to direct the

activity towards photo content they felt might benefit from audio annotation. For practical purposes we asked people to limit the size of each set to about 10 photographs.

Once the photographs for music annotation were selected, participants began to work through the set with reference to their own music collection available in the house. Sometimes a piece of music came to mind immediately as they looked at a particular photo or group of photos. In these cases, they would search directly for that piece to hand over to us later. At other times, participants would be less sure of the particular piece they wanted, but usually had in mind the mood and sentiment it should express. In these cases, they would browse parts of their collection looking for inspiration or ask us for advice. When answering these questions we encouraged them to make their own selection. Each choice was documented on a simple two-column form on which we wrote photo names in the first column and music track names in the second. The discussion of music choices was also recorded to capture the participants' reasons for particular selections. A different procedure was used for voice annotation , and is described in Chapter 6.

Album creation

At the end of each home visit we took away the music and voice album specification forms, and borrowed all the music and photo materials relating to them. Music samples and voiceover materials were digitized by recording them into a sound editing application on a PC. Photographs were scanned into an image editing application. The composite sound and image files were then assembled into audiophoto albums on the PC, using Macromedia Director. This is a professional multimedia authoring system that had sufficient flexibility to support the variety of sound and image combinations chosen by participants in the trial. It is worth noting here that simpler, photo album software of the day provided either no support for audiophotos, or only poor support in the form of one sound per album or one sound per image.

This procedure raised a number of music copyright issues. Music copying is allowed for personal use, and could be supported in musical photo editing software. However, the distribution of musical photographs to other people begins to infringe copyright law by denying revenue to artists from recipients. This would inhibit the development of photoware for musical photographs. The study procedure itself was legal in the sense of facilitating the composition of personal musical photographs for live sharing and discussion. However, it left participants with a dilemma about how to share their new music-photo albums after the study and me with the job of requesting music licences for all the music in this chapter. This is an important issue to which I will return later.

The composition process resulted in the creation of 9 musical and 9 talking photo albums containing about 10 photographs each. In addition to these personal albums, we made up a demonstration set comprised of one musical and one talking audiophoto from each album. This set was used to create screen and paper-based demonstrations, showing a variety of non-PC formats for the same material. These included presentations on a TV, a palmtop PC, a tablet PC, and in the form of an

audio enabled print, card and physical photo album. These are described in further detail in Chapter 8, which deals with the findings of this comparison.

Feedback groups

Three separate feedback groups were then held for two or three families at a time in HP Labs Bristol. Each group session started with pairs of participants reviewing their own album material together. Pairs sat up to a flat panel display with active stereo speakers on a café table, and clicked through their PC-based albums using only a mouse. A laptop computer driving this experience was placed out of sight beneath the table. The interface to each album was kept simple and uniform, as shown in Figure 5.1.

Figure 5.1 Screenshot of a PC-based musical photo album

Most album pages showed one photo at a time at nearly full screen size, above a set of multimedia control buttons displayed at the bottom of the screen. Forward and back buttons had to be clicked to advance or reverse the display of pages, and audio tracks played automatically on presentation of their corresponding page. Sound could be muted using the mute button, but not paused. Where one audio track was specified to play over several photographs, it simply played continuously while any of those photographs were displayed. In a few cases where participants had specifically requested it, multiple photographs were displayed on the same page to one or more audio tracks. After reviewing each other's albums, pairs were asked to select their favourite musical and talking photographs from each album. They wrote down their selections with corresponding reasons on a form.

The initial sharing period was followed by a group discussion of the uses and values of music and voiceover with photographs. This was an opportunity for participants to reflect on the experience of creating and reviewing their personal albums, and comment on the problems and benefits involved. Groups were then shown a demonstration set of audiophotos in a series of alternative screen and paper formats. At the end of this demonstration each participant expressed their preferences for musical and talking photo formats on a form, before discussing their answers.

Findings on the *format* discussions for music and voiceover are described in Chapter 8, along with a similar comparison made for ambient audiophotos in the audio-camera trial. Findings on the *content* selections and discussions are described separately for music and voiceover in this chapter and the next. The analysis in these chapters follows that used in Chapter 4 for ambient sound, where technical features of the audiophoto corpus are described ahead of the users' perspectives on the material. In fact, the analysis section headings are kept the same to enable easier comparison between chapters on each of these three major audiophoto types. Conversational audiophotos are treated somewhat differently in Chapter 7 where conversation is explored as another method of eliciting voiceover narration.

MUSICAL PHOTOS CAPTURED

A total of 48 music clips were combined with 94 photographs to make up nine music-photo albums. The range of musical and photographic material used was extensive, and people approached the task of selection in a number of different ways. For example, some participants chose a recent collection of photos and set each one to a separate piece of contemporary music. Others chose an older photo collection and set it to a single piece of nostalgic music. Some people even selected ten of their favourite photographs and ten of their favourite pieces of music and tried to match them with each other. This made for a very interesting set of audiophotos, albums and discussions, as participants began to explore the possibilities of the new medium and find its value.

Types

The different types of music selected are shown in Figure 5.2. This chart was generated by classifying each music clip as belonging to one or other of a standard set of a music categories used by music shops. It shows that classical music was the most commonly selected type of music for this group, but that a wide range of other types were also used.

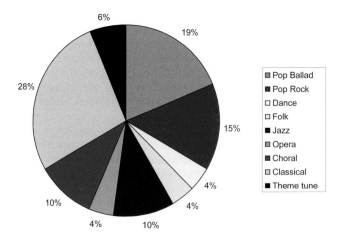

Figure 5.2 Types of music chosen with the photographs

Three typical example combinations of music and photos are shown in Figures 5.3, 5.4 and 5.5. The photographic components consist of a landscape shot, a group photo and an individual head-and shoulders portrait. These are combined respectively with a piece of classical music, a modern dance track and an old-time pop ballad. Hence the audiophoto effects of each are very different. Figure 5.3 conveys the mood of a rolling sea that occasionally crashes on the rocks in the foreground - as the movement of Dvorak's New World Symphony reaches a series of crescendos. Figure 5.4 communicates the energy and fun of a night out with the lads in some holiday location – through the pounding of a dance beat behind the series of happy faces. Figure 5.5 shows the smiling face of an older lady serenaded by a romantic ballad about beauty and love. We will return to each of these examples later, but for now it is sufficient to note the variety of content used in the study and the powerful effect of the music in modifying and accentuating the perception of each photograph.

Figure 5.3 Ocean view to Dvorak's 'New World Symphony'.

Figure 5.4 Group of friends to 'Hey Boy Hey Girl' by the Chemical Brothers.

Figure 5.5 Wife's face to 'Portrait of my love' by Matt Munro.

Durations

The duration of audio clips used for music was understandably greater than the duration of audio clips used for ambient sound. The average duration of a music clip was about three minutes (182 seconds) compared to 24 seconds for an ambient clip. However, the spread of durations was similar as shown in Figure 5.6. Ninety five percent of the clips varied from about 1 minute to five minutes. This variation is partly due to inherent differences in the length of published music tracks, especially those including short dance or jazz numbers and longer classical movements. In addition, this distribution was skewed towards the lower durations, by people who expressed a preference for specific parts of a track to be combined with their photos.

The request for parts of a track to be associated with a photograph was especially important in the case of long classical pieces or songs with extensive lyrics. This is because the mood and meaning of these kinds of tracks can change dramatically within the track. For example, the symphony represented in Figure 5.3 starts off quietly and builds to a loud finale in 7 distinct cycles over 6 minutes. By including all these cycles in this audiophoto the music echoes the repetitive movement of the

sea depicted in the photograph. Selecting the quieter or louder part of each cycle would have emphasised the calmer or more dramatic aspect of the sea respectively.

A further consideration is that each piece of music may not be played back in its entirety. This can be seen from the section on music-photo review below, which shows that participants often skipped onto the next audiophoto after just a few seconds of conversation about it. This means that the most important *work* of each track, in triggering a memory or conveying a mood, is done in the opening sequence.

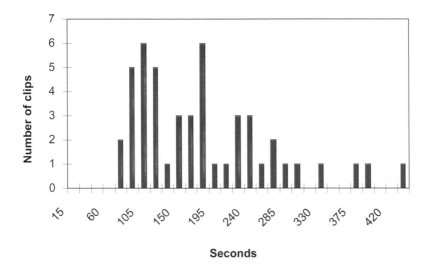

Figure 5.6 The duration of musical sound clips

Associations

None of the photos selected in the study were combined with more than one music clip. This contrasts with the ambient sound photos in Chapter 4 where a small subset were combined with several sound clips (see again Figure 4.6). Instead, the photos in this study were combined with a single music clip, as shown in Figure 5.7. In two thirds of cases there was a one-to-one association of sound to image. In the other third of cases, there was a one-to-many association, meaning that a single piece of music was combined with two or more photographs.

The ocean scene and group photo shown in Figures 5.3 and 5.4 were both associated with a single music track. However, the portrait shown in Figure 5.5 goes with an additional full length photo of the same woman. Both were associated with the same Matt Munro song. Usually a pair of photos like this depict the same scene or subject from different angles, in landscape and portrait mode, or at consecutive points in time. Other examples of *musical pairs* of photos in the study were a pair of animals taken on the same trip, a pair of buildings found near to each other, and different parts of the same waterfall.

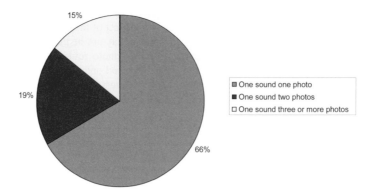

15%

19%

66%

■ One sound one photo
■ One sound two photos
□ One sound three or more photos

Figure 5.7 Audio:Image associations in the musical photo set

Some associations of sound and images involved more than two photos. These tended to be sequences of images relating to the same episode in time or even to an entire photo album. For example, Figure 5.8 shows four photos taken on a trip to Japan, combined with a single song by a Welsh male-voice choir.

Figure 5.8 Four images of Japan set to a male-voice choir

The fact that music was often used to link pairs, groups or albums of photographs together in this way is reminiscent of the use of film music to achieve continuity between shots or scenes in a movie. Conversely the combination of music tracks with individual photographs serves to set them apart from each other, even when they belong to the same set or episode. We turn now to the participants' own reasoning about these choices, and their reactions to the resulting material. This will show how conscious they were of using particular techniques, and what value they perceived them to have.

REACTIONS

Initial reactions

Most people were extremely skeptical of the value of combining music with photographs at the beginning of the study. As the quotes below indicate, they tended not to associate the two media in their minds and struggled to imagine what the combination would feel like. Consequently, the music annotation exercise was performed under sufferance, primarily to please us.

> *"I wouldn't naturally put them together. I'm not convinced" (Rob)*

> *"I don't know. I've been trying to think about it after we talked the last time. I'm looking forward to seeing it because at the moment I can't" (Traci)*

> *"I can't picture it in terms of what we are doing at the moment" (Byron)*

> *"I don't tie up photographs with music specifically. I don't like concerts on television" (Gordon)*

Only two participants spoke favourably about the possible benefits of combining music and photos. One of the older men in the study drew a comparison with film music, while the youngest man of the study immediately saw it as another way of organising and playing his music by its date of release:

> *"If one sees a film with the soundtrack off, however emotional it is, one can watch it fairly dispassionately. But you put the music on with that film and watch it and however stoic you may be, you'll find tears coming into the corner of your eyes or get other emotions. So certainly music can have a terrific effect in that respect and if you could find the right music to go with the photos I could well imagine that it would be more nostalgic, much more evocative" (John).*

> *"It sounds good yes, so I'd choose a song for each photo would I? If you've got a photo during the time you were into that sort of music, like at school or something, that might work" (Nick).*

After reviewing their own music photo albums on the PC for the first time, we asked participants what they thought of them. Most people were pleasantly surprised and a few were positively shocked at how much they liked them. The majority of comments were positive, and mentioned the power of music in capturing a mood or

atmosphere for the photos. This can be seen in the opening quote for this chapter, and in the comments below:

"I liked the music ones" (Traci)

"I thought they worked surprisingly well" (Byron)

"I thought it was really good actually. I think putting pictures and music together does actually work" (Nick)

"I think music does give the atmosphere" (Gordon)

The most dramatic conversion was experienced by Rachel. Rachel was quite outspoken at the beginning of the trial about the lack of appeal of combining music with photos and the difficulty of associating them in her mind:

"It doesn't appeal to me personally really.. I don't necessarily find the photos that I take are evocative of a certain musical experience.. Although some pictures do evoke some kind of music or sounds I wouldn't necessarily want to sit here and have it played at me. Pictures are good enough in their own right"(Rachel)

However, for her album, Rachel chose two family photographs and a series of 4 landscapes. The landscapes were set to classical or choral music that appeared to match the images perfectly. One of these musical landscapes is shown in Figure 5.9. The combined effect of listening to these photographs was to change her mind completely:

'I was impressed. I came thinking I wasn't going to be. The whole concept was quite moving really' (Rachel)

As experimenters, we also experienced something of the same conversion effect. Despite anticipating the potential value of music, rather like John quoted above, and being familiar with ambient sounds and commentary on photographs, nothing prepared us for the range of emotions triggered by some of the families' material. We found John's portrait of his wife Betty shown in Figure 5.6 to be particularly touching, and were amazed at how well Rachel and others were able to match the mood of an image with appropriate music.

Favourites

After reviewing each other's music-photo material in pairs, participants were asked to choose a favourite from each set. They were also asked to write down the reasons for their selections. In this section we concentrate on the selection of personal favourites from people's own music-photos, and contrast this briefly at the end of the section with their selections from other people's material.

Preferences were based purely on aspects of the content, rather than on the type of music, the duration of the clip or the type of sound-to-image association. Two distinct qualities were mentioned as reasons for preferring particular music photos over others. The first was the goodness of fit between the image and the music. Wherever the music appeared to capture and amplify the mood of the photograph it was liked. For example, Rachel liked all her music-photos but singled out that in Figure 5.9 as her favourite. Her reason was that:

"The music and images work together so well. The Rutter music perfectly reflects the mood of the photos" (Rachel)

Figure 5.9 Sunset over the Isle of Skye to 'A Gaelic Blessing' by John Rutter.

A similar reason was given by Byron who chose the Japanese photos and Welsh music shown in Figure 5.8 as his favourite. He singled out the first image of a wooden walkway as working particularly well with the music:

"Because the music seems to fit the tranquil mood of the garden, despite the Japanese/Welsh mix" (Byron)

The second quality that appeared to distinguish favourite music photos was the personal significance of the image or music. The more significant the music or photo, the more it was liked as a combination. For example, the group photo shown in Figure 5.4 was Nick's favourite because:

"Its one of my favourite photos anyway and I thought the music went very well with it" (Nick)

In another example, one participant chose a favourite music photo because of the significance of the music. It was a Christian rock song called *Surrender* and was combined with multiple photographs from a holiday in Italy. The lyrics of the song were important to him because they described his recommitment to God following a recovery from cancer.

In contrasting the choice of favourites from within one's own or another person's music-photo set, we found little consistency of selection. In other words, the same music-photos tended not to be chosen by both members of a pair of participants. Instead, the choice of favourites was highly idiosyncratic. This is understandable in terms of the personal significance of the material, since everyone had his or her own reasons for judging it to be significant to them. For example, Nick's girlfriend Kerry

chose a different favourite from Nick's music-photo album than the favourite Nick chose for himself. Nick chose the shot of his friends shown in Figure 5.4 while Keri chose the shot of Nick shown in Figure 5.10 below. She considered the latter to be a good audio-portrait, much like the favourite ambient-photo shown in Figure 4.11, and felt it captured Nick's personality and love of music well:

> *"It's very real, even though this was taken over three years ago, you will still find him doing this now- everyday!" (Kerry)*

Figure 5.10 Nick on his record decks, set to a DJ re-mix

However, we expected more consistency in the judgement of fit between a photo and a music track. As we discussed this with people later in the feedback groups we found that this too was highly subjective. It depends on the mood they read into the image, which is coloured by their experience of being there in the case of one's own photographs. This might be quite different to what is read into another person's photograph from the image alone. For example, the connection between the music and image in Figure 5.11 is somewhat obscur, but was chosen as the authors' favourite music-photo. To Harry who took the photo, the music went with the mood of East Berlin when he visited it before the fall of the Berlin wall. The multi-lingual cabaret song is both aggressive and inviting, much like the sign and the gateway in the photograph, although these allusions might be difficult to appreciate for someone who never experienced the city at this time.

Figure 5-11 The Brandenberg Gate in Berlin,
set to the film song 'Cabaret'

The value of music

After selecting their favourite music-photos, participants were asked what they liked about adding music to photographs and what they would use it for. Taken together, these responses suggested four key values of music perceived by families in the study.

First, adding music was seen as a way of re-creating and reinforcing the mood of the scene, as experienced at the time of capture. The music for the ocean view and the group of friends in Figures 5.3 and 5.4 appears to have been selected for this effect, as well as the choral music for the images of Japan and Skye in Figures 5.8 and 5.9. It provides a similar value to that of ambient sound in adding atmosphere and bringing the photo to life, although in a more controlled and personal way. This is because music can be selected to be more representative of the *feelings* of the moment rather than of the literal *atmosphere* of the moment, as given by ambient sound. Hence there was a sense for many people that they were often selecting the music for themselves, and that the choice of music was personal and not necessarily to be shared or understood by others:

> *"Well I chose my music for something I liked, something I enjoyed listening to, but also something that would be sort of upbeat and positive and in general reflect the mood of the photos or the place of the photos" (Vicky)*

> *"The music would be evocative of your own feelings at the time and it would be your personal choice. When I go home and show this to my husband he wouldn't necessarily fit those particular pieces of music with this picture" (Rachel)*

*"To me its just a personal souvenir that's been enhanced by the music,
and as such it wouldn't be something that was a showpiece to be put in a
museum or an art gallery. It's something which is personal and helps to
improve it; to make it real" (John)*

As with the use of ambient sound reported in Chapter 4, there was some attempt
to subvert the atmospheric value of music, to create effects that deliberately
conflicted with the mood of the photograph. This led to a second value of music in
creating a new mood for the photo, designed more for amusement or entertainment
value than for capturing a past mood. Harry's Brandenberg Gate audiophoto shown
in Figure 5.11 has something of this value, although the contrasting effect of sound
and image may also be true to Harry's perception of Berlin at the time. In another
example, a pair of mopeds in Italy were set to a piece of opera by Verdi. This was
done by Gordon as a deliberate joke, to undermine the seriousness of Verdi's music
with a modern image, taken near to the place in which the music was first
performed. A more straightforward use of music for entertainment, was also
discussed by Vicky as a way of making the photo album as interesting as possible
for others:

*"Music sort of adds to the dull part. If you are not really into photo
albums you can just sit back and go with the music" (Vicky)*

A third value of music was to evoke memories by association with nostalgic
music of the time the photo was taken. Music associated with a particular holiday or
person was said to have this kind of value, and would remind people of a whole
collection of events around a time period. A good example of this is shown in Figure
5.12.

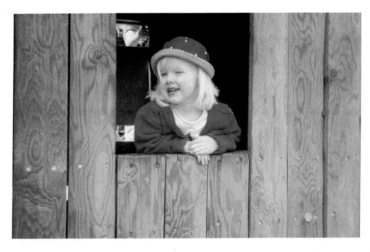

Figure 5.12 A daughter set to the song 'Thankfulness' on a children's video

Figure 5.12 is a picture of Traci's daughter taken on a trip to Bristol zoo, but set to a song from her favourite video of the time. This combination not only makes for a good audio-portrait of the daughter, it also reminds the mother of a period of home life which was punctuated by this music several times a week. Music listened to repeatedly at home, on car journeys and on the radio was also mentioned as having this nostalgic value.

Finally, a fourth value of music was to communicate some hidden message through the music itself. This use of music was surprisingly common in the music-photo collection, and second only to the selection of music to match a mood of the moment. In some ways it is the complete opposite of this latter value, since here the music is designed for someone else rather than for oneself. However, the effects may be just as subtle and poetic.

This can be seen from a series of what can only be described as 'love photos' comprising a picture of the loved one together with a song with romantic lyrics. Figure 5.5 is a good example of this, created by a husband for his wife. A more contemporary example is shown in Figure 5-13 and was created by Nick for his girlfriend. It is a picture of his girlfriend set to the track Wonderwall by Oasis and contains lyrics that might have been difficult to speak to her directly. Other love photos were created by the wives in the study for their husbands, including a picture of Rachel and her husband set to Alison Moyet's *Is this love?*, and one of Jane and Byron set to *Wind beneath my wings* by Bette Midler. We also found that parents sometimes used love songs with images of their children, as with a pair of photos of Jane and Byron's daughter set to *Your song* by Elton John.

Figure 5.13 A love photo, comprising a picture of a girlfriend set to 'Wonderwall' by Oasis

In all these cases, the lyrics of the songs took on extra significance when paired with the photographs, and appeared to speak about the people in the photos. Outside this class of romantic music-photos, we found the same use of music to communicate more subtle meanings. For example, Dvorak's *New World Symphony* was chosen with the ocean image in Figure 5.3 not only for its mood, but also for its connection to the New World:

> *"So I think that goes with that because it is the New World. It's California. Its all the things that go with the States" (Jane)*

PRACTICE

Although participants in the study did not have chance to make their own music-photo albums, the acts of specifying content, reviewing it together and discussing it later gave rise to a number of comments about the album creation process. In this section we examine these comments in the context of what people told us about their existing music and photo practices, to understand how music and photographs might be used together in the future.

Capture

The most obvious way to create music-photos is to annotate existing photographs with music. Indeed this was the method promoted in our study. However, it was mentioned above that a number of participants approached the task of combining music and photographs somewhat differently. In particular, some of the music enthusiasts in the trial pulled out favourite pieces of music to combine with favourite photos. This shows that it is possible to approach the combination of music and photographs in two ways, either by adding music to photographs or by adding photographs to music. Both views are represented in the following two quotes. These indicate the spread of opinion on whether photographs or music should be the primary medium. Eventually, these views could lead people to capture photographs or music differently, in order to improve the match with the complementary medium

> *"As Byron and I have both said, if we'd had more time we'd have picked something more appropriate. But its definitely the photograph itself which is the centre point. It's not the talking or the music – those are purely supplementary" (Jane)*

> *"This is what I was getting at before. Sometimes you've got to approach it from one side, sometimes the other. If you've got a definite visual image in your mind then you may decide to fit music to it. If you've got a definite musical image, say the 20's or something like that, then you might find a photograph of the Charleston going on, to fit with the music. It depends which point you are making" (Gordon)*

The majority view was that photographs were the primary medium, as expressed in Jane's quote above. In this context, three scenarios for adding music emerged from the discussions. Most participants in the trial captured many more photographs than they ever got around to putting in albums. The best of these were quickly

reprinted and distributed to close family and friends, or slowly archived in a chronological album. In addition, the photo enthusiasts in the trial, tended to draw on their best photos to make themed albums or scrapbooks based around specific trips or events. Some of these were given away as personal gifts. Each of these photographic creations might benefit from music, which could itself be added at the time of creation. Hence, music could be attached to a reprint at the point of sending it to a friend. Alternatively, music could be selected for attachment to an album or scrapbook at the point of its physical assembly. The challenge here would be to support music selection and capture in a way that does not add too much time to the album-making activity, and in a format that can be integrated with the selected photographs. Another approach would be to turn the album-making activity into a social event, so that people could enjoy spending time together selecting and playing music for their photographs. This idea was suggested by Rob in the study, who was aware of the way his wife hosted album-making events:

> *"I know one of the things which works well in what Traci does, is that most of the people that want to make albums just don't have the time. So once a month they all get together and glue together. So it's sort of a social thing. You've got ten people round the table with all the tools. I don't know how possible that would be to have ten people working on this at the same time" (Rob)*

Finally, people said very little about the practicalities of music selection and digitisation in the trial. Selection was *felt* to be difficult, although people managed rather well to locate suitable music tracks from within their own music collections. This activity sometimes involved a search for a particular track within an identified genre or album, and might have benefited from computer assistance. Digitisation was not mentioned because the trial methodology did not require participants to digitise their own music. This is currently being made easier for consumers by digital media players which can copy music from an audio CD for personal use. Digitisation from records or cassette tapes is not so easy and involves connecting a record deck or tape player to a computer for copying. Such difficulties may decrease in the future if personal music collections become centralised in a digital file-store, and connected to commercial music services on the World Wide Web.

Editing

Participants seemed pleased with their music-photo albums for the most part, and expressed few desires to change them. The main comments made about editing related to cropping the music clip to focus on the most important part of a track for the desired effect. Many of the classical pieces were considered to be far too long on playback, and even some of the more contemporary songs had long introductions that could have been cut out. For example, Nick expressed a desire to cut straight to the chorus of one track while Jane noted that they never reached the opening lyrics of another:

We also found that the one-at-a-time presentation of photographs used in most of the albums was annoying to the photo album enthusiasts who were used to arranging multiple prints on a page. In fact Traci and Vicky both requested a small number of multi-photo screen pages for their own audiophoto albums. They might have

increased this number if they had been able to manipulate the layout themselves and view the effects.

Review

At the beginning of each Feedback group participants were given the chance to view their music-photo and talking-photo albums together. This was usually done between pairs of people who knew each other, although Rachel and Rob were exceptions to this since they had never met before the study. We also had Jane, Byron, Nick and Kerri share two sets of albums together in a foursome. For any pair or group, the photographs were usually of events not shared by the other parties. However, Jane and Byron and John and Betty created joint albums of photos whose memories they both shared. This meant that we were able to record a rich set of interactions around the material, representing all the possible sharing combinations shown in the diamond framework in Figure 3.5.

By examining these interactions and participants comments about them afterwards we quickly discovered that the review of photographs with music was very different to the review of photographs with voiceover. The main difference was in the ability to talk over music but not voiceover:

"We didn't talk over the voices, we just talked over the music" (Jane)

Indeed, not only was it possible for participants to talk over the music-photos, the music seemed to positively encourage this. As in the lively reminiscing conversations observed with ambient sound photos, we found that the review of music-photos was animated and noisy. The musical atmosphere appeared to break the ice between those who didn't know each other so well, and generally improve the ambience of the occasion. This was true for reminiscing conversations *and* storytelling ones. In contrast, voice-photo review sessions were very quiet and subdued, as all parties paused to listen through to the recorded comments (see Chapter 6 for further details).

The style of music-photo review was as follows. We noticed that the owners of each album tended to take control of the mouse and decide when to turn each page. In reminiscing conversations both parties made occasional comments or exchanged questions and answers while listening to the music and looking at the photos. These conversations contained short periods of silence between comments, as participants absorbed the album content. In storytelling conversations, the album owners took the initiative in telling the story of certain photos. These stories were prompted and steered by the audience, as in ordinary photo talk (see Chapter 7). One minor difference was that the music itself was sometimes noteworthy, and was allowed to run to the end of a bar or phrase before being curtailed.

However, for the most part, the kinds of stories that were told were similar to the comments recorded as voiceovers for the talking-photo albums. This was illustrated most dramatically by Jane and Byron, who happened to use the same photographs for both types of albums. They reviewed their music-photos first with Nick and Kerri, telling the same stories as were heard later on their talking-photo album. The similarity was so striking that Jane often skipped through the talking-photo album

without letting the comments play through because she had just said the same thing live to the background music.

An example of a live and recorded story on the same photograph is shown in Table 5.1 below. The photograph itself is shown in Figure 5.14, together with its accompanying music clip. This type of conversation around music-photos meant that the music tended to be listened to for the duration of the talk on each photograph, rather than for the duration of the music track itself. From a rough calculation on each music session, the average length of time spent listening to each track was about 40 seconds rather than three minutes. This fits with the average duration of recorded voice commentary, which was about 30 seconds (see Chapter 6). This commentary was inflated here by about 10 seconds worth of prompting and reaction from the live audience.

Figure 5.14 A daughter set to 'Your Song' by Elton John.

Live story to music-photo	Recorded story in talking-photo
{**Verse**: *If I was a sculptor but then again no*} **Jane**: *This was before we moved house to (Henley) cottage, and we were clearing out the roof. And we found, what was* **Byron**: *My grandfather's top hat and silver topped cane.* **Jane**: *That was when leg warmers were in* **Kerri**: *Yes I was going to say they look warm.* **Jane**: *Look like (ballet) shoes don't they?* {**End of chorus**: *My gift is my song and this one's for you*} (32 seconds)	**Jane**:*This is one of my favourites and this is at our previous house and just before we were due to move. We went up into the loft and found all sorts of bits and pieces, including Byron's grandfather's top hat and silver topped cane. No sooner as we got them down and they were used for dressing up purposes as these things always are. Rhiana was four and a half at this stage and immediately dressed up alongside her fashionable gear, i.e. leg warmers, and proceeded to do a song and dance routine in our conservatory.* (40 seconds)

Table 5.1 A live and recorded story told for the photograph shown in Figure 5.14 (Jane)

Comparisons with home video

On the whole, participants in the audio annotation trial did not connect the music or talking photos they created with home video. This was in contrast to the audio camera trial in which it was natural to compare the camera to a video recorder. Here, participants viewed what they were doing as an extension of photography and a way of enhancing photograph albums. The most common comment about audio annotation itself, was that both music and voice annotation should be supported on the same set of photographs. This issue will be taken up again in the next chapter:

> *"To make it even better it would have been ideal to have it in together, music and voice" (Vicky)*

> *"I thought as a medium it worked, but not to separate voice from music" (Gordon)*

When people were prompted to compare music-photos and talking-photos with conventional home video they tended to express a preference for the photographic medium. This is revealed in the following quotes which echo the sentiments of the comparisons made in Chapter 4. The effects of combining music and voices with photographs were seen as more professional than those obtained by capturing ambient sounds on moving images.

> *"The (audiophotos) looked better. I suppose the only videos I've looked at in this setting are home videos and they're chronic aren't they? This is much more professionally put together, much more effective' (Rachel)*

"Its like someone saying 'Now for a little video set'. It's great for five minutes, wonderful if you are a grandparent, maybe and hour – but after that, no. But if you have actually snapshot it and put it to music, you've got two interest points. You're actually telling people about it, which is why journaling is so important for photo albums, and music sort of adds to the dull part" (Vicky)

DISCUSSION

This investigation began with a sense that ordinary people might be rather good at selecting music for photographs, and that this would entail engaging with the kinds of concerns held by film composers in designing music for cinema. It was also assumed, from the Desert Island Discs radio show, that music would have a variety of personal meanings for people, and might stimulate private nostalgic feelings or more intimate social interaction.

In fact, many of these starting assumptions were borne out in the results of our study. We found that despite an initial scepticism about the music selection task and their own abilities to perform it, participants were surprised at the quality and power of the music-photos they produced. Perhaps the most impressive aspect of this finding was that the music was selected 'blind' so to speak, without playback or sampling with the photographs, and only reviewed sometime later when the two media streams had been assembled according to specification. The results are likely to improve further with the ability to review music-photo combinations on the fly, and with the benefit of experience.

As in the case of selecting funeral music, participants in the trial were sensitive to the aesthetic effects of the music, and to its symbolism for the audience in mind. The selection and discussion of favourite music-photos revealed that people were concerned to match the mood of the photographs and music aesthetically, and to choose music of personal significance to them or others. This significance factor was sometimes determined simply by how much they liked the music, but more often than not there was a deeper and more symbolic reason for selection, such as its association with past listening contexts, or with its title and lyrics. This meant that the connections between the music and the person selecting it were idiosyncratic and as potentially revealing of personality as those observed on Desert Island Discs. However, in contrast to what happens on this show, participants in the trial rarely discussed their reasons for music selection when reviewing music-photos with others. These connections remained implicit in the material, and it was left to the audience to work out the meaning of the music against a backdrop of conversation about the image. This gave the music-photos a certain poetic and cinematic feel to them, particularly when viewed in the absence of the author.

The cinematic analogy is appropriate not only to the music-photo material, but also to the mindset of the participants. They tended to look at their sets of photographs as sequences of images, and used the music either to tie short sequences together or to set individual photographs apart. As with professional film composers,

participants were able to choose the music to reinforce the primary emotions of characters in the scene, or of themselves as photographers. They were also able to trigger new secondary emotions in the audience for the photographs, as in the creation of joke music-photos. Some participants even voiced film music composition concerns about which medium should come first when combining music and images, and began to ask for the incorporation of other kinds of sounds, such as voiceover, in the overall sound design.

The role of music in personal image review

Regarding the prediction that music may enhance a personal memory for a photograph, we found this to be true in two ways. In some of the music-photos, participants used nostalgic music, listened to around the time the photographs were taken, to remind them of that period. This appeared to work best for people when there was a history of repeated listening, as with theme tunes of regular TV programmes or popular music played on the radio. In these cases, an individual's memory for the scene depicted in the photograph appeared to be enhanced by association with music of the time.

Another form of memory enhancement was through the use of music to match the mood of the scene or characters in the scene, including the photographer. This was the most common use and value of music in the study, and served to 'colour' a photograph with the emotion of those who were present at the time. This is an altogether more intimate function than the attachment of nostalgic music or the capture of ambient sound of the moment, since it goes beyond the recording of sensory stimulation to reflect the inner feelings of the moment. To the extent that it is does this successfully, we can speculate that mood music will heighten the sense of retropresence to the past scene for those involved, and amplify the memories that follow.

Further benefits for the personal review of images were provided by music of other kinds. These benefits went beyond the enhancement of memory, into the realms of entertainment and communication. Pure entertainment value was delivered by music that *didn't* match the mood of the moment but created some other mood in the audience for the photograph. This was observed in a number of joke-photos. Communication values were realised by music containing hidden messages in the title or lyrics. These were most commonly seen in love-photos designed by men or women for their partners or children, as illustrated in Figures 5.5 and 5.13. Such messages were usually designed to travel between the photographer and the subject of the photo, although with practice, we can imagine others being designed for a more general audience.

Indeed, the interpretation of photographs by those not present at the time was also improved by music. At one level, the entertainment and information values of the photographs were simply increased by the additional medium - making them more interesting. But at a deeper level, participants appeared to recognise from their own behaviour, that there was some method to the selection of music for photographs, and that this method often involved re-creating the mood of the moment. To this extent, even complete strangers in the study were able to review

each other's music-photos with noticeably more interest and potentially more *empathy* than usual.

Given the benefits of music for photo interpretation, it is unfortunate that this behaviour would be inhibited today by music copyright law. Creators of musical photographs comprised of published music tracks could not send copies of such photographs to others without breaking the law. This increases the urgency for some form of micro-payment system for copies of full music tracks, or for a change in the law to accommodate different forms of music and multimedia consumption. One possibility here would be to waive charges for *partial* music tracks used with photographs, since participants in the trial either selected fragments of a track or only listened to full tracks for a fragment of their duration. In recognition of this particular use of music, I have chosen to use only one minute samples of the music photos cited in this chapter within the accompanying CD-ROM.

The role of music in social interaction

The possibility that music might enhance social interaction around photographs was also realised in the trial. It appeared to liven up both reminiscing *and* storytelling conversations, which occurred over the top of the music itself.

Part of this effect may have been due to the influence of music in any social setting as a method of raising the atmosphere and as a catalyst for conversation. As proof of this influence, imagine a party without music. However, as we have seen from the previous section, the personal impact of specific music on the photographs at hand went beyond the playing of party music on a home hi-fi. This experience was more akin to the viewing of film music and images, with all the associated emotions.

The particular effect of music *annotations* on photo sharing may therefore be to trigger precisely those emotions that are appropriate to the story of each photograph. This may serve to stimulate story-telling or simply to elaborate it in a non-verbal way. The use of music in this supporting role to conversation, was exactly what we observed in the miss-match between the duration of each music track and the length of time it was listened to. Listening time was tied directly to the duration of conversation about corresponding photographs, and usually fell well short of the duration of each track.

Talking photographs

"Spread before you your photo or photos, memorabilia and any notes. Ask yourself this critical question: 'If I am to give voice to this material, what would I have it say?' Think in terms of what information is important to capture for sharing with the next generation. Focus on what you value, and let your insights help you determine where to put your emphasis" (Campbell Slan 1999, p77).

While most of us find it difficult to enough to sort our photographs into conventional albums, a small but active community of people in the United States pursue the hobby of scrapbooking. This is referred to in the quote above, and involves the use of photos and other memorabilia to tell life stories in scrapbooks. Scrapbookers use special paper, glue and plastic covers to preserve the photographs in their books, they personalise the presentation of materials by cropping and decorating the pages in various ways, and handwrite labels and stories in the margins. In this way the scrapbook is designed to stand alone as a document for future generations in a family to review as a piece of family history. An example scrapbook page taken from Joanna Campbell Slan's book, cited above, is shown in Figure 6.1.

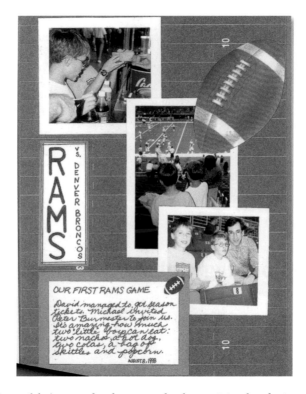

*Figure 6.1 A page of a photo scrapbook containing handwritten notes.
(Figure 7.10 in Campbell Slan 1999)*

A related hobby to scrapbooking is journaling. This involves writing down one's life experiences as a way of expressing thoughts and feelings and documenting one's life story. Hence the journal itself is usually more personal than a scrapbook, and designed primarily for authors themselves to read later in life. More important than the product, is the process of producing it, which is said to be therapeutic and life enhancing (e.g. Weldon 2001).

In this chapter we consider whether some of the personal and social values of writing in journals and scrapbooks might be captured in talking photographs. That is, if it were made possible to record voice labels or commentaries over photos, would people use this capability to capture their life stories for themselves, or record accounts of their family history for others? And if they did that, would others want to listen to the results?

An additional consideration of the chapter is the *ease* with which voice annotation might be done, compared to writing. We note that scrapbooking and journaling are specialist hobbies and not part of the common practice of domestic photography. In contrast, talking about one's photos to others is an integral part of

this practice as we have seen in Chapter 3. Furthermore, storytelling and reminiscing in conversation appear to confer all the same practical and therapeutic benefits as personal history writing (c.f. Haight 1995, Harvey 1996). If verbal storytelling skills could be harnessed more easily around photographs, either by voice annotation when photographs are first reviewed, or by recording subsequent photo-sharing conversations, then the practice and benefit of personal storytelling might be brought into the realm of domestic photography. This chapter examines the prospect for voice annotation while Chapter 7 examines photo-conversation recording.

RELATED WORK

Previous attempts to record voices with images fall into two categories. First, *voiceover narration* is often used in fiction films and documentaries to complement the visual storytelling. Second, the use of voiceover narration with photographs is also finding its way into emerging forms of *digital storytelling*, in which digital technologies are used to record personal stories.

Voiceover narration in films can be done from the point of view of a character in the film, or of an outside commentator on the story scene (c.f. Kozloff 1988). An example of 'first person' narration by a character is the voice of Philip Marlowe in the famous detective films. His voice was used to set the scene and communicate his own thoughts and feelings about the unfolding case, as in the following quote:

> *"The joint looked like trouble, but that didn't bother me. Nothing bothered me. The two twenties felt nice and snug against my appendix".*

Other examples include the reading of a letter shown on screen in the voice of its writer, or to preface a flashback or flash-forward in the story.

An example of third person narration by an outside onlooker is often to be found at the beginning and end of a film to introduce the story and draw conclusions from it. In the following quote, the invisible narrator introduces the main character of the film and sets up the rest of what follows as 'his story':

> *"His name was Jeremiah Johnson and they say he wanted to be a mountain man. Story goes that he was a man of proper wit and adventurous spirit suited to the mountains. Nobody knows whereabouts he came from but it don't seem to matter much... This here's his story".*

Other third person narrators are used in news programs and documentaries to flesh out the details of events and explain their meaning. Because such narrators appear to know more than the characters in the events, can travel to different events in space and time, and are never seen on camera, they may be referred to as the *voice-of-God*. In some documentaries the voiceover is combined with camera movement over a still image. For example, in programmes on the American Civil War, group photos are often used as a backdrop from which to describe historic characters or events.

All these techniques add an extra dimension to visual storytelling that plays on the time course of the story, and the relationship between the characters, the storyteller and the audience. All voiceovers create a kind of secret complicity and

intimacy between the storyteller and the audience, and the origin of the voice defines whether they lie inside or outside the story-world.

A few attempts have been made to apply these techniques to digital photographs. In a recent study of an electronic photo viewer, Balabnovic, Chu & Wolff (2000) asked people to organise their own photographs into sequences over which they could narrate a story. The system allowed users to do this in a number of ways. These included selecting an existing chronological set of photos as a basis for voice annotation (photo-driven), or assembling a new set for the story at hand (story-driven). It also allowed users to narrate after the photos had been selected or to begin speaking first and select photos within the ongoing narration. The authors found that everyone chose to select photographs before narrating over them, at least one photo in advance. However, as they selected the photographs, users often moved between a photo-driven and a story-driven style of storytelling. For example, they might start recording comments on an existing set of photos, but then be prompted to bring in other photos to elaborate a story. A further finding was that users did not use the voice recording facilities when showing their photographs to others face to face, nor did they record voice comments for their own use later. They preferred to explain the photographs live in conversation, and only resorted to recording a voiceover when asked to select photographs to send to remote family or friends.

Finally, a story-first approach to photographs and other memorabilia is used in an ongoing movement to encourage 'digital storytelling' (Lambert & Mullen 1998). This is really a form of scrapbooking using digital and screen-based technology rather than paper and pens. The movement arose from the work of the late Dana Atchley who was a solo performer and storyteller based in San Francisco. In the early 1990's he developed a one-man show called *Next Exit* in which he used digital media technology to project photographs and home movie clips as a basis for telling personal anecdotes. This approach was subsequently embraced and adapted by others in the area, to encourage more private forms of storytelling with digitised photographs, video clips and voice narration. A particular adaptation was to capture aspects of the verbal story within a digital scrapbook or presentation. To this end Joe Lambert and Nina Mullen set up the San Francisco Digital Media Centre in 1994, and continue to run workshops teaching business and community groups how to do this. A recent book of their experiences has been published, although it lacks detail on exactly how people choose to use voiceovers in their digital scrapbooks (Lambert 2002). For example, we cannot tell what voice, content or structures are used in voiceovers recorded at the workshops, or what relationship they have to other visual media. The same details are also missing from the analysis of user behaviour in the study by Balabnovic et al (2000).

These issues are now taken up with reference to the audio annotation trial introduced in the last chapter. Having already described the findings for music annotation, I focus here on how participants chose to combine voiceover narration with photographic content.

THE AUDIO ANNOTATION TRIAL

Nine people were presented with the ability to record voiceover content on their photographs in the context of the audio annotation trial described in Chapter 5. Essentially, voiceover recordings were made during a home visit, on a small selection of photographs. These were later assembled into PC-based 'talking photo' albums, alongside additional musical photo albums and demonstrations, in preparation for a review session in HP Labs Bristol. Details of the overall study methods and music album procedures are given in Chapter 5. However, it is necessary here to clarify the procedure for voice recording during the home visit.

Participants were instructed to select a set of about 10 photographs that might benefit from voice annotation. They then worked through the photos in order, speaking comments they wanted to associate with particular images or groups of images. These comments were recorded on minidisc as part of the ongoing record of the interview, and were later extracted for digitisation and association with the corresponding images. We also kept a log of these associations on a two-column form, detailing individual photos by name and the topic of any connected comments. Some participants planned the outline of what they were going to say in advance of recording, but most simply began speaking and recorded their comments in a single 'take'. All participants were given the chance to listen to their voiceovers, but most listened to only a small fragment and declined to change anything. The fact that we remained present in the room throughout the recording session may have led some participants to bias their comments towards our own interests and status as strangers, although we stressed the importance of choosing a target audience of their own for the recordings.

Analysis of the talking photo set, together with participants' reactions to it, is described below. As before, these data are treated separately and in order, according to the section headings used to report the findings on ambient and musical photos.

TALKING PHOTOS CAPTURED

Nine talking photo albums were created in the trial. These were made up of 105 voiceovers on 112 photos. The majority of associations between voiceovers and photos were therefore one to one, as discussed below. However, as with the musical photographs, there was great variety in the audio material used and in the intentions behind the creation of each album. Some albums were used to tell the story of a single family trip. Others were used to relate interesting aspects of favourite photos, or to comment on the importance of various people in a photo set. Because the methodology involved sharing these creations with others, participants got to see at least one other person's material in full, and the demonstration albums showing a cross-section of audiophotos from everyone. They were also able to discuss their views on these materials in a group. This method was effective in circulating different opinions about the value of voiceover, and generating some consensus by the end of the process. In this section I try to represent the variety before working towards the consensus in later sections.

Types

Figure 6.2 shows the kind of things discussed in the 105 voiceovers recorded in the trial. This was based on a content analysis of what people mentioned in each voiceover. We found that most of the basic questions that can be asked of an event or scene were covered in the voiceovers. These questions include Who, What, Where, When and Why. These topic categories were not mutually exclusive. This meant that several topics could be mentioned in the same commentary, and explains why the percentages don't add up to 100. Each percentage should be read on its own as an indication of the proportion of voiceover clip mentioning a specific topic. For example, in 60% of voiceovers, participants described *who* was in the photograph. The only question we couldn't map onto the recordings was 'How?'. The method of doing something in the photo was seldom discussed, or was incorporated into a more general description of 'What' was happening. Instead, we found that an additional question was addressed concerning the author's *emotional* relationship to the photo. Hence in 60% of voiceovers, people gave a value judgement about how they or others felt at the time, or now feel about the photograph itself. This is an interesting discovery in view of the importance of emotion in music annotation. It suggests that here again, voiceover might be used to attach emotion to a photograph as well as to describe factual details of the depicted scene.

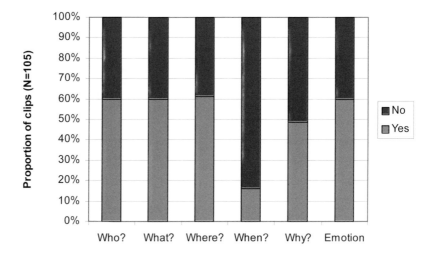

*Figure 6.2 Content analysis of voiceovers recorded over photographs*Four talking photographs are shown in Figures 6.3 to 6.6. These illustrate the ways in which various questions about the photographs are addressed in the voiceovers.

Figure 6.3 is the talking version of Figure 5.14 in Chapter 5. In fact the voiceover itself is transcribed in column two of Table 5.1. It is Jane's story of her daughter's hat and cane discovery whilst clearing out the loft before a house move. As such, it

involves a reference to every question that can be asked about the photograph, including the author's emotional relationship to it. This makes it one of the most complete and complex voiceovers in the collection.

Figure 6.3 A story addressing all the
questions of the photograph

The following question topics are addressed by the voiceover for Figure 6.3:
- the subject of the photo is Rhiana when she was four and a half (*Who?*),
- the activity she was engaged in was dressing up with Byron's grandfather's hat and cane (*What?*)
- the photo was taken in their previous house (*Where?*)
- the photo was taken just before they moved from the house (*When?*)
- Rhiana was dressing up was because they had discovered the props whilst clearing out the loft (*Why?*)
- the photograph of Rhiana is one of Jane's favourites (*Emotion*)

Note that the questions are not addressed in order, but rather worked into a chronological story form beginning with Jane's evaluation of the photograph. Details of the time and location are not literal, but relative to other times and

locations, and the fact that Rhiana is Jane's daughter is not given in this particular voiceover because it was introduced in a previous one. A final complexity is that the story is told in two voices. The discovery of the top hat and cane is told in the first person as a joint activity, while Rhiana's dressing up behaviour is reported in the third person. In general, the 1st person voice is used in 57% of voiceovers. This figure rises to 77% if the speaker is a subject of the photograph.

Figure 6.4 is another example of a voiceover addressing multiple questions about the photograph. However, this time, it is not so clear who is depicted or when exactly the photograph was taken. Also, the voiceover is not structured as a story. Instead, it takes the form of a series of observations about the most striking feature of the photo; which is the fact that everyone is wearing the same 'tank top' sweater. Thus, the main activity is said to be "*Us looking very smart with our tank tops on*", during a holiday in Malia. The broader context for wearing them and taking the picture emerges later in the voiceover. They were bought cheaply as a gift by one of the group and worn for at least three nights out on the town, of which this was "*a particularly good one*". The point of the voiceover is not really to tell the story of the tank tops being purchased and worn repeatedly, but to use the joint wearing of the tank tops as an example of how *together* they were as a group and how much fun they had. In fact, the fun elements are underscored by no less than four separate references to positive emotions in the voiceover, while togetherness is emphasised by narration in the first person.

Figure 6.4 Details of a group activity in the first person

Figure 6.5 gives another indication of the complexity and richness of voiceovers recorded in the study. As in the previous two examples, the voiceover addresses some of the standard questions that can be asked about the photograph. The

difference here is that those questions relate to two distinct time periods in which the scene was visited; the current time at which the photo was taken and previous times *"when my children were small"*. In other words, the voiceover incorporates a *flashback*. In the first part of the narration John talks about the difficulty of capturing the particular view of the bridge and village shown in the photograph. Through this account he is able to say where the photograph was taken and something about why. In the second part of the narration John goes further back in time, to talk about a previous habit of coming to the same place with his children. In this flashback he uses a past participle in the first person with phrases like *"we used to take bits of bread and throw them in the stream"*. With this technique John describes a new set of actors and activities for the scene that are not shown in the photograph, but are triggered by it. This example shows that photographs can be used to talk about memories associated with any aspect of their content, and may not necessarily relate to the time the photograph was taken.

Figure 6.5 Flashback to an activity that used to occur in this location

The practice of speaking about things outside the photograph at hand is also illustrated in Figure 6.6. This is our final example of voiceover types, and relates to a picture of gun turrets in an Albanian landscape. It is one of a series of photographs of a trip to this country by Rob in the trial. Although some of Rob's other voiceovers are more personal and descriptive of people and events in the pictures, this one is not. Instead it talks about the gun posts in the image and the fact that they point inward towards the population rather than outward towards the sea. Where, what and why questions about the image are covered in the voiceover, but in a way that describes the politics of the country rather than Rob's personal memories of the scene. Insofar as they can be counted, these kinds of externally-facing voiceovers

accounted for about 18% of those recorded in the study. These included other stories about the character of a country or its citizens, and references to the personalities of people in the photographs.

Figure 6.6 An externally facing voiceover about the politics of Albania

Durations

The length of voiceover clips varied from a few seconds to a few minutes as shown in Figure 6.7. However, the average duration was 29 seconds, with 95% of all clips lying between eight and 50 seconds. These figures are similar to those found for ambient sound clips in the audio-camera trial, but considerably shorter than the three-minute music clips also observed in the audio annotation study.

The talking photographs already shown in Figures 6.3 to 6.6 are a fairly typical length. The voiceovers in Figures 6.4 and 6.6 are around 30 seconds long, while those in Figure 6.3 and 6.5 are somewhat longer (41 and 60 seconds respectively). The one-minute narration in Figure 6.5 is due to the fact that two stories are told about the photograph, one for the time it was taken and one in flashback. These parts could almost be separated into two separate voiceovers of about 30 seconds each. Other long voiceovers have this multiple story form, although sometimes it is from the contributions of two different speakers. For example, the talking photo shown in Figure 6.8 has a 66 second voiceover with contributions from both Byron (46 seconds) and Jane (20 seconds) about their mutual friend shown in the image.

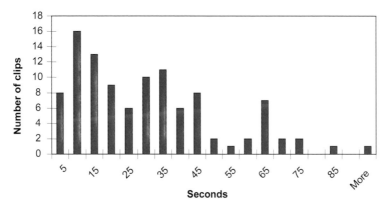

Figure 6.7 The duration of voiceover sound clips

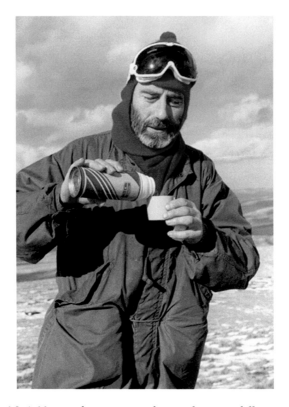

Figure 6.8 A 66 second voiceover with parts from two different speakers

At the other end of the spectrum, some voiceovers were under 10 seconds long. These tended to be simple voice labels for the photographs, such as you might write on the back of a print. An example of one of these is shown in Figure 6.9. This is a picture of Buckingham Palace in London with a seven second voiceover saying so. Voice labels of this kind typically addressed only one of the questions shown in Figure 6.2 - usually either Where or Who.

Figure 6.9 A short seven-second voiceover serving to label the photograph

Another reason for very short voiceover recordings was that they were embedded in a narration relating to a series of photographs. Individual portions of this narration still related to particular photographs, but were short. They could also cut in at the beginning or cut off at the end. This issue concerns the relationship between the voiceovers and the photographs, and will now be explored in the next section.

Associations

The majority of sound and image associations for the talking photo set were one-to-one. Hence participants recorded a single voiceover for a single photograph in 94 percent of cases. For this reason I have not included a graph of associations, as in previous chapters. Many of the voiceover recordings were self-contained stories or reflections on the photographs, as in most of the above examples. However, sometimes these stories were designed to fit together across photographs, even though their individual parts still bore a one-to-one association with constituent photographs. An example of this is given in Figure 6.10, which is the first part of an album describing a trip to Disneyland. After a scene-setting voiceover on the first photograph in the set, Vicky recorded a series of shorter voiceovers describing individual Disney characters encountered on the visit. Note that the recorded speech

on each photograph is understandable in its own right, but works better when viewed in the context of the series. In rare cases, we found that the speech on individual photographs could be truncated at the beginning or end of each clip and therefore become less understandable on its own. This is actually true of Figure 6.9, which is a voice label embedded in a longer account of a trip to London. If you listen carefully to the opening of this clip you can hear the talking begin in the middle of a sentence. We decided not to classify these voiceovers as one sound to many photographs unless authors expressed an intention to have the speech run over more than one photograph at a time.

(a) (b)

Figure 6.10 The first two talking photos for a trip to Disneyland

Where participants did express a desire for a voiceover to run over more than one photograph, it was always in the context of requesting more than one photograph per screen page. The album enthusiasts Vicky and Traci did this more than others in the trial, since they were used to arranging multiple prints on a single photo album page. An example of one of Traci's screen-based versions of this with voiceover is shown in Figure 6.11. The voiceover relates to two photographs taken inside Hamley's toy store in London. It therefore falls into the six percent of one sound to many photo associations in the talking photo set.

Figure 6.11 A talking photograph with a voiceover relating
to two images simultaneously

REACTIONS

Initial reactions

The idea of recording voice commentary on photographs was less alien to participants than the notion of attaching music. Nevertheless, they expressed some skepticism about its value, and a certain amount of dismay at having to record their own voices. Most people said that they didn't like the sound of their own voice, but would be happy to listen to the voices of others:

This prejudice continued beyond the recording process at home, and coloured the participants' initial reactions to the talking photograph albums in the Feedback Groups. In general, they preferred listening to other people's talking photos than to their own. This also made them also more inclined to favour their own music photos over their own talking photos. Both effects are apparent in the following quote by Nick:

> *"I preferred the music photos. It might have been because it was my own voice though. I think Jane's sounded better than mine" (Nick)*

However, the physical sound of one's own voice was only one reason for this preference for other people's voiceovers. In fact, several people said they got used to hearing their own voices after a while. Another reason was that the content of other people's talking photographs was simply more interesting. By definition, participants already knew the content of their own talking photographs, and were naturally more interested in what other people had to say about *their* photographs. This was revealed in a number of comments questioning the point of recording voiceovers for yourself, and praising the voiceovers of others:

> *"You know in your head the memories that you have of that particular holiday, so you don't need the voiceover" (Rachel)*

> *"I felt the photographs with the commentary were much more interesting than the music because it enabled me to see what Nick was thinking and feeling at the time" (Jane)*

Alongside the preference for other people's talking photos, was a realisation that one's own talking photographs would be more interesting to other people, and especially to those who weren't present at the time the photograph was taken. This was stated directly by Gordon in the trial, when asked if it was worth the effort of recording voiceovers on his photographs.

> *"It depends on whether the person I'm showing it to was with me at the time I took the photo, because if they were there, there is no point to all the explanation. I would do this to show to people who weren't there at the time" (Gordon)*

For others, the same realisation was expressed in terms of a shift in the intended audience for their talking photographs. When asked at the home visit who they were recording the voiceovers for, participants were evenly split in saying they were for themselves or for their close family and friends. However, when asked at the Feedback Group who they thought would benefit most from the albums, they tended to mention only geographically distant family and friends:

> *"I would send it. We've got an uncle that lives in the States so if we'd been able to send him something like this to look at the kids, a self-explanatory thing, that would be good" (Rachel)*

> *"I would use it more to send to people than to sit someone down" (Traci)*

Favourites

After seeing the talking photo material for the first time, participants voted on their favourite combinations from their own and each others' albums. They also wrote down the reason for these choices. There appeared to be three main reasons for selecting favourites from any album. These included the personal significance of the photograph, the interest of the voiceover, and the mention of emotion.

As with the selection of favourite music photos, the *personal significance* of the material was important to the selection of talking photos. For example, some participants chose a favourite talking photo from their own set because they simply liked the photograph and its associated memories. This could be seen in the selection of favourites by three of the mothers in the trial who selected talking photos containing images of their children. Jane chose Figure 6.3 showing her daughter with the hat and cane, Traci chose Figure 6.11 showing her daughter and nanny together at Hamleys, and Vicky chose an audiophoto of her children meeting Mini Mouse at Disneyworld. A similar choice was made by John, who chose a talking photo about his grandchildren. Figure 6.12 shows Nick's favourite talking photo of his girlfriend Kerry who was also present at the feedback group. Kerry also chose this audiophoto as her favourite, perhaps as much for the personal significance of what Nick said about her in the voiceover, as for the image itself. Note that this is the talking version of the same photograph that is set to music in Figure 5.13.

Figure 6.12 Nick and Kerry's favourite talking photo of Kerry

The *interest* of the voiceover was also used as a criterion for selecting a favourite talking photo. This was a slightly different criterion to the *fit* between sound and image, which was important to the selection of favourite music photos. It seemed to have more to do with the form and content of the voiceover itself. For example, Jane selected Byron's talking photo of a Japanese temple, simply because *"Byron's description is so clear and interesting"*. This voiceover is contained within Figure 6.13, and is the counterpart to a musical version shown in Figure 5.8. Byron himself chose a favourite talking photo of a friend's daughter from his own album *"Because it describes the picture so well"*. In a final example, Rachel chose Rob's talking photo of the Albanian gun posts shown in Figure 6.6 as a favourite for the following reason:

> *"It's a gorgeous photo in its own right, but the message behind it is so telling" (Rachel)*

The mention of value or *emotion* in the voiceover also seemed to increase its attraction and the likelihood of selecting it as part of a favourite talking photo. This could be seen statistically in content of voiceovers selected as favourites from participants' own albums. Seventy eight percent contained references to the emotion of the image or scene. This compares with an incidence of 60 percent in the rest of the corpus. However, additional evidence came from the *reasons* for selection, which often referred to the fact that the voiceovers revealed something about how the author was feeling or thinking at the time. This was expressed by Rachel as a reason for selecting her own favourite talking photo, shown in Figure 6.14. The photograph was significant to Rachel because it contained the image of a cross. The voiceover allowed her to explain this significance and therefore to reveal something of her own faith and personality.

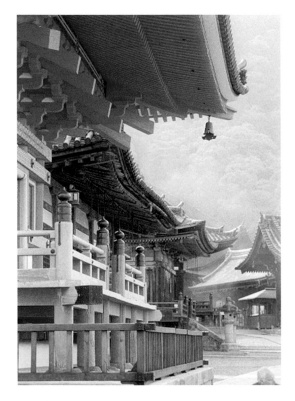

*Figure 6.13 A favourite talking photo comprising a voiceover
to a Japanese temple*

The value of voiceover
From discussion of the talking photo material in the Feedback Groups it became apparent that participants attached different values to voiceover, depending on whether it was theirs or not. If they were the author, they valued the ability to personalise the photographs or add a message to someone else. If they were the audience, they valued the way in which the voiceovers added interest and interpretation to the photographs, and revealed the personality of the sender.

In the first case, we have already seen how a voiceover was valued by an author for the way that it allowed them to *personalises* a photograph. This was introduced above, in connection with Figure 6.14. Rachel's favourite talking photo shown in the figure was actually a self-portrait in which she appears in both the photograph and the voiceover. In her case, she liked the voiceover because it allowed her to speak about her faith.

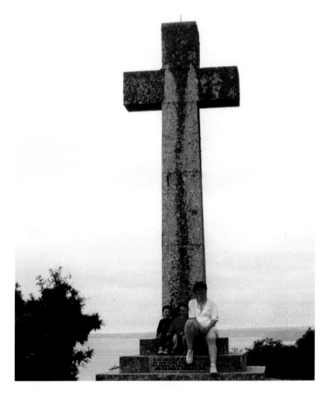

Figure 6.14 A self-revealing talking photo

Equally personal voiceovers were recorded on images that did *not* contain the speaker (see for example Figures 6.3 to 6.5). These can also be seen as self-portraits of a sort, in which the speaker can enter the life of the photograph through the voiceover. Clearly they are most revealing when the author speaks about their own feelings, thoughts or beliefs. However they are also revealing even when such things are not mentioned, simply because of the way the voiceover is spoken. This can be seen in Rob's Albanian gun post voiceover in Figure 6.6, whose content is impersonal and doesn't mention emotion. His voice itself is still full of character, and serves to personalise a photograph that is utterly devoid of people and life. In this way, voiceovers came to act as *voice signatures* for photographs, through which people could reveal more or less of themselves to others, depending on what they 'wrote' into the recording.

Writing is actually a good analogy for how people used and valued voiceovers as a communication medium. Again for authors, voiceovers were seen as another way of *adding messages* to photographs, akin to writing a letter to send with reprints, or journaling in the margins of a photograph album page. In both these situations, the writing explains the reason for sending a photograph to a particular audience.

Voiceovers did a similar job for their authors. They also appeared to give authors a chance to voice thoughts and feelings that are hard to articulate face-to-face. For example, Traci told us that she designed her favourite talking photo in Figure 6.11 as part of a series for Rebecca her nanny who is shown in the picture. On an earlier photo she stated that Rebecca came over from the States to help out during a period when Rob was ill, and *"was very much an encouragement to us"*. This choice of words, and their location within a series of happy photographs taken during a sad time, underscores the value that Traci placed on Rebecca's help, and constitute a kind of multimedia thank you card. Although Traci had tried to tell her this directly, she felt that the talking photographs would be more effective in communicating her feelings:

This kind of subtle communication is similar to that observed for some of the music-photos that communicated a hidden message in their lyrics. The most direct use of music for this purpose was in love photos of the kind shown in Figure 5.5. The same phenomenon was observed again in talking photos such as Nick's message to Kerry in Figure 6.12 and John's talking version of Figure 5.5 to his wife, shown in Figure 6.15. This shows the same image of Betty's face, accompanied this time with some of John's thoughts about her. For people who may find it difficult to talk about their feelings for their partners directly, voiceovers like this may provide a more natural alternative to letters, email or text messages.

In the context of receiving photographs voiceovers were seen to *add interest* to photographs that might have been more boring on their own. This was mentioned directly by John who was thinking about being handed a large pile of someone else's holiday photos to look through. In this scenario he seemed to judge the talking photos to be more interesting than a live explanation by the author, although the majority of participants felt that their greatest benefit was realised when the author was absent. There may also be an overall enhancement of interest by virtue of selecting certain photographs for annotation, thereby filtering out the least interesting ones. Finding out more of the story of the photo and the memory of the author appeared to be the key sources of interest added by voiceover:

> *"This to me is part of the boredom when people get their holiday photos out and they bring out a big pile of envelopes with hundreds of photos in. Whereas with this, as we have all been saying, it seems that the voice makes it more interesting" (John)*

> *"In Vicky's the music was excellent, but it needed the voice to tell me what was going on" (Traci)*

Discovering the thoughts and feelings of the author in relation to the photographs, was the final value of talking photographs to those receiving them. This is the flip side of the value of expressing such feelings by senders. There were many indications that participants liked this revelatory aspect of the voiceovers, not least of which was the use of this criterion in selecting favourite talking photos (see above). But perhaps the most succinct comment on this value came from Betty who noticed that the playback of a voiceover on a photograph shifts the receivers' attention from the photograph to the speaker. To this extent a talking photograph

raises questions not only about the scene and what is happening within it, but also about the person recording the voiceover on the scene and their relationship to it:
 "With the voice you immediately think of the person that's speaking"
 (Betty)

Figure 6.15 A spoken love photo from a man to his wife

PRACTICE

The ease or otherwise of recording and using talking photographs is discussed in this section. Some initial judgements are made from observing the process of voice recording during the home visits, and the process of reviewing the results during the feedback groups. Participants also made comments about their likely use of the medium after the review sessions.

Capture

On the whole, participants took easily to the role of recording voiceover on their photographs. This was despite their professed dislike of hearing their own voice on

playback. Recording may have been made easier by our presence as strangers in the house, since we inadvertently became a live audience for their commentaries. However, participants were encouraged to think of another, more realistic, audience for their comments, and seemed to have little trouble in visualising someone and thinking of something to tell them.

The real problem was in selecting the right someone, and the appropriate set of photographs to annotate. I have already noted above that there was an initial tendency for participants to record voiceovers for themselves or their close family, such as children and partners. Once they had seen the results of these attempts, they reported wanting to shift their audience to distant family and friends. This can be seen in terms of the three album contexts for annotation mentioned in the discussion of music capture in Chapter 5. Attempts to annotate chronological photo albums with voiceover were judged less successful than attempts to annotate sets of reprints or themed albums to give away. Future voice annotation would therefore be directed towards the latter two contexts, as illustrated in the following quote:

> *"Its probably just like a gift to someone. That's what I would use it for"*
> *(Traci)*

In the context of designing talking photos to give away, participants made two kinds of suggestions for enhancing capture. Either the voice comments could be made more spontaneous by capturing them along with the photographs on camera, or they could be made more professional by scripting voiceovers recorded later. The first suggestion might be more appropriate to reprints, while the second would enhance themed albums or scrapbooks:

> *"If I was taking a role of film and I could talk and say something about the photographs, then I might want to do that" (Byron)*
>
> *"I'd record it at night when the kids were in bed. I would probably sit down and write down what I wanted, then record" (Vicky).*

There was also a feeling that a sequence of photos worked better for voiceover and needed to be selected carefully before recording. This was encapsulated in a discussion between Traci and Vicky in the study. Vicky used a series of photographs of her children with different characters at Disneyworld for her talking photo album, while Traci used more of a mixed set relating to different days out. Both women judged Vicky's album to be more effective because it told a single story over the photo set.

> *Traci: "I mean it sounded like I was just saying it off the top of my head, whereas Vicky's sounded like a story"*
>
> *Vicky: "I think my photos probably helped compared to yours, because yours would have been hard to carry a theme through or create a dialog that was sort of a continuous story"*

Editing

Apart from the observations made above about capturing talking photos differently, participants said very little about editing them. Most voiceover recordings were done in one take, and were judged good enough to use in their original form. This finding on the acceptability of voiceovers should not be

surprising, since it is the very same attitude that participants had to their photographs. While some photos were judged better than others, few were judged bad enough to require modification.

What was requested was the ability to combine voiceover with music on the same photographs. This was mentioned briefly in the context of reporting the music findings, and demands further attention here. This combination can be seen as quite a natural thing to request by people who were asked to review the value of music and voice annotation in the same study. Some of these people even experimented with putting both types of sound on the same set of photographs and could directly compare the effects. These included Byron and Jane, John and Betty, Gordon, and Nick. Aesthetically, combining these effects leads to interesting results such as those shown in Figure 6.16. This figure combines the music and voice parts already shown separately for the images of Betty in Figures 5.5 and 6.15. The sound mix can be heard on the accompanying CD-ROM for Figure 6.16 and contrasted with the sounds for the other two figures. Functionally the mix is more compelling than the individual sounds, since voice and music serve to personalise a photograph in different ways and communicate different kinds of information about the associated mood and memory.

The main problem with combining music and voice has to do with the relative loudness of each and the difficulty of listening to both tracks together, especially when there are lyrics in the music track. This can be experienced directly, by listening again to the audiophoto in Figure 6.16. Participants acknowledged this interference problem in responding to an extra music-and-voiceover album we had made up from Jane and Byron's albums. This highlights the need for careful sound balancing in mixed tracks, and perhaps for manual controls at playback that could be used to change this balance interactively.

Review

The presence of voiceover on a photograph tended to inhibit conversation around it, when participants tried to share their albums with each other. This was in stark contrast with the review of musical photographs which seemed to stimulate conversation. In a typical session, the author of the talking photo album would control the turning of each screen-page, in time to the ending of each full voiceover clip. While the voiceover played, participants would listen quietly, waiting until the end to make further comments or ask questions. This pattern was broken only in rare cases where the same photograph had been seen before as part of a music album, and the author had already told the recorded story live (see again Table 5.1).

Figure 6.16 Musical and talking photo of Betty by her husband John

This kind of review behaviour meant that participants tended to look quietly at each talking photograph for about 29 seconds – the average duration of voiceovers themselves. However, because of the wide range of clips around this time, some pairs of participants spent far longer staring at a single image in silence. The record was achieved by John and Betty who listened patiently to John's verbal description of their association with a waterfall for 103 seconds. This is a long time to sit without talking in any social setting, and is made all the more noticeable by the fact that their focus of attention was on a single static image.

To put this into perspective, the average pause length in conversation is usually one second (Jefferson 1988) while the average duration of a *moving* image shot on television is about five seconds. So the tendency to suspend conversation for so long around a photograph is very unusual indeed, and must be due to some powerful social force at work. One possibility is that participants were treating the voiceover *as* conversation. They would therefore tend to wait for its contribution to finish before speaking themselves. This is in marked contrast to something like watching the television, where speaking over television voices appears to be more acceptable.

DISCUSSION

In short, the opportunity to record voiceover on photographs was welcomed by participants in the trial, despite some misgivings about the sound of their own voices. Everyone had a lot to say about the photographs they selected and were keen to experience what a talking photograph would feel like. However there were various problems with voiceovers which limited their usefulness to listeners.

For example, the content of voiceovers did not always tell the story-of-the-photo in Berger's terms (Berger 1982a). Stories were something that participants strived for in the activity of selecting and commenting on their photographs. But they were not always evident in what they actually said. Typically, participants would answer two or three classes of questions about each photograph, such as who was in it, where the photo was taken and what was happening. Furthermore, when they did describe a temporal sequence of events, this was just as likely to refer to a period covered by multiple photographs or not really covered at all (for example with a flashback), as it was to refer to the local period of time in which the photo was situated. These accounts could also be told in the first or third person. In short, any voiceover pointed to the *context* for a photograph, but it could do this at any level, from more than one perspective, and in more or less detail depending on the intended audience. This kind of selective description was identified by Rachel in the trial, at the end of her voiceover on the stone cross of Figure 6.14. She concluded by saying:

> *"So that was a potted history, a snapshot of our time in Cornwall"*
> *(Rachel)*

The notion that a voiceover is itself a snapshot of all the things that *could* be said about a photograph is reminiscent of work by Sacks (1970) on the news-worthiness of stories in conversation. By analysing the presentation of news in conversation, he found that what is news to one audience is common ground to another. Speakers are aware of this and act to select, mark and phrase information interactively, in order to maximise its news-worthiness.

Participants in our study appeared to do something similar with their voiceovers, giving a *version* of what could be said which they believed would be news to the intended audience. This arrangement worked well as long as the intended audience was someone else who could be clearly visualised at the time the voiceover was made. However, if the intended audience could not be visualised, or was the author him/herself, the voiceover was less newsworthy and effective.

In the worst cases, it was impossible for authors to record any version of events that was not already known to them. This made them disinclined to use voice annotations for archiving photographs for future personal use. This is despite the fact that they might benefit from such annotations long term, when their own memory for events fails. One way out of this paradox might be to archive voice annotations recorded for others, within a personal photo collection. These might be used to retrieve photographs from the collection and to remind authors of forgotten details with the passage of time. A similar technique has been developed for collecting text annotations from email messages with photo attachments (Lieberman & Liu 2002).

Role of voiceover in personal image review

Thus, although voiceovers were recorded for almost all the uses of photographs shown in the diamond framework of Chapter 3, participants settled on one use above all as having the highest value. This was the ability to add personal and contextual details to a photograph in order to aid its *interpretation* by a remote audience. This finding explains why the ambient commentary in the audiocamera trial was felt to be less valuable than ambient environmental sounds. Participants in that study tended to use such commentary as a voice label for themselves rather than as a voice message for others, and were consequently disappointed in the results. In both trials, voice labels were not found to enhance the memory of a photograph for the people involved. This pattern of findings is similar to that observed by Balabanovic et al (2000) using different methods. In their study, subjects only recorded voiceover on photographs they imagined sending to others.

The reason for these effects becomes clear when we consider the specific reported values of voiceover in our study. A talking photograph was perceived by its receivers to be more interesting than a silent photo and to be more revealing of the thoughts and feelings of its author. These were the end-user benefits. In addition, the authors and senders of talking photographs valued the way they allowed them to 'frame' a photo with contextual information and to personalise it with something of themselves. Such personalisation could be done directly, by including a direct emotional reference to how the author felt about the image or activity depicted. It was also done implicitly by attaching the author's voice itself as a signature or self-portrait of sorts. These dual benefits of voiceover to senders as well as receivers imply a value to the processes of recall and recognition of an image, as well as to its private interpretation (see again Figure 3.5). However, this value has more to do with the representation of the self to oneself and others, than with the remembering of the event itself. Voiceovers then, appear to influence the communication and interpretation of images, and this can be just as much of a benefit to senders as to receivers.

Role of voiceover in social interaction

Despite the benefits of voiceovers in the interpretation of photographs, they were found to be less than useful in live social interactions. Their presence was found to inhibit conversation around photographs. This led to the bizarre situation of two or more participants staring at a photograph for long periods of time while listening in silence to recorded voice comments. Because speakers are so sensitive to the shifting interests and responses of recipients in conversation, live commentary on a photograph is likely to be altogether more newsworthy and interesting than recorded commentary.

This may also go some way to explaining the frustration with ambient sound in the audiocamera trial of Chapter 4. Many of the ambient sound clips included voice commentary and recorded conversation. Participants found it difficult to talk over these, especially in storytelling conversations. Any ambient commentary arising in these situations would therefore be more difficult to talk over because of the competition between live and recorded explanations.

Conversational photographs

"Had I showed for example all my wedding photos – I'd have had a summary of the day from my perspective which in years to come would be a nice memory for me or an interesting story for our daughter" (Brid, Storytelling photograph study)

Imagine for a moment you are a photograph. You would have a pretty interesting social life for an object. You will be conceived instantaneously in an environment of ambient sound and activity. You will be born into a family with at least one parent, either at hospital (the photo processing lab) or at home (the home photo printer). Your family will fuss over you at birth, passing you around and talking about your resemblance to people and things in the past. Then you will get proudly shown off to family and friends who will comment on your charm and good looks. Eventually your novelty will wear off, and you will be put to bed for a while, possibly in your own space (album), until such time as one of your parents decides to wheel you out with your brothers and sisters to see how you are getting on, or to show you off again at social gatherings. If you are really lucky, you will get to stay out forever (frame) to attract the comments of visitors. Granted this is something of a shallow life, which revolves around appearances and gives you very little scope for initiative. But hey, you don't have to go to school or work, and you still get to meet a lot of interesting people and make a variety of friends for life.

This scenario illustrates for domestic photography what Schaverian (1991) means by the *life of an image* in art therapy. I have represented this life as lines of social interaction around a photograph in the diamond framework of Chapter 3 (Figure 3.5). These lines show that there is a sonic environment around printed photographs which is every bit as rich and varied as that which exists around the original experience that the photograph represents. Just as we can choose to preserve the original ambient sound context of this experience with the photograph, so we can choose to preserve the later sound context – not once, but many times during the life of the photo. Although the later sound contexts may include ambient sounds, they are likely to contain a greater proportion of conversation, this time about the photograph or experience itself. I call this kind of conversation *photo-talk*, to distinguish it from ambient conversation around the time of image capture. Just as we considered the properties and value of ambient photographs in Chapter 4, we now consider the properties and value of *conversational photographs*, by which I mean photographs combined with recordings of photo-talk.

Because photo-talk occurs spontaneously around photographs and contains conversation about the images, it serves as a free source of voiceovers. Given the benefits of voiceovers described in the previous chapter, at least in aiding the interpretation of photographs by a remote audience, it would be useful to capture them automatically. This would overcome the time and effort required to consciously record voiceovers for each new set of photographs. In the example above, perhaps the conversation between family members about a new photograph, could be recorded and transmitted with the photograph itself to remote family and friends. Alternatively, perhaps a collection of conversations around a single photograph could be recorded and kept with the photograph for future personal reference by the author or subject. These possibilities are explored here and contrasted with previous findings on the properties of voiceover on photographs.

The approach to studying conversational photographs is somewhat different to that used to study other kinds of audiophotos. The use of a single trial methodology is possible, but would affect the very behavior we are trying to study. It would involve asking people to share photographs with each other, and then to select parts of the recorded conversation to keep with the photographs for posterity. The ensuing conversation might be very different from that which would have taken place spontaneously without intervention. A more suitable approach would be to record spontaneous episodes of photo-talk, and then to ask participants to identify those parts of the conversation they would like to keep with the photographs involved. This is a considerable challenge, since an experimenter would either have to be on hand to do this sporadically over long periods of time, or delegate the tasks of recording and selecting to participants themselves.

In fact, a variation of both approaches is reported here. A study of naturalistic photo sharing was used to examine the character of photo-talk itself, and its potential to serve as an effective form of voiceover for the photographs involved. The findings also establish a basic understanding of ordinary printed photo sharing against which to evaluate comments on print-based and screen-based methods of sharing audiophotos in the next chapter. Participants in this study were asked to fill

in photo-diaries tracking the occurrence of photo sharing conversations over a three-month period, and to record as many conversations as possible on audiotape. A subsequent laboratory study of photo sharing was used to assess the value of recording particular kinds of conversational photographs identified in the first study. Participants here reviewed a video of their photo sharing session and ticked off, from a contact sheet, those photographs for which they would have like to have saved the corresponding conversation. To set the scene for both studies, I briefly review existing work in this area, in order to build on what is already known about these sorts of conversations.

RELATED WORK

While almost nothing is known about photo-talk itself, a related form of talk without photographs has been extensively studied. I will refer to this form as *conversational storytelling*. This involves telling stories of one's own or other people's lives in order to make points in the course of a conversation. This is one kind of talk amongst many that have been studied within the fields of sociolinguistics and conversation analysis (Goffman 1981, Drew 1994). The relevance of conversational storytelling to photo-talk will become clear as we apply what is known about it to a common sense view of storytelling with photographs. I present this view as a 'straw man' theory about photo-talk that is de-bunked by the work on conversational storytelling, and by work reported later in this chapter.

Thus from any experience, such as a holiday abroad, people may take photographs to remind them of the things they did. Any individual photograph can trigger a memory of what actually happened and this can be used in conversation to illustrate a story describing the course of events. Because the photograph always indexes the same event and memory, it should lead to roughly same story being re-told time and again in different conversations. Furthermore, because the order of photographs in a set usually corresponds to the order in which they were taken in time, the stories they trigger will tend to be narratives describing the unfolding of activities over time. I will call this account the *slide-show model of photo-talk*, because it suggests a single person standing up before an audience and taking people through a series of photographs and memories in a fixed presentation. Although the audience might call out questions of clarification from time to time, or gasp in amazement at twists in the storyline, the presentation would run its course until the last photo had been explained. In fact this model is implicitly assumed in current digital photo sharing applications. They usually distinguish between an ad hoc photo browsing mode for personal use, and a more linear slide-show mode for presentation to an audience. Stories are assumed to be cued by the presentation, and to unfold with the photographs.

Conversational storytelling turns out to be an altogether more difficult and complex achievement. In the first place, the storyteller must find a way of introducing the story in the course of an ongoing conversation and phrase it in such a way as to reach a conclusion. Failure to do so would result in the storyteller being

perceived as mad, rude or self-indulgent, and the point of the narrative would be lost (Polanyi 1985). Consequently there is usually 'entrance' and 'exit' talk in the course of telling a story in conversation that marks it out from other activities such as remarks, questions, requests and so on. This marking is particularly important if the story is to take more than one turn, since it forestalls the listener from interrupting the story in its telling (Sacks, Schegloff & Jefferson 1974). Sacks (1968a, 1974) describes the talk which does the initial marking as a *story preface*, and shows how it sets up the listener to listen for a certain point in the story's completion. For example, in the following story preface, a woman (A) gets ready to tell her friend (B) about a car wreck she saw on the freeway (see Figure 7.1). However, the point of the story is that it was not reported in the local paper. The relevance of the paper is introduced at the outset of the story. Consequently, B does not respond to A's initial question about reading the papers in the second turn. She waits until the story of what happened on the drive to Ventura is completed with "It wasn't in the paper last night, I looked" some nineteen turns later (not shown). In each of these examples the figure labels are used to introduce a number of conventions for transcribing talk, developed within conversation analysis. Only those which are helpful to the analysis are used. For further details of these and other transcript conventions see the opening sections of Atkinson & Heritage (1984).

```
A: Say did you see anything in the paper last night or hear
   anything on the local radio, Ruth Henderson and I drove
   down to Ventura yesterday
B: Mm hm
A: And on the way home we saw the:: most gosh-awful wreck
B: Oh::::
```

Figure 7.1. A story preface (Sacks 1968b).
A colon (:) indicates drawl on the last syllable before it.

While the introduction of stories relating to photographs might be prefaced by the presentation of a particular photograph, it is unlikely that this act alone would perform all the subtle work of a conventional story preface. It is much more likely that any stories about photographs will be embedded in a stream of non-story talk, and require introduction and conclusion in the usual way.

Another finding about the conclusion of stories further complicates this picture. In conversation, people often tell *second stories* in response to a first. A second story not only demonstrates that they have been listening and understand the point of the first story (Sacks 1968b), it also serves as a form of reciprocal self-disclosure (Duck & Pittman 1994, Sprecher 1987). For example, in response to the story prefaced in Extract 1 above, B offers the second story shown partially in Figure 7.2. It describes her witnessing a different disaster and also failing to find it reported in the papers. Although these stories are not full of intimate life details, their exchange serves to maintain a friendship between these two women that includes sharing their observations and questions on life (c.f. Duck 1994). In the context of a friendship, a one way sharing would be strange. The telling of a series of (first) stories from

photographs without allowing the audience to respond would also be strange, especially if the audience is well known to the storyteller. Photo-talk then, might be more or less littered with second stories by audience members. These would have nothing to do with the photographer's memory of events but everything to do with the audience's memory of similar events and observations.

```
B: You know, I looked and looked in the paper- I think I told
you f- for that uh f-fall over at the Bowl that night. And I
never saw a thing about it, and I   looked in the next couple
of evenings.
A: Mm hm
B: Never saw a th- mention of it.
```

Figure 7.2. A second story preface (Sacks 1968b).
A dash (-) indicates a word cut off in mid-flow.

So far we have seen that stories about photographs, as about anything else, might be embedded in a stream of talk that includes non-story talk, introductions to the stories, conclusions or punch lines, and second stories told by the audience. A final set of findings from the literature shows that individual stories themselves are subject to variation within and between tellings. This means that the same story may never be told in the same way twice. This has to do not only with the influence of the audience on the story, but also with the influence of the storytelling on the author's memory for the story.

From any event it is possible for people to generate a wide variety of accounts or descriptions. This can be seen from witness statements to the police following a crime, or from the verbal accounts of crimes in courtroom interactions (Atkinson & Drew 1979). In fact, the system of cross-examination in court can elicit quite different accounts of the same event from the same witness, depending on the choice of words and line of questioning used (Drew 1985). In general, people try to design their versions of events to be relevant and understandable to the person they are talking to, and that person usually cooperates with them to understand what they are saying. (Grice 1975). These two factors of *recipient design* and *audience participation* work together to shape the account or story that is told for any event.

Stories are further affected by the presence and participation of others who share the memory of the story subject. In fact, where two or more people share the memory, the story is often told collaboratively with input from each of them. A brief example of *collaborative storytelling* is shown in Figure 7.3. This shows part of a joint account of the film ET, being generated by a group of undergraduates who have just watched it (Edwards & Middleton 1986). Instances of this kind of talk are challenging for theories of human memory which overlook the role of other people in the process of remembering. They are cited as evidence for new theories of *collective remembering* which suggest that memory itself can be reconstructed and shaped through storytelling with others (Edwards, Potter & Middleton 1992, Edwards 1997). Eventually, people may come to believe more strongly in the stories they tell of an event than in the memory of the event itself (e.g. Tversky & Marsh

2000). They may also learn to recognise and participate in the re-telling of familiar family stories as a way of fostering group rapport and passing on family values. Norrick (1997) has called this *re-membering*, because it involves the strengthening of family or group membership through the joint re-telling shared stories.

```
Karen:  Elliott is sitting at his school desk and they are doing
        experiments with frogs are they
Diane:  and he lets all the frogs out
        {General hubbub of agreement}
Tina:   sets all the frogs out yeah
Lesley: and what's that little girl that he fancies
John:   it's when he's watching E.T.'s watching television and John
        Wayne kisses the heroine in the film
Diane:  oh so Elliott kisses [her
John                         [and then Elliott kisses the little
        girl
```

Figure 7.3 Collaborative storytelling about the film 'E.T.'
(Edwards & Middleton 1986). Square brackets([) on consecutive lines
are used to indicate overlapping speech

Only two published studies have attempted to look at these kinds of behaviours in the context of storytelling with photographs. One of these was mentioned in Chapter 6 in connection with recording voiceover on digital photos (Balabonovic, Chu & Wolff 2000). This study also included a 10-15 minute period of face-to-face photo sharing using a handheld photo viewer. Participants were found to move between a 'photo-driven' and a 'story-driven' method of sharing photographs. Either the photographs themselves appeared to trigger the conversation or the conversation suggested a story that might be illustrated with new photographs. This begins to place the style of talk somewhere *between* a slide-show and ordinary conversation.

The focus on photo selection in this study obscured analysis of the conversation itself, and lacked consideration of story prefacing, second stories and audience participation. The use of pairs of participants also excluded the possibility of looking at collaborative storytelling, in which two or more people tell a shared story to others. An earlier study of printed photo sharing between parents and young children, aged between 4 and 6, discovered some of these phenomena operating in photo-talk (Edwards & Middleton 1988). For example, parents acted to bring the children into a conversation about the past events represented in the photographs, increasing audience participation and encouraging collaborative storytelling. The main shortcoming of the study was the fact that the setting was not characteristic of ordinary photo sharing situations with a variety of adults and children of more equal status in the conversation.

In the next section, I describe a new study of photo-talk recorded in situations with just this kind of diversity. The aim of the study is to see whether the findings of studies on conversational storytelling apply to photo-sharing conversations, or whether the latter are special in some sense, because of their dependence on

photographs. This will reveal the extent to which the slide-show model applies, in spite of known phenomena that cause speakers to mark and change their stories for the audience at hand, and listeners to collaborate, steer and respond to stories in various ways. The implications of the findings will then be used to target particular kinds of photo-talk that might be recorded as free voiceover for photographs. A follow-up study is then reported which elicits reaction to the use of this kind of talk in conversational photographs.

THE PHOTO-TALK STUDY

Eleven families in Northern California were interviewed at home about their photo organisation and sharing practices (Frohlich, Kuchinsky, Pering, Don & Ariss 2002). Each family owned a personal computer, and at least two of the following three digital photography products: a scanner, a digital camera, and a photo-quality printer. In addition, they used at least 10 rolls of conventional film a year. These criteria ensured that the participants were involved in both analogue and digital photography and could answer questions on both subjects in the interviews.

At the end of the interviews, families were given photo diaries and audio tape recorders with which to record subsequent photo-sharing conversations. The diary comprised a simple table in which each row represented a single photo-sharing episode, and each column entry represented a piece of information about it. The information was written in by hand, and included details such as when and where the episode took place, the name of the photo set, whether the photos were in loose or album form, the names of the other participants, and whether they were present at the time the photos were taken. Families were asked to fill in one entry in the diary each time they got their photos out to share with someone, or each time someone else presented their photos to them. They were also asked to tape record these conversations if possible, with the permission of the other people involved. This procedure was followed by each family for a three month period over the Christmas of 1998.

Some basic properties of photo-talk are evident from the resulting diary data. This will be reviewed first before examining the details of the recorded conversations themselves. This approach is similar to that used in Frohlich, Chilton and Drew (1997), in which various quantitative aspects of a set of conversations are used to motivate the qualitative analysis of individual conversations.

BACKGROUND FEATURES OF PHOTO-SHARING CONVERSATIONS

A total of 127 photo-sharing conversations were recorded in full in the photo diaries. This amounts to about one conversation a week for each family. The majority of conversations involved collections of printed photographs, despite the fact that families were using digital photography products. This can be seen in Figure 7.4, which shows the proportion of different types of photographs shared.

Most sessions involved either loose prints or prints in albums, with only 7 recorded episodes of screen-based photo sharing. This suggests that participants may have been printing out digital photos to share them face-to-face, in preference to sharing them on the PC or the camera itself.

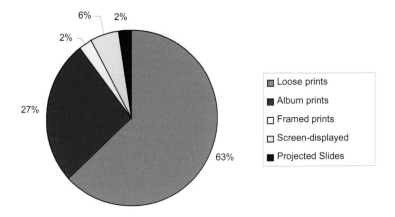

Figure 7.4 Proportion of conversations using photographs of different forms

The form in which photographs are shared is likely to influence the kind of conversation that takes place around them, since this will affect how many people can see individual images at the same time and who can take control of them at any point. Other contextual factors that may influence the conversation include the location in which the photos are shared and the number and type of participants. On these dimensions we found that eighty two percent of conversations took place in participants' homes; usually in a kitchen, dining area or living room. The average number of participants present was four. These people tended to be family (40%) or friends (50%) rather than acquaintances (10%).

A final feature of these conversations was recorded for its relevance to the diamond framework in Figure 3.7 and turned out to be a critical factor in the ensuing talk. Participants were asked to indicate in the diary, whether or not each partner in a photo-sharing conversation shared the memories represented in the photographs. This effectively determined whether the conversations involved reminiscing or storytelling. The findings are summarized in Figure 7.5. We found that the majority of conversations involved reminiscing between people who had all been present at the time the photographs were taken, while a sizable minority involved storytelling with people who had not been present at that time. An additional discovery was that a third set of conversations involved a mixture of reminiscing and storytelling because they included more than one person of each kind. Typically a couple sharing the memories of the photographs would show them to another couple.

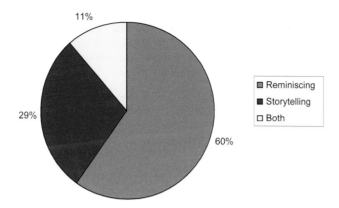

Figure 7.5 The proportion of reminiscing and storytelling conversations with photographs

While this picture of photo-sharing may not be representative of the full spectrum of domestic photographic practices, it does resonate with what has been reported by other methods (e.g. Chalfen 1987). In the next section we go beyond both interview and diary self-reports of photo-sharing, to examine the content and dynamics of photo-talk from those conversations recorded on tape.

THE CONTENT AND DYNAMICS OF PHOTO-TALK

The character of the recorded conversations was dramatically affected by whether or not the participants shared the memory of the events depicted in the photographs. Essentially, stories of the photographs emerged only in the storytelling conversations, or in the joint storytelling-and-reminiscing conversations, between people who did not all share the memories represented by the photographs. Together these conversations made up forty percent of the total number of conversations recorded in the study (see again Figure 7.5). In the remaining sixty percent of reminiscing conversations, participants tended to make a series of short remarks and observations about the photographs. These were often directed towards finding the memory together, only to leave it unelaborated once it had been discovered.

An example of this kind of reminiscing talk is shown in Figure 7.6. This conversation took place within a family of five who were looking over a new set of prints developed from an old roll of film. It was Christmas 1998 when the conversation was recorded. The main topic of the conversation was deciding when the photos were taken. Each member of the family chips in their own contribution to this topic, often in the form of questions, until the family as a whole arrives at an estimate of Christmas 1996. Many of these contributions are difficult to hear because they are made in overlap with an existing speaker (shown in square

brackets). Although the question of 'When?' the photographs were taken is addressed by this talk, it is done so in a way that is both protracted and unclear. Furthermore, the participants did not go back to address other questions about individual photographs shown in the conversation: making it altogether unsuitable as a form of voiceover on the photographs themselves.

```
Mar: No :   you know what? is that last, year's, presents?
     though?
Emm: Yeah those are last [ y e a r : s : . ]
Joh:                     [What's that big b]ox
Nie: Yeah well we must have had that roll in there
     fe[r a long ti[me]?
Emm:   [No that's la[s ]t °years.°]
Mar:             [ JO::HN? ]don'[t  bi]te my shoul:der:]
Joh:                          [sorry.] I didn't bite yu-]
Mar: Yes you di::[d
Nie:            [But loo-]
Emm:            [That's la]st years because these  are  in
     yuhknow thuh fireplace:
Joh: But we had um
Emm: They're normally li[ke
Mar:                    [Uh granma n' granpa's stockings are
     there
Nui: Was that the y[ear we had two? christma]sses?
Emm:               [ Was that  last year ]
Mar: That was two years ago
Nie: It was [christmas ninety si]x then
Emm:        [ Two  years  ago ]
Mar: Yep cu[z (granma prop]er) [poppa didn't come] this
Joh:      [ Y E S c u z-]      [ c u z-  m o m ]
Mar: la[st chr]istmas=
Joh:   [ m o m]
Joh: Thuh calenders
Mar: Uh [ha]
Nie:    [Ye]ah (0.4) the do[:g wasn't even full grown ]
Mar:                       [I didn't do calenders last] year
Joh: Ri:ght
```

Figure 7-6 A reminiscing conversation about some old Christmas photographs.Speech spoken loudly is shown in capitals.

One reason why a range of questions are not addressed in reminiscing conversations is that the participants already know the answers to most of them. In fact, telling the story of a photograph to someone who was with you when you took it would be bizarre, unless they had forgotten the event altogether. Even in these cases, there is evidence that people are reticent to explain a photograph directly. This can be seen in Figure 7.7, which shows a fragment of conversation between two sisters, Jenny and Clare. They are looking at photographs of Jenny's daughter's birthday party at which they were both present. Jenny has forgotten **why** she is shown making a phone call in one of the photographs. Instead of telling her, Clare feeds her clues about the event that cause Jenny to remember that she was phoning

her daughter's new pager. In this way, the two sisters arrive at the answer together. This kind of collaborative question-answering is typical of reminiscing conversations, but tends to stop short of collaborative story-telling itself. The instruction to "Remember" is used here as elsewhere to encourage others to find and rehearse their own version of events from memory rather than to listen to someone else's version.

```
Jen: What am I doing making a phone ca:ll? why would I take
     that picture [look at those thi:ghs ]
Cla:               [ O h  t h- o::h ]do you remember what
     you're doing here?
Jen: No.
Cla: Think for a second Valerie's birth[da:::y?]
Jen:                                    [OH: yeh] Valerie got
     her new uhm  pager that she want so badly un I was pagin'
     her
Cla: U[ h u r? ri:]ght? uhu?
Jen:  [that's right]
Jen: That's why you took a picture with her makin' a phone call
```

Figure 7.7 A reminiscing conversation in which one person prompts another to
remember why a photograph was taken

In the absence of storytelling about the events depicted in photographs, reminiscing talk tends to focus on individual questions of context, on the superficial appearances of people and things in the photographs, or on the technical features of the photographs themselves. Question-answering has already been illustrated in Extracts 7.6 and 7.7. An example of commenting on appearances is shown in Extract 7.8. Dan compliments Marjorie's appearance in one of the photographs and Marjorie objects and finally diverts attention to another photograph. This is a common response to compliments, but should not be taken to indicate that the compliments are unwelcome (Pomerantz 1978). Other things people commented on included subjects taken from unusual angles, how people and things have changed, the exposure, focus and composition of a photograph, and the camera equipment used. Again, these subjects are unlikely to make good voiceover clips for photographs.

More promising voiceover material can be seen in the storytelling conversations recorded in the study. These include conversations in which there is also an element of reminiscing (shown as 'Both' in Figure 7.5). In these cases, some account of the activities taking place in the photographs is often given to those who were not present at the time. However, as we shall see, these accounts were not presented routinely for each photograph as the slide show model of photo sharing might suggest. Instead, they were often triggered by audience interest in a particular photograph or by a turn in the ongoing conversation that made an account relevant at that point. As in storytelling without photographs, accounts or stories of photographs were often marked at their beginning and end, modified according to audience interest and participation, told collaboratively with others who did share the memory, and followed at times by second stories from the audience. The main

difference between photo-talk and ordinary conversation seemed to be in the pace and focus of the talk. Photo-stories were embedded in a photo-turning activity that formed the focus of the conversation, and served to prime certain topics associated with each photograph at a particular time and pace. It also meant that participants could pause quietly for several seconds in the conversation to examine a photograph in mutual silence. To appreciate these characteristics, let us consider some further fragments of photo-talk.

Figure 7.9 shows a typical photo-story being told by a wife to her husband. Tracy, the wife, had recently been on vacation with a friend, Annabelle, and was showing photographs of the trip to her husband Simon when she got back. In

```
Mar: An who's tha::t.
Dan: That's a great picture uh you
Mar: No it's really not=
Dan: =It is a great pict[ure uh you. ]
Mar:                    [No it's really] kinda ugly hhh.=
Tom: =(Na[:r.)]
Dan:   [No i]t's no[t yer har-]
Mar:              [ I T I S] UGLY Tom.
Dan: Let me take a look at it
Mar: Oh look at Emma...
```

Figure 7.8 A reminiscing conversation involving an assessment of a photograph.

contrast to the symmetrical kind of reminiscing conversation shown in Figure 7.6, this conversation is led by Tracy with occasional contributions from Simon. Tracy marks out a photograph of a tea room in Atlanta Springs as worthy of particular attention, by saying "This was an interesting thing" and asking Simon a question about the picture. This serves as the preface to a story about the discovery of cups suspended in a tree and dishes (saucers) placed in the ground beneath it. The close of the story is prompted by Simon who asks for clarification of the name of the place and, by implication, some further explanation of the strange decorations. Tracy doesn't provide an explanation but changes her earlier description of the tea room to a "dish garden", underlining the strangeness of the experience. The joint laughter at the end of the story serves to mark its closure for both parties. In this way, the account exhibits many of the properties of storytelling in ordinary conversation, but happens to be triggered by a photograph of the place being spoken about.

```
Tra: Annabelle and me anyway we ate at the painted lady er:m
     tea room
Sim: Uhum?
Tra: A::nd ee- we were sittin' out [ en this: ]
Sim:                                [Is that one] of thuh
     rooms? in thuh house?
Tra: Uh- no t[his wu]z th[is wuz uh] in still in
Sim:        [oh this]   [o k a y ]
Tra: Atlanta springs .hh an:d urm
Tra: This? was a real interesting thing can you tell what's
     in that tree? right there?
Sim: They look like pumpkins
Tra: Well those are actually lights.
Tra: An um tch
Tra: Buh- what's hanging in the tree is a cup an she
     an- thuh ther wus liddle tea cups hanging all over this
     tree? an then underneath it in thuh ya:r:d there were
     liddle like dishes to match thuh tea cups so
Sim: Why::?
Tra: I don't know b[u t  a- hh]h.
Sim:              [heh heh heh]
Tra: Annabelle said look at thuh dishes out there they all
     are
Sim: En did you say that's called the tea garden
Tra: I said it was thuh dish garden [hih hih hih]  hh hih
Sim:                                [heh heh heh]
```

Figure 7.9 A storytelling conversation between a wife and her husband

The fact that this story is tailored to Simon's interests and intervention, can be seen in Figure 7.10 where Tracy tells the same story to two other friends, Katie and Lyn. The story elements are similar but the telling is different. It is now more appropriate to the relationship Tracy has with her female friends. Hence, Tracy first picks up on the name of the tea room, the "Painted Lady", to make a joke about its connection to herself and Annabelle. Katies' humourous response and Lyn's laughter indicate that they get the joke, allowing Tracy to continue with the account. This time the story is told in an extended turn which Katie and Lyn refrain from interrupting despite several pauses in the middle. Whereas Tracy's description of the place as a "dish garden" was prompted by Simon's question in the first telling, it has now become the punchline of the story as something she said to Annabelle at the time. In fact these words were most probably spoken to Simon first, judging from Figure 7.9. These modifications show that photo-talk is subject to recipient design in the same way that ordinary conversation is, and that this influence may even lead people to modify story elements between tellings.

```
Tra: An we ate at the painted lady café
Kat: hmm
Tra: I thought that was appropriate for thuh two of us
Lyn: huh huh huh
Kat: I'm not touchin[g that one]
Lyn:          [Ha ha ha h]a
Tra: And they had in thuh tree there were cups hanging in thuh
     tree? an stuck in thuh dir:t were liddle plates haf
     sticking up out thuh dirt an I looked out thuh window an I
     said it's a dish garden
Kat: Did you ask them why?
Tra: No  I just got a (picture)
Kat: Okay interesting
```

Figure 7.10 A re-telling of the same story as in Figure 7.9, to two female friends

In addition to the implicit role played by the *identity* of the audience in the storytelling, we observed a much more direct role through their active participation in the conversation. Some indication of this role can be seen in the contribution of Simon to the conversation shown in Figure 7.9. For example, Simon asked a series of questions that led to the framing and conclusion of the first story told by Tracy. A more dramatic illustration of audience participation is shown in Figure 7-11. Here Emily and Jack were showing two visiting friends, Grace and Ted, pictures of an old vacation in New Zealand.

```
Emi: Anyway um (uh that was [that was stunning)]
Jac:                        [thuh farmstead wa]s beau-  I mean
     really intere[sting ]
Emi:              [But yuh]know it's set up like a museum so
     they demonstrate all thuh different cra:fts uh
Jac: Un this is thuh
Emi: That's wh[en (      )] buy the spinning wheel
Jac:          [spinning wheel]
Gra:            [Uh- This looks] like a Fe:rry or something
     they're saying goodbye? or welcome or something
     {Pause}
Emi: Ee- thuh were yuhknow we took a ferry from thuh little
     tow- uh thuh town of queensland over tuh this
     (r[anch over: ) ]
Jac:   [Down this lake] maybe:: ten mile[s (there)
     -
     {Discussion of mountains and weather for 20 more turns}
     -
Jac: Oh this is this is back in
Emi: That's a lovely place
Jac: This is back in queensland I think you're getting ready
```

*Figure 7.11 A storytelling conversation in which an original attempt to tell
a story is rejected and redirected by the audience*

The photo-talk in Figure 7.11 was triggered by the fact that Grace and Ted were soon to visit New Zealand themselves, and were interested in learning more about the country from their hosts' old photographs and experiences. At the beginning of the stretch of conversation shown, Emily and Jack are showing a photograph of a farmstead that contained a craft museum. As it turned out, this was near where Emily bought a spinning wheel, and both Emily and Jack begin to tell the story of the spinning wheel purchase until Grace interrupts with a question. The interruption is done in overlap with the story preface in which the spinning wheel is first mentioned. This serves to reject the story at that point in favour of obtaining further information about a Ferry shown either in the farmstead picture or in another one close by. After a pause, Emily and Jack go on to answer the question together, and a series of related questions about the weather in that region. However they don't give up on the spinning wheel story. A subsequent photograph "back in queensland" is used to set-up the story preface for the second time, using an almost identical form of words. This time the visitors desist from interruption and the story follows.

Although audience participation here only served to delay the onset of a photo-story from the storyteller's point of view, it also elicited useful details of the geography of New Zealand from the audience's point of view. In the context of a pending vacation to the country this information is likely to have been more interesting to Grace and Ted than the fact that Emily bought a spinning wheel there on a previous trip. This trade-off between the interests of the storytellers and the interests of the audience lies at the heart of this kind of photo-talk and was actively negotiated in the storytelling conversations we analysed.

Where there was more than one storyteller, this conflict of interest and perspective extended to the storytellers themselves. Two storytellers might want to draw out different lessons from the same experience or would simply remember different details of the same event. This led to exactly the kind of collaborative storytelling observed by Edwards and Middleton (1986).

An example of this is shown in Figure 7.12. In a typical photo-sharing session, Natalie and Edward are showing their photos of a recent camping trip to their parents, Jim and Delia. In this part of the conversation, Natalie and Edward are prompted by Delia to tell a story of their encounter with racoons. Natalie and Edward work together to relate the story from their own recollections, with Natalie uttering the story preface "The first place we stopped was like a zoo". Edward subsequently takes up the story and resists an attempt by Natalie to take over half way through. Natalie completes the story with a more forceful ending than Edward's "So we packed up and left". She uses more dramatic language such as "just freaking along" to indicate the frantic state in which they left, and tie the ending back to her own story preface in which she likened the campsite to a zoo. This shows that photo-stories are not only influenced by the audience, they are also influenced by multiple storytellers who may collaborate to tell the story together.

```
Nat: So this is where we stopped thuh first night
Jim: So yo[u took off from here]
Nat:       ['cuz we had gr(h)eat] tr(h)ouble
     s[o we didn't make        it all]
Jim: [ yer heading for (home)]
Nat: Thuh way
Jim: and Noel? was with yo[u
Del:                       [was this [thuh] next morning?
Nat:                                 [yeh ]
Del: 'Cuz yo[u guy]s stopped in ell aye mm hm
Nat:        [y e h]
Del: That doesn't look ba- I mean it was a bona fide camp site
Nat: Yeh [no it wuz] fine
Del:     [ mm hm ]
Nat:  B[u- thuh first place we sto]pped was like a zoo
Edw:   [ there  were  so  many ]
Edw: Yeah we pulled intuh on[e s i t e] right near thuh warder
Nat:                        [hu-hh. huh]
Edw: Un there is kind a seven racoons en there were skunks
     just walking all over
Del: Oh my goodness
Edw: Then I threw ro:cks at thuh racoons en they just kinda
     brushed um off their eyes en kept comin' after us
Del: Hu-[hh.
Jim:     [Ku-[hh.
Del: So you hadn't un packed yur
Edw: So:: uh[: we're eating ]
Del:        [yuh didn't camp]
Nat: Well we kin[de[r had hh.]
Edw:            [Di[n n e r :]
Del:              [Oh you w]er:e?
Edw: S[o we packed [up an' left] un: went to another one
Nat: [So I (jus-) [ huh  huh ]
Nat: He just drove me I'm like holding on tuh thuh pa:n an' all
     thuh dinner stuff in thuh ca:mper en he's just freaking
     along yuh know
```

Figure 7.12 Collaborative storytelling by a young couple to their parents

Another feature of the episode shown in Figure 7.12 is that the story is triggered from a single photograph that does not seem to contain images of the racoons or skunks that the story is about. Delia's original observation is about the campsite Natalie and Edward travelled to *after* they had escaped from the killer racoons! We found it was common for stories to spring off a single photograph in this way, often at the prompting of the audience and sometimes in a direction not illustrated by the photograph itself.

Another example of a story about something *not* shown in the photographs is shown in Figure 7.13. In this conversation Dan and Mary are being shown photographs by their friends Nicola and Lenny, whose daughter is also present. Just prior to the clip shown, Dan asks if the photographs were taken with Nicola's point and shoot camera. As it turns out, they were taken with another camera that was lost

and then surprisingly found and returned sometime later. Nicola tells this story with
help from Lenny, and Dan responds with a *second* story about a similar incident in
which Mary's purse was stolen and then discovered sometime later.

```
Nic: My camera disappeared at thuh Honalulu airport a thought it
     [ wuz stolen ]
Mar: [.hh en that's] why you got thuh new liddle one?
Nic: Yes Len[ny bought me thuh new liddle one] fer my:
Dan:        [ N o : :   k i d d i n g ]
Len: I g[ot her a (elth)]
Nic:    [it's own it wuz] it wuz in a liddle fa:nny pack it wuz
        in a liddle fa:nny pack en it wuz my camera an Dan's
        disposable camera [and my] comb was there
Mar:                      [OH:::.]
Nic: An that wu- that wuz like all that wuz in that liddle
        fanny pack .hh en so: I didn't discover it till we arrived
        in San Fransisco so it wuz just lo:st. so a mean it was my
        own stupidity to have [.hh lo:st it s]o
Mar: [That's sad though]
Nic: I was just very upset aboudit end about two weeks ago a
        woman ca:lled ur: from Honalulu baggage clai:m she works
        weekends in thuh baggage claim .hh en she'd found...

     .
     {The story of how the lost possessions were eventually
      returned continues for approx 20 seconds}
     .
Nic: Yeh she- she sent um back so: i[t it's
Dan:                                [isn't that wild
Mar: That's amazing  that's ama[zing
Dan:                           [it's like when Mary lost her
        purse fer some reason that she got it back. a wallet? or
        whatever it was?
```

Figure 7-13 A first and second story unrelated to the photograph that triggered
them

Sometimes people did unfold a story with reference to a sequence of photos, but
this was always at a pace and manner dictated more by the audience than the
material. More often than not, the turning or passing of photographs within the
group served to make relevant certain topics of conversation, and some of these
would be developed into stories at the whim of the storytellers or the prompting of
the audience. In between these developments, which have been picked out for
illustration in Figures 7.9 to 7.13, there appeared to be a good deal of what might be
called 'filler talk' by storytellers such as that shown in Figure 7.14. This is taken
from another portion of the conversation between Tracy and her husband featured in
Figure 7.9. Here phrases such as "an then this", "here", and "that was", are used to
mark the passage onto a new photograph and preface a simple voice label. Pauses
are introduced between each photograph, at which point the audience gets a chance
to make a comment or ask a question. In this exchange Simon remains silent apart

from expressing an objection to Tracy's assertion that the trees were changing
colour.

```
Tra: Lady's things an it was just decorated real real sweet .hh
     an then this was on thuh RO:ad from ur:m
     (1.0)
Tra: Oklahoma to arkansas .hh just some of th- su- thuh scenery
     that we stopped un
     (1.0)
Tra: Took- thuh trees here were just beginning tuh tur:n
     (0.7)
Tra: An: en it just wuh- absolutely gor:geous
     (2.2)
Tra: That was a little f[arm
Sim:                    [can- ee- I can't really tell that much
     of a colour change there  I mean that's not all yellow
     anyway
Tra: mm hm
Sim: That d[oes ] look mottled
Tra:       [koo-]
     (0.9)
Tra: It wuz really priddy
     (1.9)
```

*Figure 7-14 Filler talk by Tracy in between storytelling to her husband Simon.
Pauses in seconds are shown in brackets between the lines.*

SUMMARY OF FINDINGS ON PHOTO-TALK

In short, we have found in this study that photo-talk is composed of two quite
distinct types of talk. Reminiscing talk was the most common type, and took place
between people who shared the memory represented in the photographs being
shown. It was characterised by equal participation in the conversation by all
concerned, a good deal of overlapping talk, and a reticence to elaborate the story-of-
the-photo beyond identifying where and when it was taken. Storytelling talk was the
other kind of talk, and took place between people who shared the memory of the
photographs and those who didn't. It was characterised by unequal participation in
the conversation, little overlap, and a tendency for the photographer to develop the
story behind *particular* photographs in a set. The way in which such stories were
told in these conversations, appeared to be similar to the way in which stories are
told in other forms of conversation. Hence they involved opening and closing
sequences, tailoring to the audience, audience participation, collaboration, and even
the telling of second stories in response. The main difference between storytelling in
photo-talk and 'ordinary' talk, appeared to be in the way the story was initiated out
of a photo-turning activity that made certain kinds of information *topical*.

Returning to the slideshow model of photo sharing we can say that these findings
provide further evidence against it. Both kinds of photo-talk are highly interactive
and influenced by the participation of an audience. In fact, in reminiscing

conversations, the contributions are so equal that it is not appropriate to distinguish between an audience and a presenter. These roles move between participants with each utterance. Even in storytelling conversations where the presenter or presenters are defined by their knowledge of the photographs, the audience was found to prompt and direct the conversation by timely interventions and responses. Indeed, the presenter's talk was interspersed with pauses to encourage this. The fact that most photo-sharing conversations were found to involve the handling of loose prints may also have contributed to this effect, since it would have allowed the audience to look at images which were out of synch' with the current narrative. Such dislocation of image and sound consumption may have created opportunities for redirecting the narrative to images not currently being talked about. While this would be frustrating in a slide show, it appeared to be the norm in the photo-sharing conversations we examined.

The implications of these findings for capturing conversational photographs are that only certain kinds of conversation are likely to be interesting enough to keep. In particular, only storytelling conversations appear to contain details that generalise beyond the conversational context itself and concern the story-of-the-photo in Berger's sense (1982a). The kind of reminiscing conversations shown in Figures 7.6 to 7.8 are unlikely to have long-term value as a form of voiceover on the corresponding photographs. Furthermore, *within* storytelling conversations, it may only be the stories themselves that are required for capture and storage with the photographs. The intervening filler talk and audience comments may be judged too boring or distracting to retain

To test these hypotheses, we move onto a second study in which we gave people the chance to decide for themselves, which parts of a storytelling conversation they would like to keep with its associated photographs. This study is similar to those reported in earlier chapters, and involves the generation and review of audiophotos themselves.

THE STORYTELLING PHOTOGRAPH STUDY

In order to give people a chance to record their own conversational photographs from storytelling conversations, it was necessary to find a situation in which these conversations could be recorded in full for later review. The spontaneous conversations recorded in the previous study were tape recorded without reference to their associated photographs, and could not easily be followed-up. However, an unpublished laboratory study of photo-sharing, carried out for other purposes, had recorded 14, 20 minute sessions of storytelling conversations on video. This study was carried out with Nadja Linketscher and Maurizio Pilu. In this study, each photograph had been scanned and captured in digital form, so that it could be shared on-screen across two rooms through a photo-conferencing application called *PicShare*. An average of ten photographs were shown and discussed in each session, at a rate of about one every two minutes. One of the values of this system is that it could easily support the capture of photo-sharing conversations. To explore this

possibility, an additional follow-up exercise was carried out twelve months later on the recorded conversations. This was done in collaboration with Tony Clancy and allowed us to test reactions to recording storytelling photographs in general.

Ten pairs of work colleagues and four extended family groups were asked to review their photo-sharing sessions at home, by watching themselves on video. Work colleagues were originally drawn from the HP Bristol site, while families were recruited from the local Bristol area. During this task they were given a printed contact sheet showing thumbnails of all the photographs shared, and asked to mark all photographs for which they would like to keep the corresponding conversation. In addition, they were asked to select a favourite conversational photograph from this set. Participants were then requested to complete a simple questionnaire describing their reasons for keeping the selected conversational photos, for **not** keeping the others, and for choosing their favourite audiophoto. The questionnaire also prompted participants to vote on whether or not they believed the recorded conversation made the photographs more interesting, informative or enjoyable, and to indicate whether they would like to record conversation with photographs again. Most of the conversations related to recent sets of photographs not seen by the photo-sharing partners in each pair or group. However, the interval between the original session and the follow-up research was about one year, and gave the conversations and photographs an older feel. This interval also made it difficult for us to track down all the original participants and encourage them to respond. Sixteen out of 22 individuals carried out the follow-up task and completed the questionnaire. Twelve people were members of the original pairs of subjects, while four belonged to one family group of two parents and two grandparents.

Despite the missing data, the responses from our 16 respondents contained a wide variety of opinions and experiences with the task, and furnished us with enough data to report a preliminary set of findings on the value of conversational photographs. This is done in the next section through an abbreviated form of analysis used in previous chapters. Statistical data are reported ahead of a discussion of favourite audiophoto selections and comments on the value of conversational audio. However, the statistics refer more to the subjective judgements and votes cast on the medium, rather than to the properties of the conversational photo set, and there is no discussion of the practice surrounding the capture, editing and playback of conversational photo material. We leave these details for a future full-scale trial, and concentrate on determining whether such a trial is justified from the data we have.

STORYTELLING PHOTOS CAPTURED

It has already been mentioned that the mean duration of a conversational photograph in this study was about 2 minutes. The association between sound and image in this set was always one-to-one because of the way a single photograph was presented at nearly full-screen size for discussion at any time. In fact, the duration of an individual conversational photograph was defined by the duration for which the

image was displayed at this scale. For the most part, participants tailored their conversation to correspond to the currently displayed photograph, and the speech stream could be segmented quite straightforwardly at image transitions. The exceptions to this rule usually occurred when authors began to introduce the next photograph ahead of the current one. In these cases the entire conversational recording window for any given photograph was displaced to start a few seconds before the display of the photograph itself.

A key question for the study was whether or not participants would choose to keep *any* of the conversation corresponding to particular photographs. We found that on average they opted to keep the conversation on about half of the photographs shared. In those cases they did not express a desire to edit the conversations. This begins to show that there was some perceived value to the storage of storytelling conversation around photographs, but that this did not apply to every single photograph.

Two other factors in the selection of conversational fragments and photographs, were the ownership of the photographs and the relationship between photo-sharing partners. The interaction between these two factors is illustrated in Figure 7.15. In general, people opted to keep important or forgotten details mentioned in their own talk on their own photographs, or revealing details on the photographs of close partners. They tended to reject most or all conversation on photographs shared by casual acquaintances, as shown by the low percentage of photographs saved by this group in Figure 7.15. We defined acquaintances as people who did not socialise with each other outside work. In contrast, acquaintances retained nearly as many of their own photographs as did friends. Within the family group, we found that people were more interested in saving conversation on each other's photographs as shown in the Figure. In fact, the grandparents in this group opted not to keep any of their own conversation on their own photographs on the grounds that they would not have time to listen to conversation on their own photos in the future. This explains the very low proportion of own photos saved by family members in Figure 7.15.

The overall ratings for the conversational photographs saved are shown in Figure 7.16 below. These show that the addition of conversational audio to these photographs was considered to increase their interest, information value and enjoyment by the majority of participants. The biggest consensus was around the 'informative' dimension. When asked at the end of the exercise whether they would like to record conversation on photographs again, three quarters of participants said 'Yes'. The remaining quarter were split equally between saying 'No' and 'Don't Know'. While the reasons for these votes are complex, their importance is clear. There are at least some circumstances in which saving the conversation around a photograph will be considered worth doing, and therefore worthy of further study and support.

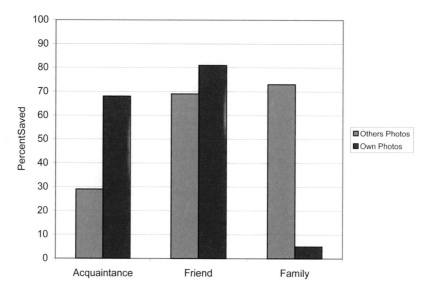

Figure 7.15The proportion of conversation saved on other people's photographs and one's own photographs by different groups in the study.

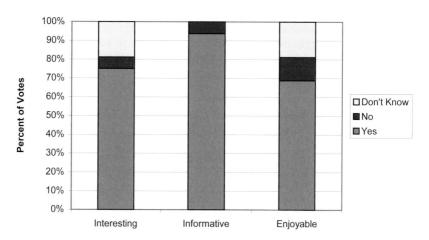

Figure 7.16 The extent to which participants agreed that recorded conversation enhances a photograph in different ways.

REACTIONS

Favourites

A number of favourite conversational photographs were selected because they contained well-formed stories. These stories possessed the same kind of clarity and interest found in favourite talking photographs with voiceover. For example, Figure 7.17 shows two people on a paraglider from the boat below. The conversation is led by one of the paragliders, Christine, who describes her feelings of terror as she took part in the ride. The story therefore provides an evaluation of the experience as well as a broader description of it, and was voted a favourite by Christine's photo-sharing partner Viv. As Viv points out in her own words, this audiophoto was a favourite because:

> *"The conversation is an interesting and informative narrative on the photograph" (Viv)*

Figure 7.17 Viv's favourite conversational story told by her partner Christine

However, favourite conversational photos were not always chosen because they were complete stories. Often the talk was considered attractive because it triggered a memory in the author or had some other personal significance. For example, the photographs shown in Figure 7.18 were chosen as favourites because they reminded the author, Amanda, of the changing appearance of the same lake on consecutive days of her holiday. The accompanying conversation isn't so much a story as a description of the lake on both days with additional questions and observations by the audience, Jess.

(a)

(b)

*Figure 7.18 Amanda's favourite conversational photographs which reminded
her of the changing light on a lake*

A similar conversational photo was selected by Dorothy in the study. She chose a
picture of herself in a mountainous landscape, taken by her husband. Her own
conversational comments described her memories of being surrounded by wild herbs
such as sage, rosemary and thyme, which gave the place a wonderful smell. The
conversation itself appeared to remind her of this smell:

> *"The conversation talked mainly about the sights/sounds/smells that went with the photo. This was definitely a bonus that the photo does not capture" (Dorothy).*

Other conversational photographs were chosen for their personal significance. These included a snapshot of Debbie outside a boutique in New York on her 40th birthday. This was chosen by her mother in the family group, not only because of the content of the conversation but also because of the association with that event:

> *"By hearing the conversation it helped me to feel I was sharing in that special day" (Joy).*

Both factors appeared to be at work in Figure 7.19, which was the favourite audiophoto of its author, Lyn. It shows the presentation of a birthday present at a friend's party, and led Lyn to describe what was in the present bag shown. The event was significant in its own right and the chosen moment indicates the kind of relationship Lyn and her friends have with the birthday girl, Tracy. Listening to the conversation later, Lyn was also reminded of details of the event she had forgotten since the conversation:

> *"I'd forgotten Tracy kept asking 'Do you want to know the time?' and kept carrying the bag, until I heard the conversation" (Lyn).*

Figure 7.19 Lyn's favourite conversational photograph which reminded her of forgotten details (Lyn)

The value of storytelling conversations

The criteria used for the selection of favourite conversational photographs begin to indicate some of the values of storytelling conversation of this kind. To a large

extent it appears to be similar to the value of voiceover on photographs, as identified in the previous chapter. Hence, when people were judging the value of conversation on *other people's photographs* they tended to appreciate talk that told the story-of-the-photograph and added interest to it, or which personalised the photograph with the speakers' voice and opinion. However, there did not seem to be the same sense of intimacy in the conversational records as in the privately recorded voiceovers. Whereas voiceover appeared to convey the speaker's inner thoughts and feelings, and sometimes communicate hidden messages to the recipient, conversation did not. In fact most of the reasons for keeping conversation with photographs were pragmatic rather than sentimental. This brings us to one major difference between the value of voiceover and the value of conversation. Conversation was often selected on people's *own photographs* as a personal reminder of forgotten details of the memory.

The reminding value of one's own storytelling activities was actually the most commonly mentioned. An example of this has already been given in Figure 7.19, which showed the handing over of a present at a party. Another example of the reminding value of conversation is shown in Figure 7.20. This is distant photograph of two moose entering a lake in which the photographer, Meg, and her partner are canoeing. Meg's excitement at this encounter is evident from the story she tells of it in the conversation, and is echoed in her comments about why she chose to keep it:

"I chose to keep this mostly because the moment was pretty cool (seeing a moose) and there was a good story behind it – some of which I had since forgotten about" (Meg).

Figure 7.20 A conversation photograph about canoeing with a moose, valued for its reminder of the event. (Meg)

The other values of interest and personalisation can be illustrated with reference to some of the conversational photographs selected by the family group. Their photographs were unusual in that they contained not only recent photographs taken by the younger 'parents' of the family, but also older photographs of one of the parents, Debbie, when she was about 6 years old. These were brought in by her parents, who we refer to as the 'grandparents' of the family. This set of photographs is interesting because it shows how different members of a family have different views of the value of each others' photographs and conversation.

Regarding the recent photographs brought in by the parents, these were judged by the grandparents as much more attractive than their own photographs. Figure 7.21 shows the grandmother's favourite conversational photo of Debbie mentioned in the previous section. This contained a description of Debbie's 40th birthday trip to Paris which served to connect her mother to the occasion. It was also valued by Debbie's father, who was unfamiliar with Paris and was interested in the comments about it:

"The Parisian scenes and context was outside my experience and the images were enhanced by the commentary and the added information" (Ron).

Figure 7.21 This conversation and photograph of a daughter was found to be interesting by her parents

Regarding the older photographs brought in by the grandparents, these were judged differently by Debbie who formed the subject of the photos, than by Debbie's husband Chris. Chris was intrigued by the commentary provided by his in-laws about his wife when she was 6. For example one of his favourite conversational

photos was that shown in Figure 7.22 of Debbie, her brother and two school friends. Debbie appears second from the left. Chris' interest in these kinds of conversations is somewhat understated in the following quote:

"*It was useful to identify the background to the photograph, i.e. when, where, who, etc.*"(Chris)

Figure 7.22 *This photograph of a wife with accompanying conversation by her parents was found to be interesting by her husband*

Debbie's interest in her parents' photographs of herself was perhaps the most complex of all. She appreciated the new information provided by her parents in conversation and also liked the fact that the photographs were personalised by the voices of her parents and husband. In addition, the photos and conversation worked together to trigger personal memories she had not had for years. These effects can be appreciated from the audiophoto in Figure7.23, and her comments below:

"*The most valuable part for me was the sharing of historic photos from my parents' collection. I chose to keep the parts where my mum and dad were sharing pictures of me and answering my questions. It forms a good memory for the future. It is good to have a stored memory of mum and dad chatting and explaining their playful responses to Chris' comments....Memories of actually wearing the clothes came to me as I saw the photos*" (Debbie).

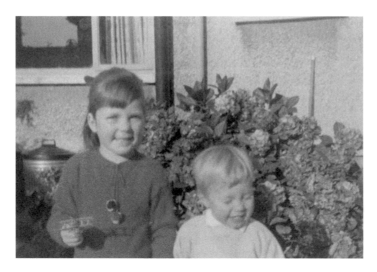

*Figure 7.23 A four-way conversation valued for a variety
of reasons by Debbie, pictured left*

Some final comments from participants in the study suggested that there was also value in the original video record of the photo-sharing session. One participant preferred the entire video record to any selection of individual conversational photographs, and pointed out the different feel it had to conventional home video. Another liked the fact that the video happened to contain a split screen showing the face of the 'sender' or main speaker in the conversation.

SUMMARY OF FINDINGS ON STORYTELLING PHOTOGRAPHS

By giving people the opportunity to store their storytelling conversations around photographs, we have found that *some* parts of the conversation were considered worthy of keeping because they enhanced the photographs. However, these parts did *not* always correspond to well-formed stories as predicted from the previous study. The selection of conversational segments was related more to the relationship participants had to each other and to the photos at hand.

A key relationship factor was whether the photographs belonged to you or others. This could be seen from Figure 7.15, which showed that acquaintances were more interested in keeping conversation on their own photographs than on other people's photographs, whereas the reverse was true of family members. Friends were equally interested in keeping conversation on their own and their partner's photographs. Another way of looking at these findings, is to say that the value of keeping conversation on someone else's photographs was related to the value of

keeping the photographs themselves. Only very close friends or family were interested in doing this, perhaps because they had more shared history and context to maintain with each other.

The choice of which pieces of conversation to keep was dictated by the value they had for each group of people involved. Clear and well-formed stories were selected out of interest in other peoples' photographs. Other remarks and conversational banter were selected for the way each type of talk personalised one's own photographs and reminded the photographer of forgotten details. We also found that a mixture of these motives could be evident in individual selections, such as those made by Debbie in Figure 7.23.Debbie liked the banter on her parents' pictures of her as a child, but also appreciated her parents stories on these pictures. In fact, Debbie was in the same position as the children in Edwards & Middleton's (1988) study of parent-child photo-sharing. Although she was a subject of the photographs being shared, she did not fully share the memory of the original event. This gave the reminiscing talk a storytelling quality - which was further extended by the presence of her husband as an independent audience.

Despite the provisional nature of these data, the evidence for the value of conversational photographs is clear enough to warrant further research. A future study might explore the use of such facilities in a trial setting, to examine again what conversation would be recorded but also to find out how such recordings would subsequently be used.

DISCUSSION

We began this chapter with the observation that photographs live in an environment of conversation, and that some of this conversation could be captured in another kind of audiophoto. Two studies were then reported which looked at this environment and the prospects for recording it.

In the first study of photo-talk we found that all the features of conversational storytelling reported in the literature were present around photographs, but only in forty percent of photo-sharing conversations. These conversations were those in which photographers or the subjects of photographs shared the images with an audience who was not present at the time the photographs were taken. We referred to these as storytelling conversations in Figure 3.5, although the stories they contained were subsequently found to be embedded in other kinds of talk involving questions, answers and general observations. A further sixty percent of photo-sharing conversations took place exclusively between people who shared the memory of the events depicted in the photographs. We referred to these as reminiscing conversations in Figure 3.5, since they involved remembering the event together. Somewhat surprisingly we found that reminiscing talk did not involve direct descriptions of the events or memories represented by the photographs, but rather contained a collection of remarks, questions and judgements about the photos which were highly specific to the participants own recollections. These conversations appeared to be unsuitable for saving, although further work might try

to verify this conclusion. In contrast, storytelling conversations appeared to contain just the kind of details recorded in voiceovers, which had already proved to be useful for the interpretation of other people's photographs (in Chapter 6).

In the second study we examined whether storytelling conversation might have the same properties as voiceover, and expected participants to select well-formed stories as a kind of free voiceover. While conversational stories were found to be of greatest interest on other people's photos, other parts of the talk were valued on one's own photographs. Other people's voices and one's own conversation was found to be useful for personalising the photographs and reminding the photographers of forgotten details.

These two uses of conversational photographs are summed up neatly in the opening quote of the chapter, in relation to a wedding album. Conversation over the album might be used as a long term reminder for the bride and groom, or as an interesting story for their children in the future.

The role of conversation in personal image review

The value of recorded conversation on personal photographs for enhancing memory was a surprising outcome of the study. It flies in the face of the rejection of voiceover for this purpose in the audio-annotation study.

One factor may be related to the methods used in the studies. The time interval between recording and listening to personal voiceovers (several weeks in Chapter 6) was much shorter than that involved in recording and listening to personal conversations (several months in this chapter). It is likely that *any* spoken commentary on a photograph will become more useful as a reminder over time.

Another reason may relate to the expected practice of recording voiceover and conversation. Even if the value was perceived to be equivalent, participants may have rejected the idea of recording voiceover on their own photographs because of the effort and time involved. In contrast, participants may have recognised that recording photo-sharing conversation would take little extra effort. This may have led them to view it more positively as a form of indexing their own photographs.

However, a third explanation is particularly compelling. Participants in the audio-annotation trial were most reticent of recording voiceover when they could not imagine an appropriate audience. In fact the most difficult audience to record for was oneself, since participants already knew the story of their photographs and found it hard to anticipate what details they might forget. In conversation, the issue of identifying an audience disappears. The audience is physically present, and from the analysis of photo-talk we know that speakers act with great skill to tailor their conversation accordingly. We also know that audiences themselves act to bring out new details and explanations from speakers. This process results not only in free voiceover for speakers, but *freely-tailored* voiceover full of twists and surprises that speakers could not have anticipated themselves. In this sense the conversational recordings are also personalised, beyond the mere inclusion of other people's voices. They reflect accounts that emerge with the audience, containing facts and details that speakers could not have deliberately recorded for themselves. Such account may work as better reminders of the events than voiceovers, whilst also reminding speakers of the people they shared their photographs with in the past.

The value of recorded conversation on other people's photographs is more easily explained, especially in the light of the earlier findings on voiceover. Essentially, the stories in storytelling conversations work just like voiceovers for a remote audience. They add contextual details and interest that reveals more of the story-of-the-photograph. What is curious in the case of recorded conversation is that these details have already been heard live in conversation. The decision to record them must therefore be related to a desire not to forget them on subsequent reviews of the photographs. This presupposes that the audience expects to keep and review the photographs again and explains why their relationship to the photographer or subject is so important. If the relationship isn't close enough to involve keeping the other person's photographs, then there is no need to remember their interpretation. This account also explains why recorded conversation lacks the intimacy and impact of voiceover heard for the first time. It suggests that the value of recorded conversation for an audience is ultimately linked to a second-hand use in memory, rather than a first-hand use in interpretation.

The role of conversation in social interaction

The activity of using recorded conversation in live conversation with photographs was not examined in the studies. However, this is unlikely to be valuable, given the strong negative effect of playing voiceovers in live conversations reported in Chapter 6. The activity itself is somewhat bizarre and seems to stretch the reflexive nature of photography too far. While there may be some circumstances in which people want to listen back to themselves or others talking about photographs, I have assumed that they would do this alone and without further conversation. To want to review a conversational photograph with someone else is certainly possible, but would need to involve an interest in the conversation itself rather than the photograph to which it related. A feasible scenario for this might be listening to photo-sharing conversations your ancestors had with their friends and family when they were young. Future work might address such interactions, but I predict that participants will find it difficult to talk over the recorded conversations, and will not want to further record the conversation on a conversation.

Paper versus screen playback

"You've got flexibility about who's got what and where" (Paul, audiocamera trial)

Our journey so far has taken us through the properties of different kinds of audiophoto content. PC-owning families have been encouraged to combine audio of various kinds with photographs in order to reflect on its potential value and use. This chapter changes direction somewhat, in order to connect these perceptions of content to the practicalities and technicalities of its capture and playback on different devices. In particular, it looks at the way various playback options affect the experience of reviewing audiophotographs. The interrelationship between content and technology was said in Chapter 2 to be one of the lessons from the history of new media development. All successful new media have involved innovation on both fronts, with content responding to and favouring particular forms of technology. This relationship is examined here by drawing together reactions from the same families to the playback of ambient, musical and talking photos on a range of different devices.

As noted in Chapter 1, there are two main classes of devices for the playback of audiophotos. Screen-based devices, such as the PC, TV or PDA, already support the presentation of sounds and images and could be used quite easily to create and present audiophoto albums. In addition, paper-based artefacts, such as the

conventional photographic print, album, frame or card, might be augmented with audio using existing or new technology. These technologies support audio playback from paper, or *audioprints*. Indeed, as we saw in Chapter 2, technologies for audio-enabled books have been around for some time, and have led to a number of commercial audioprint products for talking photo albums, frames and cards.

Both screen and paper forms of playback of the same material were presented to families in the audio-camera and audio-annotation studies. Their reactions and comments are reported in detail here. However, before launching into the methods and findings of this comparison, I briefly review insights from related work to guide our approach and analysis.

RELATED WORK

Two sets of prior research are relevant to the question of paper versus screen playback of audiophotos. The first set of work stems from the debate on the future of reading, while the second relates to the importance of tangibility in design.

The future of reading

Insights on the use of information on paper and screen come from an extensive literature on the reading of office documents. Developments in document scanning and management technologies in the 1980s led to an active debate about the prospects for paperless offices. It was suggested in the business press of that time that these would be more efficient and environmentally friendly places, in which documents would be routinely authored or captured into the electronic realm, before being distributed, read and processed on-line. Although this prediction has not turned out to be true, it generated and good deal of research into the use of paper and screen-based documents and a clearer understanding of the value of each (Sellen & Harper 2002).

The locus of the debate has now moved to the future of the book, rather than the future of the office (Nunberg 1996). This is because recent developments in computing and screen technology now make it possible to design lightweight reading devices for 'electronic books' (*e-books*). These might be used to carry large amounts of up-to-date information in a form that can be annotated, linked and shared in new ways (Schilit, Price, Golovchinsky, Tanaka & Marshall 1999). Because of the high cost of specialised e-book devices, they have been targeted at the professional reading market, and research has continued to focus primarily on office documents and information. However, some of the insights from all this research may carry over to the use of domestic documents and photographs.

For example, it is not just the optical characteristics of a display that affect reading on screen. Reading performance is also affected by text formatting, manipulation and control factors (Dillon 1992). Another insight is that it is important to distinguish between different kinds of paper and screen experiences when making comparisons between them. The history of reading shows that reading (and writing) behaviours have changed with each development in paper technology (Manguel 1996). Hence reading from clay tablets and papyrus scrolls was very different to

reading from a handwritten parchment codex or a bound textbook. In the modern age, similar differences exist between the reading of cards, posters, documents, brochures, magazines, books and other forms of paper. Different kinds of screen experience result from reading the same content on screens of different sizes and resolutions; such as on a PC monitor, a TV and a handheld device. Furthermore, extensions and modifications to the *content* of screen-displayed information are also possible on screen-based devices. These include the addition of other media such as audio and video, and other structures such as hyperlinks - including links and communication back to the original author.

These possibilities are creating new forms of computer literacy which have only just begun to be recognised and studied (Bolter 1991, Snyder 1998). A final complication is that people have been found to read material differently, depending on what they are trying to do with it (Adler, Gujar, Harrison, O'Hara & Sellen 1998). For example, people will search specifically for matching information when trying to make comparisons within or between texts.

Leaving aside differences in the *content* and *purpose* of paper and digital documents, a number of studies have begun to reveal important differences in the properties of paper and screen-based media. Thus, in an experimental comparison of reading the same technical document in order to summarise it, O'Hara & Sellen (1997) identified a number of *affordances* of paper that made it easier to use for this task than a computer screen. They define affordances, after Gibson (1979), as physical properties of paper which encourage certain kinds of interactive behaviours. These included:

- Support for annotation while reading
- Ease of manipulation and navigation within a document
- Ability to spread out and compare information across pages

Subsequent work in more naturalistic settings has confirmed the importance of these affordances of paper, especially for supporting the interweaving of reading and writing activities (Sellen & Harper 2002). At the same time it has also shown the value of the following affordances of screen-based material for carrying, finding and exploring information:

- Allows access to a large amount of material
- Supports full-text searching
- Quick links to related materials
- Content can be dynamically modified or updated

The fact that paper and screen media have such different affordances for reading and writing behaviours leads people to move between them for different tasks. For example, the creation of documents tends to be done on-line, with paper in a supporting role. In contrast, the review and discussion of documents tends to be done on paper (Figures 3.2 and 3.3 in Sellen & Harper 2002).

In reality then, people do not opt for paper *or* screen forms of reading as a general preference, but move between them for different purposes. In a final twist to this conclusion, Luff & Heath (1992, 1997) have shown that this movement can take place at both macro and micro levels. Paper or screen documents may be consulted in different phases of work (macro level) or in the same phase concurrently (micro

level). This latter activity involves the co-reading of screen and paper surfaces, and is common not only to conventional offices but to other complex workplaces such as traffic control centres, medical centres and call centres (Luff, Hindmarsh & Heath 2000). In such settings, the *micro-portability* of paper becomes important as a resource for calling attention to information, orienting it to colleagues and bringing it into a conversation. In this respect, paper makes the information itself more tangible.

Tangibility in design

The notion of tangible interaction with information has been promoted for some time as a desirable property of future personal computing. When computing is 'ubiquitous' and resides in all manner of objects, furniture and architecture, people may be able to interact with it in more natural ways (Weiser 1991). This will not necessarily be through dedicated reading devices. For example, simply moving into a room might trigger the display of ambient sound, or moving an object on a desk might control the display of projected information (Ishii & Ullmer 1997). This approach to the design of future interfaces between people and computers attempts to augment the behaviour of ordinary objects and spaces, in contrast to simulating those objects and spaces within an enclosed computer world. For this reason it aims to create a kind of *augmented reality* rather than a virtual reality (Wellner, Mackay & Gold 1993). Considerable progress is now being made in this area, especially through the use of tags, sensors and wireless networks of information that can be triggered in ad hoc ways (e.g. Hawley, Poor & Tutja 1997, Want, Fishkin, Gujar & Harrison 1999).

I mention these developments because they are part of a trend towards tangible computing. They show that the tangible nature of paper is now recognised as an advanced and desirable property of human computer interfaces in general. Such tangibility may give paper some functional advantages over screen-based devices, when it comes to reading, writing and sharing information.

Another reason for mentioning tangibility in design is that it may also confer some non-functional advantages over screen-based technology, especially in the photography domain. This is because people have a tendency to develop sentimental attachments to objects, both as personal possessions and as souvenirs. For example, in a survey of cherished possessions, it was found that the *utility* of the possession was a relatively minor reason for the object being special (Csikszentmihalyi & Rochberg-Halton 1981). More common reasons were that the objects triggered *memories* or *associations* with people or events, gave a certain *style* or *personality* to the home, and provided enjoyable *experiences* or *qualitie*s. Photographs in particular were valued for their memories, qualities and association with others. They turned out to be the most cherished objects cited by grandparents and the second most cherished objects cited by women of all ages. The association of objects and photographs with people was particularly strong. This has been noted in other contexts and cultures where objects become almost magically endowed with the personal characteristics of their owners (Hoskins 1998). In some cases these objects are considered to have power in their own right, while in others they are seen as merely signs or remembrances; as in the catholic and protestant views of the bread

and wine used in Christian worship (Schaverian 1991). Schaverian goes on to show that images as well as objects can take on these kinds of meanings, even to the extent of serving as tangible talismans or charms.

Given the importance of tangible objects as both functional and non-functional things, it may not be so easy or desirable to replace them with digital copies. This can be seen from a recent study of digital music, which found that although users enjoyed the greater choice of music available in MP3 format, they still wanted to purchase and handle it through a form of physical music packaging (Brown, Geelhoed & Sellen 2001). In another context, it has been suggested that physical souvenirs might be brought into the digital world by taking a photograph of them and annotating the photographs with stories (Stevens, Abowd, Truong & Vollmer 2003). However, a photograph of a souvenir is unlikely to be as powerful as the object itself in evoking a connection to the past. A more promising approach might be to augment the souvenirs themselves with stories, so that the objects can continue to be handled in the usual way (Frohlich & Murphy 2000). Essentially the same argument has been applied to audiophotos (Frohlich, Adams & Tallyn 2000) and is developed below.

Application to audiophotography

In short, although the idea of a paperless home has never received the same attention as a paperless office, we can expect many of the same insights to apply. Rather than domestic paper documents and photographs being replaced by screen-based technology, it is more likely that they will continue to co-exist with it, perhaps in a modified form. This is because the affordances of paper and screens are different, and will continue to lead people to move between them for different purposes. The key question for digital photography is therefore not 'Which is best, a printed or screen-displayed photograph?' but rather: *'In what contexts will people prefer certain kinds of paper or screen-based experiences with photographs?'*

This question is also a key research issue for audiophotography. Because of the existence of talking book technology for augmenting physical paper with sound, it is possible to provide a paper alternative to the screen-based audiophoto. The audioprint alternative not only removes the need to use screen-based technology for this particular multimedia format, it also provides continuity with existing tangible methods of handling photographs. As we have seen from previous work on tangibility, this may be an advantage both functionally and non-functionally. Functionally, it may easier or more flexible to handle, retrieve and share printed photographs than screen-based ones. Paper may also be a more accessible and reliable medium for archiving photographic images long term. Non-functionally, prints may be better for forming psychological attachments to photographs. Conversely it may be more difficult to form attachments to ephemeral screen images, or to believe that they will not vanish forever. Viewed from this perspective, we might ask an additional question to the one mentioned above, concerning movement from the status quo: *'What advantages must screen-based photographs offer for people to give up the tangibility and familiarity of prints?'*

Approach

Our approach to these questions is to layout a range of different paper and screen options for playback of the very same audiophoto content. These options were then experienced and discussed by participants in our two main studies of ambient sound, music and talking photographs. Analysis then focuses on the contexts in which people report using or preferring certain playback options, and especially on the conditions for shifting to screen-based forms of playback. In exploring context, we refer again to the diamond framework in Figure 3.5. Because the playback experience in these studies was limited by the early technology for audioprints, we rely largely on the participants anticipated uses of audiophotos on paper and screen. This is a shortcoming of the focus group methodology itself. These studies should therefore be seen as precursors to more extensive field trials with fully integrated versions of each playback technology shown.

In the next two sections, we step through the findings of each study separately, before bringing them together in a final discussion.

PLAYBACK OF AMBIENT PHOTOGRAPHS

Photographs with ambient sound attachments were reviewed on paper and screen in the context of the audio-camera trial described in Chapter 4. The overall methods used in the trial are described in that chapter. In this section we describe the review procedures in further detail.

The first stage of audiophoto review took place in home visits after four families had captured ambient sound photographs using an audio-camera unit on their summer holidays. Within these visits families jointly reviewed the total set of photos and sound clips captured. This was done first without sound from the prints alone, and then with sound played continuously from an *audio-cassette* loaded into each families' home hi-fi unit. This can be seen as a form of audioprint playback from paper, in which the prints and sounds are unsynchronised. After this experience the families selected about 10 favourite audiophotos for incorporation into a digital album that we later assembled for them. The original prints and cassette tapes were left with the families for them to show to others if they wanted to.

About one month later, families were invited in pairs to attend two separate 'Feedback Groups' at HP Labs Bristol. Each group session started with a discussion of their overall reaction to audiophotos and their subsequent use of the prints and cassette tape. Their favourite audiophoto albums were then made available for them to show to each other in two forms:

- **PC album**: Participants could click through a screen-based album on a multimedia PC, using a mouse to select on-screen navigation buttons. Albums were authored in a multimedia editing package called *StudioM* from GoldWorks Inc. Sounds played only when the photographs were themselves selected by clicking on them. Simple audiophotos with a one-to-one association of sound and image were shown one screen at a time. More complex audiophotos with a single sound clip for several images

were also shown on the same screen, but with individual images revealing themselves at the right time in the sound clip. It was suggested that material from the camera could be uploaded to the PC for this experience.

- **CD album**: Participants could randomly access sound tracks from a hi-fi system using track numbers written on the back of each printed photograph. The hi-fi unit was placed on a table next to a pack of loose prints. It was suggested that track-numbered prints might be provided with a corresponding audio CD from a photofinishing shop, or that the prints and CD could be made with a home PC and printer.

After each family had reviewed each others' albums in these formats, two further options were presented for comparison:

- **TV album**: The PC album experience could be replicated on an interactive television. It was suggested that the camera might be plugged into the television and used to control the on-screen album.
- **Audioprint scanner**: The printed photograph could have sound data on the back, in a form that could be scanned and played back from a handheld device. This capability was simulated using the prototype shown in Figure 8.1. A handheld box containing a speaker and a slot was plugged into a minidisc player. Four audioprint samples, one from each family, were prepared with corresponding audio tracks stored on minidisc. Automatic playback of sounds from the prints was demonstrated by inserting a print into the slot in the box, pressing 'Play' on the minidisc unit, and passing the print around the group. It was suggested that such prints could be made on a conventional printer.

Individual participants were then given forms containing all the above options, including the original audio cassette method experienced at home. They were then asked to place them in order of preference. The results of individual rankings of these options were discussed in relation to the handling of entire sets of audiophotos. Two further options for sending or exhibiting individual audiophotos were presented for final discussion:

- **Audiophoto cards**: A self-playing audiophoto could be created as a gift by customising a recordable greeting card. Three commercial cards of this kind were passed around the group as examples of this. They contained photographs from different families in the trial with sounds that could be played by pressing a corner of the card. It was suggested that these could be made up manually by sticking adhesive prints to a card base and recording the sound through a line in socket or an integral microphone. Alternatively they could be requested as a digital photofinishing service.
- **Audiophoto frame**: A self-playing audiophoto could be displayed in an audio-enabled photo frame. In the absence of any commercial frames of this kind at the time of the study, a prototype was made as shown in Figure 8.2. This comprised a standard 6" x 4" picture frame with an analogue sound recording and playback unit stuck to the back. The sound could be started or stopped by pressing a button on the back of the sound unit. It was suggested that this could be made up manually by inserting a

printed photo into the frame and recording a corresponding sound through a line in socket or integral microphone.

Figure 8.1 The prototype audioprint scanner
(Figure 1 in Frohlich, Adams & Tallyn 2000).

Figure 8.2 The prototype audiophoto card and frame

RESULTS FOR PLAYBACK OF AMBIENT PHOTOGRAPHS

Overall preferences
The results of the playback ranking exercise are shown in Figure 8.3. The average rank score is shown for each playback type. So higher preferences are shown by lower scores. Essentially, people preferred the two methods of review with the strongest association of sound and image; the PC album and the audioprint scanner. In both these cases the sound and image data are stored and invoked together, rather than kept separately and indexed to each other, as with the audio-cassette or the CD album. These last two options were felt to be too difficult or restricting to handle in the context of discussing and sharing photos face-to-face. The following comments were made about the audio-cassette method, but apply equally to the CD method. This is because in practice the CD was allowed to play through like an audio-cassette tape, without manual intervention from the users. It appears that in the heat of a photo-sharing conversation it is not possible to control images and sounds separately:

> *"It was too fiddly" (Mervyn)*

> *"There's no time to linger over the photos when you are listening to the sounds at the tape pace" (Philip)*

> *"I wanted to control the pace (of the tape) and hold the photo myself" (Sue)*

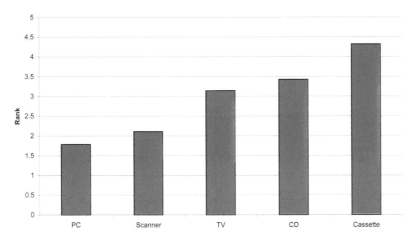

Figure 8.3 Average ranks for each of five audiophoto review options

In the course of discussing the status of these preferences, it became clear that each individual was not voting for a single method of playback in order of preference. In conversation afterwards, most people expressed a desire to use more than one method of playback depending on the context. Significantly for our analysis this often included a screen *and* paper method. This can be seen from

Figure 8.4 which shows the overlap of first and second choices made in the study. The participants were split broadly on whether they voted for a paper-based option or a screen-based option as their first choice. The undisputed paper option was the audioprint scanner while there was heated discussion between the advantages and disadvantages of the PC versus the TV (see below). However, when we look at the *second* choices of each group we find that a subset select the alternative medium. Furthermore, paper is chosen by these people as a *complement* to the screen option or vice versa.

Reactions to devices

The reasons for the above preferences become clearer when we consider participants' reactions to individual device options. Since the audio-cassette and CD options were quickly rejected by participants, discussion centred around the other main options of the PC, TV and audioprint scanner. We now step through discussion of these devices in turn. Reactions to the card and frame are also covered at the end of this section.

Paper option first	Opposite medium		Screen option first
Viv	Anna	Geoff	Paul
Christine	Mervyn	Debbie	Philip
Sue	Thomas	Chris	Will
			Liz
			Julie

Figure 8.4 Overlapping preferences for paper and screen playback options.

PC album

The PC album was liked and disliked for a number of reasons. The teenagers in the trial mentioned liking the PC itself, and associated it with playing games in an

upstairs study or bedroom. The idea of presenting photographs and sounds on the PC therefore fitted into this recreational pattern of use. The PC also turned out to be in an appropriate location for sharing audiophotos with their friends, who they tended to entertain upstairs.

> *"I like computers. I can switch off and go and play games" (Julie)*

> *"All you have to do is turn on the computer" (Thomas)*

> *"It's so easy to use, there's an option to have sound or you can just flick through" (Liz)*

> *"I don't take my friends to the lounge because that's adult. With a computer in my bedroom that would be a social place" (Anna).*

The adults were more ambivalent. Their opinions split roughly along gender lines. The fathers in the study recognised the power of the PC for editing audiophoto material and creating albums. They found the demonstration album interface easy to use and enjoyed the professional look of various features such as the automatic transitions associated with multi-photo pages.

> *"It looked impressive and you can trawl through them easily" (Chris)*

> *"I'm starting with the editing and I'm thinking you're going to have to sit at a PC and do that anyway so why not have it based around a PC and have it portable to other media?" (Paul)*

In contrast, the mothers in the study disliked the PC itself, and considered it too 'technological' a device for presenting photographs. They also argued that it was in the wrong place for sharing audiophotos with family and friends, since visitors tended to be entertained downstairs in the living room.

> *"I just think the more technological it gets, the more it puts me off. I want something simple, I don't want it complicated" (Sue)*

> *"The PC is not for us. Its in a small room in our loft conversion" (Debbie)*

> *"I don't want to get away from prints" (Viv)*

One of the objections to the PC album was that it was not portable. This was seen as a disadvantage because it restricted audiophoto access to a particular room of the house and also prevented the sharing of audiophotos with others outside the home. Sharing with grandparents who did not have a PC was thought to be a particular problem in this respect. A number of suggestions were made by teenagers and fathers to overcome these objections. These included the use of a portable (laptop) computer for sharing audiophotos, storage onto floppy disks or CD-ROMs, and printing the photographs without the sounds. In all these cases, the solutions were seen as supplementary to the presentation of audiophotos on a desktop PC, which was still seen by some participants as the best vehicle for showing material to a group of people. Again these findings imply a movement between different devices for different contexts of use.

TV album

Many of the advantages of the PC were seen to apply also to the TV. Hence the large screen format for photographs and the high quality sound, were appreciated by

those who valued such attributes on the PC. Additionally, the TV was sometimes seen as more suitable than the PC as a device for sharing photographs, because it encouraged a more relaxed and familiar style of interaction in a better location. Since the TV was considered equally at home in a bedroom or living area, this option appealed to both teens and adults who imagined using one in the most suitable location for them. The compatibility of storage format was also seen as an advantage. Because the study pre-dated the launch of DVD players in the UK, participants assumed that the audiophoto albums would be stored on video-cassette which was seen as a pervasive medium. Interestingly, these participants expected the same level of control and interactivity with the video-album as with the PC-based album, and did **not** want to view the album as a static slideshow.

> *"You could have it just like a PC. You could just flick through and have a special thing to put it through. I just thought it would be much better to have the video because more people have got a TV and video than have a PC – so that means you could show it to your friends" (Will)*

> *"You would sit on comfy chairs, and if you were showing special occasion photos to friends you'd present them on TV in the lounge" (Debbie)*

> *"TV is more sociable and people are used to it " (Viv)*

The similarity of the TV and PC albums led some participants to propose an ideal solution involving both. This was either seen as a single integrated device or two separate devices with connectivity between them. The PC could then be used for editing and creating albums that could be moved to the TV for sharing.

> *"I think ultimately if PCs are in every home and they are going to be Entertainment Centres in people's lounges, then no problem" (Chris)*

> *"Well if you have one of these predicted combined PC/home TV things then it would be an ideal combination wouldn't it?" (Geoff)*

> *"Well if you had an input that was for both PC and TV then you could do anything you like on the PC, if you've got one, and send it down the line on the internet or fax or whatever, or print and edit, and use the television in a social situation and send it to someone else with a TV. So you've got flexibility around who's got what and where" (Paul)*

Audioprint scanner

The ability to print audiophotos and play them back in your hand was welcomed by all the women in the trial. They saw instantly that this would allow them to continue using printed photographs as usual but with the added bonus of associated sounds. They praised the 'low tech' feel of the device, the fact that there was little or no set-up required, and the benefit of preserving tangible prints. One of those benefits was the longevity of paper as a storage medium. They simply didn't trust digital forms of storage. Another benefit was portability. Printed photographs can be shown anywhere, and mothers wanted the same flexibility with audiophotographs.

> *"Its small and mobile and the photos and sounds are together" (Christine)*

> *"And you've still got prints" (Viv)*

"I just want to show them casually where I am at the time... With this you could sit out in the garden" (Sue)

"There is something nice about having that tangible print in your hand. In fact I'd feel very insecure if the images were just stored on the PC" (Debbie)

The use of physical prints also appeared to imply a more intimate form of sharing than displaying photographs on a large screen. For this reason it was seen as particularly suitable for sharing audiophotos within the family, in reminiscing conversations.

"I imagine we would use it more than when we are showing photographs to other people" (Christine)

A subset of men and teenagers also saw the audioprint scanner as a useful complement to the PC or TV (see again Figure 8.4). They also mentioned portability as an advantage over a fixed PC or TV, and even suggested that the scanner was more appropriate than a laptop, which seemed too 'high tech' for sharing audiophotos. This sentiment also appeared to extend to the micro-portability of handling individual photographs. This was reflected in a number of comments about the accessibility of prints.

"I don't want to show £5 worth of photos on a £2000 laptop" (Chris)

"It's portable. You can bring it to other places' (Mervyn)

"I flip through photos 'cos they've got that feel to them. If you add equipment it feels like you are imprisoning the thing" (Geoff)

"You can go to the back one (with the scanner) without pressing the button all the time" (Thomas)

A number of concerns about the audioprint scanner emerged in this discussion. These included the ramifications of sending audioprints to others, editing audiophoto material, putting audioprints in albums, and getting better sound quality from a smaller device. Mothers in particular asked about sending material to others and realised that recipients would also need a scanner to playback the sounds. Although the cost of these devices was said to be low, this was still seen as a drawback to the solution. Fathers were concerned about editing material on the camera alone and struggled to understand if this could be done on the scanner. In fact, with this technology it could not. Some participants noticed that the scanner could not be used on photographs in albums where the printed sound data would be inaccessible. Several also objected to the size of the scanner itself and wondered if the external sound quality could be maintained in something more like an MP3 player. All these concerns lowered the perceived value of the audioprint scanner somewhat, especially in the eyes of fathers and teenagers. This led them to ask for printing from the PC, where editing, sending and high quality playback could be achieved more easily.

Audiophoto cards

The additional options of sending or exhibiting individual audiophotos in self-playing cards or frames were shown at the end of each session. The technology

involved in both solutions was similar, comprising the storage of up to 20 seconds of sound on a voice chip attached to a miniature microphone and speaker. However, the packaging of this technology within a cheap cardboard greeting card designed for sending, or a solid wooden photo frame with a glass cover, led to quite different reactions from participants. In general, they loved the cards but hated the frame.

Initial reaction to the audiophoto cards was overwhelmingly positive, as people imagined themselves receiving cards from friends and family. They were seen as novel, fun and easy to use. Furthermore, participants recognised that there was no need for the receivers of cards to have additional playback technology, such as a special scanner. The fact that they were self-contained and self-playing was seen as their biggest strength. This train of thought led participants to consider how they would use the cards as senders, and generated a range of creative ideas. Special occasions such as graduations, the birth of a baby or a birthday were mentioned in this context, as well as postcards from holiday. One father in the trial noted that new sounds could be re-recorded over olds ones, so that you could re-use a birthday card. Another father thought of recording holiday postcards from home before departure.

> *"That's brilliant... You could send a photo of the kids to grandma with them singing 'Happy birthday'" (Debbie)*

> *"They'd be great for a special occasion" (Mervyn)*

> *"You could say 'Happy birthday' and send something else from your holiday" (Thomas)*

> *"You could get your mother to send her birthday card back!" (Geoff)*

> *"It would be a lot easier than writing (postcards). You could record it before you go!" (Chris).*

To make the cards more suitable for these uses, participants suggested several improvements. They wanted the cards to be slimmer and in postcard form. They asked for a longer duration of sound storage so that they could send a clip of ambient sound with a voice message appended. Others suggested the possibility of adding multiple photographs. A final request was the ability to generate the cards from a PC, since the process of attaching digital photographs and sound clips from a camera was unclear. In short, the cards received considerable attention in the discussion because they were seen to have so much potential for sharing audiophotos with remote family and friends. In contrast, discussion of the audiophoto frame was short and not so sweet.

Audiophoto frame

Contrary to our expectations, there was an almost universal negative reaction to the audiophoto frame demonstration. In fact the most positive comments related to using it as a more long-lasting card that the recipients might want to keep. For example, one family thought of giving a framed audiophoto of their friend's baby's dedication to them as a present. The idea of keeping and displaying personal audiophotos in this form just didn't work for most of the participants. Whereas people were comfortable with the notion of glancing repeatedly at the same displayed photograph, they reacted against listening repeatedly to the same sound clip.

"Oh my goodness, That is over the top" (Christine)

"It would sell very well in Bavaria or Russia. They go in for musical boxes there" (Geoff)

"I wouldn't want to hear it over and over again" (Sue)

Although the audiophoto frame was not liked as a vehicle for displaying personal audiophotos, several people thought of commercial applications such as talking books, travel guides and holiday souvenirs. The most creative application was a kind of autographed audiophoto, explained enthusiastically as follows:

"Imagine if you were in a fan club and it was (a photo of) your favourite pop star... David Cassidy in my day... And it had a personal message. ['Hello Debbie I'll always love you'(Chris)]. You could sell buckets. Fantastic!" (Debbie)

Summary

In short, we have found that it was rare for individuals to express a preference for a single paper or screen-based method of audiophoto playback. Most participants recognised that one solution did not fit all circumstances of use, and expressed a desire to move between solutions depending on circumstance. A common combination, at least for teenagers and men in the trial, was to use a PC to create audiophoto albums which could then be shown on the TV or printed out as audioprints. Women were more inclined to favour audioprints alone, but also expressed interest in sharing audiophotos on the TV.

Within each paper or screen-based playback category, participants were very sensitive to the form and type of option available. Not all options were considered equal, even when the very same core technology was involved. For example, audiophoto cards and frames elicited opposite reactions as a result of the very different packaging involved. The card packaging implied a model of purchasing and creation designed for sending audiophotos to others. This behaviour was valued by participants and judged to be well-supported by the technology. In contrast, the frame packaging suggested the long-term display of audiophoto material for oneself. This was not valued so highly, and led to rejection of the technology. A similar thing happened with the perception of audioprints whose sounds could be played back from an audio CD or a handheld scanner. Although printed photographs were used in both cases to trigger the sounds, the *method* of triggering was seen as simply more convenient with the handheld scanner and allowed greater freedom of movement. The scanner also simplified the overall process of producing audioprints, since it cut out the necessity for a separate storage device (i.e. the CD itself).

The perception of screen-based options was also sensitive to the option type. Careful attention was paid to the different behavioural ramifications of using the PC or the TV as an audiophoto player. Participants noted that they were located in different rooms in the house and that this would affect how easily they could show audiophotos to different groups of people. The distance from the TV and PC screen was thought to affect the tone of the playback experience, and the greater flexibility of the PC was felt to be more suitable for editing audiophoto material. Finally, the different storage formats of PCs and TVs and their ownership by others became an

issue, as participants thought of taking audiophotos out of the house or sending them to others. All these findings show that participants judged each playback method on a very wide range of criteria. These included the set-up costs of using the equipment, constraints on the contexts of use, and compatibility with existing technology and behaviour – as well as the playback experience involved.

PLAYBACK OF MUSICAL AND TALKING PHOTOGRAPHS

A similar approach to that used in the audio-camera trial was used again to assess reaction to paper and screen–based methods of musical and talking photo playback. Participants in the audio-annotation trial were shown the same demonstration material on a variety of paper and screen devices. All of these demonstrations were shown in the Feedback group sessions, after participants had reviewed and discussed their own musical and talking photo albums on a desktop PC (see again Chapters 5 and 6).

As a result of the playback findings in the audio-camera trial, reported above, we modified the mix of paper and screen-based options used in the audio-annotation trial. The importance of portable screen-based options was acknowledged by the addition of a Tablet and a Palmtop device to the PC and TV. The success of self-playing audioprints and the involvement of album enthusiasts in the trial also led us to include an Audiophoto album option, alongside a handheld Audioprint player and Audiophoto card. Because of the lack of interest in the Audiophoto frame, and the already large number of playback options, we decided to drop the frame from the list of paper options. This left us with four screen-based and three paper-based demonstrations as described below.

The screen-based options for audiophoto playback were shown as follows. In each case it was suggested that participants could associate music or record voiceover on the device itself, or via an editing process on a desktop PC.

- **PC album**: Participants viewed each other's musical and talking photo albums on a flat panel display with stereo speakers, placed on a circular café table. The interaction was controlled by using a mouse to select forward and back buttons which turned over virtual pages of the album (see Figure 5.2). Sounds played automatically on presentation of each page.
- **TV album**: Demonstration material was presented on a 21 inch TV screen with stereo speakers. The TV album was authored using HP Memories Disk software on a PC to burn a CD-ROM in video CD format. The CD was then played back from a DVD player connected to the TV, and controlled from a DVD remote control device. The album was played through in slideshow mode, but it was suggested that pages might also be advanced manually, as with the PC album.
- **Tablet album**: A demonstration PC album, also created in Macromedia Director, was shown on a 12" Fujitsu 512 Tablet PC. Photographs were shown nearly full-screen at an absolute size of about five inches by seven

inches. Participants controlled the turning of screen pages by tapping on screen-displayed buttons with a pen stylus. Again, sound played automatically on presentation of each page.

- **Palmtop album**: A lightweight version of the Tablet album with more compressed image and sound files was created using the HP Pocket PC camera software running on an HP Jornada PDA. This software already supports audiophoto capture and playback; automatically associating sound and image files with the same filenames. Photographs were shown full-screen at a size of about two inches by three inches. They could be controlled using forward and backward movements of a rocker switch on the casing, with sounds playing automatically for each new page.

The paper-based options for audiophoto playback were shown in the following way:

- **Audioprint album**: An audio-enabled photograph album from Brookstone Gifts was filled with demonstration content from the trial. This product supported the association and playback of a twenty second sound clip for each double page spread, from numbered buttons beneath the pages (see Figure 8.5). The demonstration album was created by placing individual six inch by four inch photographic prints on self-adhesive pages and recording the first 10 seconds of their associated music or voiceover tracks in memory. Participants could then browse the album, pressing the appropriate buttons for each page at will. It was suggested that participants could create their own albums manually.

- **Audioprint player**: A new improved audioprint player prototype was built in response to feedback on the previous prototype and the results of a separate technical investigation. The second version was based on the use of solid-state storage in the paper itself to hold the audio data associated with the photograph. Hence a voice chip from ISD measuring 5mm square and just 1mm thick was mounted on a substrate and embedded in each print sample. Each chip stored up to 30 seconds of high quality sound. The sound could be played back in real-time via contact with the handheld player shown in Figure 8.6. Three audioprint samples were created for demonstration in the Feedback session. It was suggested that individual audiophotos could be printed on an adapted HP printer loaded with 'audiopaper'.

Figure 8.5 The audioprint album

Figure 8.6 The second prototype audioprint player
(Figure 3 in Frohlich, Adams & Tallyn 2000)

- **Audiophoto card**: A two-page opening card similar to that used in the previous trial was demonstrated in the Feedback groups. It was suggested that participants could create their own cards manually.

After seeing these demonstrations, participants were asked to indicate on a form, which device they would like to use to playback musical or talking photographs. They were allowed to tick more than one option for each type of audiophoto, in recognition of the fact that multiple options were requested by individuals in the previous study. Forms were then collected as a basis for discussing selections. The resulting votes and comments will now be described.

RESULTS FOR PLAYBACK OF MUSICAL AND TALKING PHOTOGRAPHS

Overall preferences

The preferences for different kinds of playback methods are shown in Figure 8.7. This time, preferences are expressed in terms of the number of votes for each method. Each of the eleven participants was allowed to vote for as many methods as they thought they would use. Votes were cast separately for the playback of music and talking photographs.

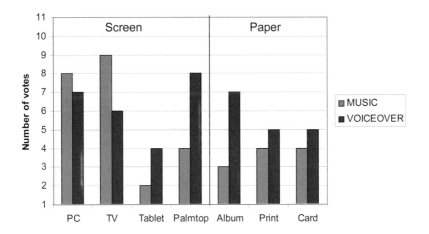

Figure 8.7 Preferences for the playback of musical and talking photographs

This graph is a dramatic illustration of the fact that no single playback method was preferred over others. The PC and TV options came out top overall, but a large number of people also indicated wanting to use the palmtop, album, card and print methods. The least favoured method was the tablet, although even here, four out of eleven individuals said they would be interested in using it. A further finding, not

shown in the table, was that each participant selected an average of 2 screen methods and 1 paper method of playback. Again there was no single dominant playback method, even within the preferences of individual participants.

One pattern that is evident in Figure 8.7 is the divergence of playback preferences by content type. Some playback methods received more votes for musical rather than talking photographs or vice versa. The PC and TV were seen as more suitable for playback of musical photographs, while the handheld devices and paper methods were seen as more suitable for talking photographs. The reasons for this pattern and the selection of multiple methods of playback, can be seen from the discussion of preferences that followed the voting activity. It is to this discussion that we now turn.

Reactions to devices

As before, there was more discussion of favoured than non-favoured options for playback, with comments focussing more on the positive than the negative aspects of each device. However, no device in this study was ruled out as a potential method of playback, unlike the audio-cassette and CD album in the previous study. There was also more openness to playback of audiophotos on the PC and other screen-based options, particularly by women in the sample. This may have been because the study was carried out in 2003; several years later than the audio-camera trial. Participating families were therefore more familiar with computers and the sharing of photographs via the PC and internet, even if they did not necessary own a digital camera themselves. Hence we begin with comments on the PC as an audiophoto viewer, and go on to consider all the other screen and paper-based methods of playback in turn.

PC album

The PC was seen as a good way of storing, editing and sharing audiophotos privately within the family, and as a method of sending audiophotos to other people. It was seen as less suitable than the TV for showing audiophotos to extended family and friends. This was partly because the interaction was said to become cramped with more than about 2 people, and because the location of the TV was more appropriate to entertaining guests (see below). PC and TV contrasts of this kind were common in the discussions and the idea of networking one to the other emerged again as a way of getting the 'best of both worlds'. One elderly member of the group pointed out that the PC screen was difficult to read from compared to the TV, but on the whole the consensus was that both devices delivered a high quality audio-visual experience.

> *"I would get a reasonable sized display with the quality and resolution but I'm very biased I think" (Harry)*

> *"Well my PC screen is bigger than your TV screen so its fine for showing photos" (Vicky)*

It was the storage, editing and communication capabilities of the PC that really differentiated it from the TV. People could imagine editing audiophoto material much more easily on the PC, and sending audiophotos to others via email or the web. They also saw the PC as a possible place to archive photographic material.

These kinds of uses were cited as often as sharing audiophotos on voting forms, which also asked participants to write down when they would use each playback method selected. Some typical written comments were as follows:

"As a record or to send to family or friends" (Traci)

"Sending or placing on the internet"' (Rob)

"Editing photos and manipulation" (Gordon)

"Personal use only" (Rachel)

TV album

The TV was seen primarily as a way of showing audiophotos to groups of family and friends. This was cited as the most common context of use on the voting forms. The viewing distance from the TV, seating comfort, and the public location of the TV were all said to contribute to its suitability for group sharing. Some typical comments from the discussions were as follows.

"Its more relaxed I think sitting around like this than sat on a computer chair...I just find it more relaxing to sit and watch a TV than a PC" (Rachel)

"For me the TV is something where a group of people can share it and there's no problem. With the PC once you get more than two people it tends to get a bit crowded" (Jane)

Other reasons for using a TV album included greater familiarity with watching TV rather than using a PC, especially by visiting parents or grandparents. This reason carried over into a debate about how to send audiophotos to distant relations who did not have a PC. Although the possibility of sending video-cassette tapes was mentioned here, participants were more inclined to send augmented prints of one kind or another (see paper options below).

Tablet album

Only a small number of participants voted for the tablet as a playback device, and most comments made in discussion were negative. For example, it was considered too heavy and bulky to hold or carry for long, and too difficult to share with others because of its restricted angle of viewing. Essentially, only about two people could comfortably look at its surface at any one time. On top of this the sound quality was thought to be poor compared with the PC and TV.

"You've got an angle problem" (Harry)

"You've got to get it at the right angle as well otherwise you can't see anything. Sounds awful as well" (Rachel)

"Its unrecognisable" (Gordon)

In spite of these sentiments, several people mentioned its potential for showing audiophotos in a business context. Jane worked in an Art and Design Department of a university and thought that the tablet would be useful for carrying around a multimedia portfolio. Bryon suggested using it as a selling tool, and began to imagine new kinds of audiophoto adverts that might be created for this purpose. These comments show that certain devices are associated with certain contexts of

use, and that both these factors affect the kind of content that might be created and shown in them. Unfortunately here, the work-related contexts of use associated with the tablet device appear to be similar to those of a laptop and worked against its use with domestic audiophotographs. A similar effect was encountered in the audio-camera trial when discussing the merits of sharing audiophotos on a laptop computer. Like the laptop, a tablet was felt to be a form of technology overkill for the casual showing of photographs.

Palmtop album

In contrast to the tablet, the palmtop received a large number of votes and much more positive comments. Its main advantage appeared to be its extreme portability, which made it suitable for showing audiophotos out of the home. This was cited as the main context for use on the voting forms in connection with visiting friends, going on trips and carrying it around to use in unplanned conversations. These factors were reiterated in later discussions. Somewhat surprisingly, the strongest advocate of the palmtop was Betty, a grandmother in the trial. She preferred it to more familiar paper-based solutions because it held a great number of photographs but fitted in her handbag.

> *"I like the idea of that, that you can take it around anywhere if you were visiting somebody you could take it there to show them " (Betty)*

> *"Well that is one for the grandmothers to put all the photos of the grandchildren in, similar to the things they carry around now to the WI (Womens' Institute) or wherever they gather" (Jane).*

Although the viewing angle and sound quality problems were mentioned again for the palmtop album, participants seemed more willing to tolerate them for the convenience of showing audiophotos wherever they happened to be. Two concessions they did make to these problems were to mention one-to-one sharing with individuals rather than groups of people, and to favour the showing of talking rather than musical photographs. In fact twice as many people voted for the palmtop album as a method of playing back talking photographs compared to musical ones (see again Figure 8.7).

Audioprint album

In contrast to the palmtop, the self-playing audioprint album was seen as too large to carry around. It was therefore considered to be a piece of technology for archiving and sharing audiophotos in the home. Its two perceived uses both related to 'special' photographs. Participants saw themselves using it as a showcase for archiving and sharing memories of an important event or trip. Alternatively they considered it suitable for creating as a gift to send to family and friends abroad. Given these occasional uses, participants required much higher quality sound capture and reproduction to match the high quality of printed images. This was revealed in complaints about the short duration and poor quality of music and voice clips in the demonstration album. Like other print-based methods of playback, the album was seen as more suitable for voice commentary than music. In this case the commentary was felt to go particularly well with the personalisation of a special set of photographs, as shown in the following quote.

"I think the album would be nice with the sound to send to people who live a long way away who you don't ever see. So you could do the pesonalised message that went with it. I'm thinking about years ago when my mum's brother lived in South Africa and we used to sit at home and make tapes that we sent him with all the news, which wasn't just about news, but family voices." (Jane)

A number of participants were concerned about the potential cost of an audio-enabled album compared to what they usually spend on a conventional one. This led two people to suggest a re-usable album player, similar to the audioprint player, which could be used with any album. Albums themselves would have to have some kind of removable storage medium associated with them that could be inserted into the player when required.

"Could you put something different in there to record on, like a tape or CD, for different albums?...What I mean is, if you've got a lot of albums, if you had something like that which would slot into the album, you could put a different recording into each album to suit" (Byron)

"You'd have to make it so that the photo album wasn't disposable, i.e. you can take the photos out and put a new photo in and play it" (Vicky)

Audioprint player

Whereas the audioprint album was seen as a device for special audiophotos, the audioprint player was seen as a device for playing back routine audiophotos. This distinction roughly echoes that between loose prints and albums today, where albums are reserved for a subset of the best prints (Frohlich, Kuchinsky, Pering, Don & Ariss 2002). Hence, participants spoke about using the player to browse through printed audiophotos themselves, and also to annotate regular prints with voice messages for sending to others. This accounts for the increased number of votes for voice rather than music playback in Figure 8.7. The issue of recipients of audioprints needing a player to playback the comments emerged again in this study. However, participants here resolved it by limiting the use of sending to very regular or routine recipients who could be provided with a player with the initial set of audioprints.

"I could buy the attachment and send it too, if I was going to send a lot of photos. And the kids could record their voices and photos or whatever and I would just have to mail the photos off. And they can just plug them in and listen, or just look at the photos if they don't want to listen" (Vicky)

Audiophoto card

Audiophoto cards received the same pattern of votes as the audioprint player (see again Figure 8.7). However, they were judged more similar to the audioprint album in their potential use. They were associated with the sending of special audiophotographs to distant family and friends on occasions such as birthdays, anniversaries and other causes of celebration. In fact they were treated as extension of conventional greeting cards, which could be used to hold personal audiophoto material instead of a pre-designed message and graphic. Participants appreciated this

flexibility, not only for sharing photographs more effectively, but also for designing new kinds of communication on these special occasions.

> *"I would certainly be willing to make a card on some specific special occasion. I guess that is taking a picture from the camera, printing it out and making a recording, whether that's music or voice" (Jane)*

Summary

Findings on the playback of musical and talking photographs were essentially similar to those on the playback of ambient photographs. No single playback method was preferred above others and participants expressed a desire to use different methods for different purposes. In fact, because of the change of methodology for measuring preferences, we were able to determine that each individual wanted to use about three different playback methods. On average two of these were screen-based methods while one was paper-based. In this study, movement between options was more a matter of context than personality, since there were fewer idiosyncratic choices or age and gender differences. Common contextual factors affecting playback selection were the type and size of the audience for audiophotos, whether they were being shown in or out of the home, and whether the audiophotos were routine or special in some sense. Mention of this latter dimension was a new development, and appeared to be significant for the choice of screen or paper methods of playback.

Routine audiophotos were associated mainly with screen-based playback. Participants expressed a desire to review their own audiophotos together on the PC, or to show them to visitors on the TV. They also favoured use of a Palmtop device for showing routine audiophotos out of the house. This trend extended to the regular sending of audiophotos to distant family and friends through the PC. The only exception to this rule was mentioned in the case of sending audiophotos to people without computers. Participants seemed to favour using audioprints with duplicate sets of audioprint players distributed across households.

In contrast, special audiophotos were usually associated with paper-based playback. Hence, the audioprint album was seen as a vehicle for archiving precious sets of audiophotos for personal use, or for sending to others as a gift. Audiophoto cards were seen as a more disposable kind of photographic communication to others on special occasions. This trend appears to mirror a recent decline in the number of digital photographs being printed at home. Consumers are becoming more comfortable about reviewing photographs on-screen and more selective about which photographs they decide to print out.

DISCUSSION

Having remained neutral about the technology involved in audiophotography in previous chapters, this chapter has been devoted to its examination for audiophoto playback. A key issue to resolve was the relative value of paper versus screen-based methods of playback, since unlike video clips, audiophotos could technically be

played back from a variety of audioprint devices. Previous research on the future of reading and tangibility in design suggested that both paper and screen methods of playback might be preferred for different reasons, although the usefulness and familiarity of photographic prints might inhibit a move away from the paper medium.

In fact we found that participants were impressed by the screen-based audiophoto albums they were shown in each study, and indicated their willingness to use them for playback in a variety of contexts. The PC, TV and Palmtop albums were found to be most appealing, because of a number of features they possessed which paper prints did not. These can be seen as comparable to the affordances of screen-based documents observed by Sellen & Harper (2002) and listed in the introduction to this chapter. For audiophoto review, screens were valued for the following affordances:

- Compact access to a large amount of material
- Content editing
- High quality audio-visual experience
- Viewing comfort
- Efficient transmission of material

These screen properties overlap with those of Sellen & Harper, particularly through the inclusion of editing and access to large amounts of material. The latter property was probably the main attribute underlying the attraction of the Palmtop as a portable method of playback. However, other properties in their list were not mentioned as important in the domestic audiophoto context, such as full-text searching or links to related materials. Instead, other properties were important, such as audio-visual quality, comfort and transmission. All these factors lead us to an answer to the question of *'What advantages screen-based photographs must offer for people to give up prints?'*. They must begin to create a more comfortable and compelling viewing (and listening) experience than can be achieved on paper, with associated gains in the efficiency of storage, editing and transmission of material.

This shift towards screen-based methods of playback by no means eradicated the desire for printed audiophotos, but it did mitigate their use. Essentially audioprint methods of playback came to be reserved largely for the review and sharing of *special* audiophotos. In particular, the audioprint album and cards were seen as good ways of packaging selected audiophotos for special occasions and sending them as personalised gifts to other people. Audioprints used with a handheld player were considered for more routine use, alone or with a small number of family members. These methods possessed a number of properties in common that made them superior to screens for these purposes. These can be seen as affordances of paper that are relevant to audiophoto playback.

- Ease of manipulation and navigation
- Ability to spread out and compare information
- Longevity of archiving
- Lowest common denominator for sharing
- Tangible form

Again there is overlap with the affordances of paper important to the office setting, mainly through the continued relevance of manipulation and the ability to spread out more than one image at a time. However, the ability to write on prints or other paper whilst reviewing photographs was not relevant. Instead, it was more important to know that recipients had a way of playing and seeing what they had been given, that the material was not going to become obsolete over time, and that it had a tangible form that could count as a gift. Other benefits of tangibility may well emerge in practical use, since differences in the dynamics of screen and paper conversations are not immediately apparent in a focus group setting.

In short, we have found that the lesson of the paperless office debate also applies to the debate about the future of digital photographs in the home. Domestic photographs like office documents will not go completely paperless because the properties of paper remain valuable for particular contexts of use. This value is increased in the case of audioprints where ambient, musical and spoken sounds can be invoked from the paper to enhance memory and communication around it. Screen-based photographs and sounds extend these values, when contexts of use change. This leads us to predict the co-existence of paper and screen-based methods of audiophoto playback in and out of the home.

Exactly which methods are appropriate to which contexts is complicated to explain from the data, but some answer is demanded from our other research question about context switching: *'In what contexts will people prefer certain kinds of paper or screen-based experiences with photographs?'*. Using the contexts of use identified in the diamond framework of Figure 3.7, I have attempted to summarise the findings for each context in Table 8.1. This shows the playback methods considered most suitable for each context, across the two studies. An entry in a cell refers to the kind of photo sharing that was thought to be appropriate to that particular method and playback context. Empty cells simply reflect the lack of any comments on the appropriateness of the method and context combination.

Rather than describing these playback choices again for each context, it is worth noting some of the factors that led participants to change their choices within each column of the table. For example, we found that the *location* of the activity affected playback selection especially in social settings. The PC and TV were preferred for sharing audiophotos in the home, while the palmtop or audioprint scanner were preferred for sharing out of the home. *Audio quality* was another factor affecting choice of playback method in several contexts. In general, higher quality was required for music playback and for public sharing of audiophotos, and this favoured the PC and TV methods whenever possible. The *existing infrastructure* was also an issue in the selection of methods in the 'Interpretation' column of the Table 8.1. This led some participants to choose self-contained paper-based methods of playback like the audioprint card or album when sending material to other people. Finally, the *effort* of creating or transmitting material was considered when thinking about the overhead of using each method. This worked against some of the paper-based methods such as the audioprint album.

PLAYBACK CONTEXTS

		Remembering	Interpretation	Reminiscing	Storytelling
SCREEN	PC album	Routine individual downloads and editing	Recipient of routine emails or web postings	Routine group reviews	
	TV album			Routine group reviews	Special group presentations
	Palmtop album	Routine individual reviews		Routine pair reviews	Special pair reviews
PAPER	Audioprint Player	Routine Individual reviews	Recipient of routine audioprints	Routine group reviews	
	Audiophoto Card		Recipient of special occasion cards		
	Audiorprint album	Special event album	Recipient of special event album		

Table 8.1 A summary of audiophoto playback methods
preferred for different contexts of use

These factors reveal more than the use of a wide variety of criteria for playback selection. They show a certain kind of systems thinking by participants, who judged each method in terms of its overall process of use as well as by the playback experience it delivered. This view is consistent with a way of thinking about media as socio-technical systems of production and consumption rather than simple, technological means of presentation.

Hesse (1996) develops this argument in relation to the future of the book, by contrasting the printing press (technology) with the modern literary system of supporting authorship and readership around fixed writings (system). The real challenge of new technology, according to Hesse, is not in providing new technical methods of reading books, but in changing the relationships between author and reader so as to transform the system of book publishing. In the same way, the real challenge of audiophoto technology is not *only* in providing new ways of reading photographs, but *also* in changing the relationship between photographers, subjects and audiences so as to transform the system of domestic photography.

Participants in these studies appeared to recognise this instinctively for the system of photography represented by the diamond framework. Some presentation methods appeared to priviledge or disadvantage certain actors or activities in the system, compared with others. This led people to optimise the system for particular uses, by switching technical methods. This results in a kind of *domestication* of technology, by selecting and adapting its properties to existing social practices.

In the final chapter, I take this argument further by reflecting on the prospects for a new integrated practice of audiophotography, arising out of the technological possibilities of audiophoto capture and playback, and the range of values different kinds of sound seem to provide.

Conclusions

"Beyond information and communication, the new computing will emphasise innovation... Computers are tools for doing and making. They fit comfortably with the Renaissance definition of *homo faber*, man the maker" (Shneiderman 2003, p11)

In this last chapter, I review what we have learned about domestic photography and the role of sound, in order to outline the prospects for a new practice of audiophotography. These prospects depend both on the motivation to incorporate sound capture into the ordinary processes of photo taking and sharing, and the existence of suitable technology to allow people to do this in an accessible way. Hence I discuss the kind of technology required and its relationship to the *content* people want to create. I conclude with recommendations to consider content design in research on computer-mediated communication, and some personal comments on the future of audiophotography.

LESSONS ON PHOTOGRAPHY

Although the focus of this research has been on the role of sound in domestic photography, it has also thrown up discoveries about photography itself along the

way. This process has been similar to the study of visual illusions, which often reveal new things about the process of ordinary visual perception. By studying audiophotos, we have often seen how photographs themselves seem to work. Given the lack of previous research on domestic photography, it is worth summarising these insights now, ahead of a return to the question of sound.

Out of a review of previous research I proposed a new framework for understanding domestic photography, shown in Figure 3.5. On the whole, this has proved useful as a way of understanding the interactions with photographs that we have observed in our studies. In particular, the distinction between the personal and social use of images helped clarify the dual role of a photograph in serving as a memory trigger or as a prop for communication. The enumeration of three classes of 'users' of photographs also served to highlight the various perspectives that people can have on the same image and the different things they might ask or say about it. Indeed, the prediction that the photographer and the subject of a photograph might have a completely different kind of conversation about the photograph with each other (reminiscing) than with someone not present at the time (storytelling) turned out to be correct. Reminiscing conversations sounded quite different to storytelling ones, because they were designed to find a shared memory rather than to describe a private memory to others. The fact that the majority of naturally occurring conversations around photographs turned out to be reminiscing conversations without stories, was a surprising but major finding of Chapter 7.

Some shortcomings of the diamond framework also emerged from the research. The voice used in storytelling did not vary cleanly by photographer or subject. Subjects *were* more likely than photographers to speak in the first person when recording voiceovers on photographs, but *both* parties also used the third person to refer to the activities of others (see again Chapter 6). In addition, it was common to find more than one subject or audience talking about a photograph. In fact, the average number of people in a photo-sharing conversation was four (Chapter 7). This is hard to represent in the framework diagram, which shows a single photographer, subject and audience around a photograph. This arrangement also implies a real-time sharing of photographs, whereas participants in our studies reported extensive asynchronous sharing by mail or email. The sending of photographs back and forth between people in the framework diagram cannot easily be shown at present, nor can the review of photographs over long periods of time.

To accommodate these shortcomings I suggest another use of the framework to show a series of photo 'outings'. An example series is shown in Figure 9.1.

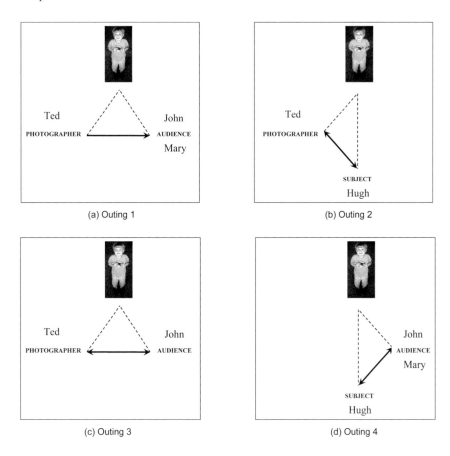

Figure 9.1 Extended use of the diamond framework to show a series of
photo outings over time.

Individual triangles in Figure 9.1 represent an outing made by the same
photograph. Each outing uses the relevant part of the diamond framework to show
exactly who was involved in reviewing the photograph. Arrowheads are used on
connecting lines between participants to show whether the interaction is live (two-
way) or asynchronous (one-way), and multiple name labels are used to represent
multiple people in the subject or audience role. In the first outing, a photographer,
Ted, is shown to send a photograph to two audience members, John and Mary.
Outings unfold from left to right over time, showing the social history of the
photograph. For example, in the second outing Ted shows the photo to its subject,
Hugh, before going on to discuss the photo with John who received it earlier. Mary
then shares it with Hugh while John is present. This scheme captures the cyclical

nature of photo sharing better than an individual diagram, and shows how new meanings might accrue to photographs over time.

In addition to applying the diamond framework for photography, the above research has revealed a number of new insights about how domestic photographs *work*, both as memory triggers and as communication props. Let us take each of these roles in turn.

There were many ways in which photographs seemed to serve as memory triggers in our studies. These extended far beyond a simple association with the moment in which the photograph was taken. There *was* a sense in which photographs reminded people of the informational details of an original event. This process was made visible in reminiscing conversations like that shown in Figure 7.7 where two girls are discussing why they took a picture of their friend on the telephone. However, just as powerful was the effect of a photograph in triggering something of the original emotion of the event. This can be seen as a very practical form of transference from the image to the photographer or subject (c.f. Schaverian 1991), which works at a subconscious level to take them back in time. This effect was referred to in Chapter 4 as retropresence. We can imagine it also working on an independent audience for the photograph, by keying into *their* emotional memory of similar events, thereby creating empathy with the photographer or subject.

It was also found that the same scene depicted in a photograph could have multiple informational and emotional associations. This was highlighted most dramatically in the case of the flashback voiceover recorded for the photograph in Figure 6.5. The photographer, John, spoke first about the capture of this particular image, but went on to describe previous visits to the same location when his children were younger. The fact that the same scene was associated with much earlier times of John's life, lent poignancy to the photograph and his commentary on it. In fact, we suggest that it is the *comparison* between memories, then and now, which gives rise to a sense of nostalgia: defined as a longing for past times. In general, we found that a photograph could have multiple associations by indexing a broader chunk of time than that depicted in the image itself. These chunks appeared to relate to each other in a tree hierarchy as shown in Figure 9.2. The same kind of hierarchy has also been found in other studies of autobiographical memory (Conway 1990). Each level in the tree corresponds to a different chunk of time, ranging from instantaneous 'moments' at the top of the tree, through 'activities' and 'episodes', to entire 'eras' in a person's life. Whole collections of memories and emotions could be evoked from a photograph associated with a lower branch in the tree. This was particularly true of portraits of individual people, which often led the photographer to think and talk about the history of their relationship with the subject (as in Figure 6.8).

There were also many ways in which photographs served as communication props. The photographs could be used in live conversations or messages, for reminiscing or storytelling. In reminiscing conversations we found evidence of collective remembering, where two or more people would use details in the photograph to remind each other of the original event (Chapter 7). When an audience member was also present we observed collaborative storytelling, where the story of the event was told jointly by the original participants (also in Chapter 7).

This interactive use of photographs serves to deepen the relationship between members of the original capture group by shaping a public account of their experience. These accounts may come to be quite prized and well-known over time, as family stories, or group stories which help to define the relationship of participants and their identities as members of a family or group (Norrick 1997).

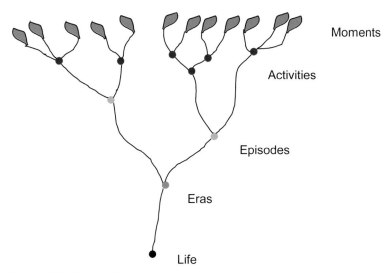

Figure 9.2 A hierarchy of memories and emotions associated with photographs

In storytelling conversations, *some* photographs were used as springboards for stories. Other photographs were not so effective as springboards, and were used only to mention aspects of the context of capture, or were passed over altogether. This suggests that although there may technically be a story-of-the-photo behind every photograph, not all stories are equally interesting or even noteworthy in conversation. The story for any particular photo may also differ with the audience. Hence, we found that storytellers were very good at designing their stories to interest particular audiences, and that audiences were good at steering storytellers to photographs and stories of interest to them. This meant that it was difficult to record a general-purpose commentary on any set of photographs without having a particular audience in mind (Chapter 6). This led to tension for some participants in our studies who wanted to personalise and contextualise their photo albums to hand down to their children and grandchildren for posterity. In this respect, the very flexibility of a photograph for telling multiple stories became its downfall as a memory record for future generations.

THE ROLE OF SOUND IN PHOTOGRAPHY

The above insights on domestic photographs now form a good basis for understanding the role of sound in photography. This section begins by summarising the *effects* of introducing different sound types into the diamond framework diagram. The *reasons* for these effects are then considered in terms of the way sounds influence the use of a photograph as a memory trigger or a communication prop.

Figure 9.3 shows the positive influence of sound on each form of interaction in the diamond framework. The four different types of sound we have considered in the book are shown in different colours in the key and figure. The presence of a coloured line on the diagram indicates some kind of enhancement to the selected form of interaction.

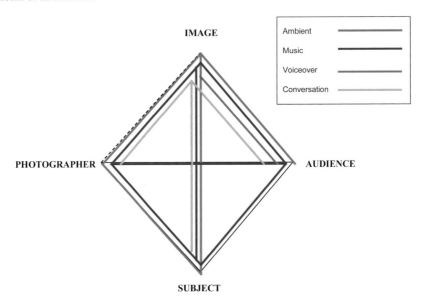

Figure 9.3 The positive influence of different sound types on interaction with a domestic photograph.

Ambient sound was the first type of sound we considered and one of the most attractive for enhancing photographs. It seemed to enhance the photograph as a memory trigger by keying into an audio memory for the event. In addition it added extra information and atmosphere that was appreciated by audience members for interpreting the meaning of the photograph. This background ambience appeared to liven up reminiscing conversations but inhibited storytelling ones, where audience members preferred to concentrate on a live discussion of the photograph. This explains why ambient sound does not appear on the storytelling lines in Figure 9.3.

In contrast, music appears on all the lines in Figure 9.3. This is because it was found to work like ambient sound for enhancing memory and interpretation of a photograph, and was less interruptive for all kinds of conversation around the photograph. In the first case, music was felt to colour the photograph with an emotion or mood that helped all participants remember or imagine what it felt like to be in the scene. It also triggered memories by association with particular pieces of music or by the addition of hidden messages through the lyrics of a song. In the second case of social interaction, music seemed to lift the atmosphere for sharing a photograph, as at a party. It was found to stimulate conversation, even in storytelling situations.

Voiceover was probably the least flexible form of sound for enhancing photography. Its benefits were limited to aiding the interpretation of a photograph by a remote audience. However, for this purpose it was extremely effective. Audience members reported a much greater interest in the photograph with a voiceover attached, and appreciated the way the content and the voice itself personalised the image for them. Voiceover authors also liked the way they could personalise and frame a photograph with commentary, once they had overcome their stage fright in recording themselves live. But for all other interactions with photographs, voiceover was disliked. Photographers and subjects of photographs didn't need or want to hear themselves explaining the images, and all participants found it difficult to talk over a voiceover recording in conversation. Voiceover therefore had the opposite effect to music, of inhibiting rather than stimulating photo-talk.

Finally, photo sharing conversations themselves were found to have some use in reminding people of the contexts in which their own photographs were captured or shared, and helping the interpretation of the photograph by an audience. These benefits of recorded conversation are shown on the *personal* interaction lines of Figure 9.3. However, this finding only seemed to apply to selected parts of storytelling conversations that contained the best stories. Reminiscing conversations were less likely to contain useful contextual details or descriptions, while much storytelling talk was found to contain filler comments or non-photo related material. Furthermore, people did not want to playback any records of previous conversations in a current conversation. This accounts for the absence of conversation labels on the *social* interaction lines of Figure 9.3.

The reasons for these effects of sound on photography relate to the way sound enhances a photograph's capacity to trigger memories or conversational moves. For example, certain kinds of sounds appeared to remind people of whole phases of their lives, such as the sound track in Figure 5.12. Because this tune was played repetitively in a video programme serial, it came to be associated with an extended period of childhood in which the serial was watched. Other repetitive ambient sounds came to have similar long-term associations, such as the regular playing of the trumpet in the square of Figure 1.1. These cases show that certain sounds may trigger collections of memories from a lower part of the memory tree shown in Figure 9.2. Generalising from this observation it may be that recorded sound itself is less specific to a particular moment in time than a photograph, and therefore triggers

a more nebulous and broader set of connections in the mind. An even broader set may be triggered by more primitive senses such as smell or taste.

Against this observation, ambient sound was also found to trigger a very specific feeling of retropresence to the past. People reported an emotional reaction to hearing the sounds of a particular scene, which appeared to transport them back to that scene in time. I observe anecdotally that this kind of effect is even more powerful if you close your eyes, and seems to be enhanced by high fidelity recording and playback. It appears that an image is enough to trigger a visual memory of the scene that can then be enjoyed imaginatively by listening to its associated sounds. I have found very little discussion of the relationship between visual imagery and photographs in the research literature, but suggest that audio may play a role in stimulating visual imagery from a photographic context.

The fact that sounds have a duration and unfold over time probably contributes to this effect, since for any ambient audiophoto, the listener is taken forward on a journey that may include the taking of the photograph itself. Listeners must therefore imagine an approach, a capture and a development of the scene, depending on when the photograph was taken within the sound clip. This property of audiophotos contrasts with the *ice*-like property of photographs in pointing backwards to a frozen moment in time, or the *fire*-like property of video in pointing forwards to the unfolding of a scene (Wollen 1989). Audiophotos contain a paradoxical combination of both, by pointing backwards to a moment that then unfolds. In this respect they can be likened to *water*, which has a slower and more predictable movement than fire, but can run its own course over a particular mental landscape. In this respect audiophotos appear to satisfy a need for greater realism in photography without removing the space for imagination (c.f. Chalfen 1998).

Regarding the ability of sound to affect conversation around an image, I have found that its duration can alter the length of time a photograph is regarded and discussed. This worked to inhibit conversation around a photograph with voiceover, as participants stared at the image and waited politely for the voiceover to finish before talking to each other. In other cases the effect of the sound was more positive, allowing participants to talk over a music track for example while enjoying the emotional ambience and associations created by it. Information contained in a musical or ambient sound clip could itself become a talking point in the conversation, and serve to further extend the conversation around the audiophoto. When this sound stretched beyond an individual photograph, it gave a certain pace to the presentation of multiple photos. This sometimes set up a narrative explanation of a sequence of images, although it was more common for narratives to spring off individual photos in the sequence and become out of sync' with the upcoming photos and sounds. Alternatively, extended sounds such as music tracks worked to bracket groups of photos together as belonging to the same set. This allowed photographers and subjects to talk about a group of photographs and the activity they represented. All these factors combined to change the dynamics of photo sharing conversations in various ways.

Compared to the expectations of myself and my colleagues about the role of sound at the beginning of our studies, these findings contained a number of

surprises. Music had a more powerful effect on photographs than we anticipated, especially on ourselves as observers of other people's audiophotos. Ambient sound turned out to be richer than we expected, because it contained other kinds of sound such as music, live voiceover and conversation within it. This may explain why it had mixed effects in photo sharing conversations, where it was probably the spoken parts of it that were most annoying for storytelling. Voiceover was seldom used as a personal voice label, as suggested in our early focus groups. It was also *much* more disruptive to live conversation than we anticipated, and gave rise to some of the most bizarre conversations we have ever witnessed. Recorded conversation was less useful than we expected because we didn't understand how difficult it would be to *find* a story to record. We were also amazed at the different way an audiocamera was used compared to a camcorder. Users began to listen more carefully with the audiocamera and think in terms of capturing sound memories as well as visual memories. This was something they never did with a camcorder, despite its ability to record sound. The ability to record sound memories in all these forms, confirms Edison's original belief in the sentimental value of phonographic recordings compared with photographs. However, the *combination* of audio with photographs brings two memory-making practices together, and gives people a practical way of enjoying sound memories as an extension of photography.

AUDIOPHOTO CONTENT AND TECHNOLOGY

The different values of sound in photography suggest that consumers may want to combine one or more types with the same photograph. They may also want to switch these clips on or off, individually or together, depending on the playback context. This leads to a new vision for future audiophotographs, illustrated in Figure 9.4. Photographs might be displayed within a virtual frame whose edges can be used to playback ambient sound, music, voiceover or conversation associated with the image. Touching more than one edge of the frame at once might start multiple clips playing together, and allow users to create ad hoc mixes of sound types at playback time. This possibility can be experienced directly on the CD-ROM album by clicking on multiple edges of the screen-based figure. An equivalent experience might be provided around a printed photograph by pressing different buttons on an audioprint player for different types of sounds, or by associating different areas of the print with different sound information..

Figure 9.4 The future audiophotograph

This scheme might be extended to accommodate a number of other preferences and findings about audiophotos. Thus, a short sequence of images might be displayed in a single frame to allow users to associate different sound clips with a group of photos (as in the use of one-to-many associations in our studies). Alternatively, a sound type setting might be made for the photograph, and each edge used to replay a different segment of the same sound type. For example, four friends could record separate voiceovers on the same photograph to add their personal perspectives on a shared event.

We might even begin to think about incorporating video clips into the future audiophotograph, by getting the image to move within the frame. This notion has been popularised in the Harry Potter books and films where characters in a photograph come to life and speak for a few seconds as the viewer approaches. Note that the use of video here is very different to a conventional home video tape. The length of the video clip is probably the distinguishing factor, since the new photographic form suggests the chunking of a video stream, or the capture of shorter chunks, by index scenes. The result is much closer to the *living photograph* idea of Demeny and Edison reported in Chapter 2, in which an image is given sound and movement together, to animate it briefly rather than to sweep it away in an extended cinematic narrative. In the spirit of this animation, and in the light of our studies, I also suggest two other uses of video-with-photographs. One is the panning of a static image in time to a voiceover or conversation about it. The other is the filming of environmental movement to match an ambient sound clip, such as trees swaying in a breeze or rain falling into a pool. The latter form might be called 'textural video'

since it lends a certain visual texture and life to an otherwise static scene. In a combination of all these ideas, it might be possible to create an immersive audiophotograph, in which a three dimensional scene is offered for visual exploration, complete with ambient surround-sound and additional audio clips.

These ideas begin to suggest the kind of multimedia memory records that people may want to capture, store and playback in the future. More specifically, the audiophoto combinations are content recommendations that have emerged from this research on the value and properties of different kinds of sounds with photographs. They are presented in this form to show that the primary requirement for audiophoto technology is the support of an appropriate audiophoto *data format*, across a variety of photographic devices. Today, such a format does not exist, so users are stuck with the capture and storage of separate images, sounds and video that have to be brought together in complex multimedia editing tools. This leads to a synchronisation problem akin to that faced by sound and film engineers in the days of the silent movies. Individual data streams *can* be captured and played back, but the effort of combining them outweighs the benefit of seeing them combined. What is needed is a new standard data type that represents sounds and images together in a flexible and synchronised form.

Some efforts have been made in recent years to design editors which automatically combine digital image (jpg) and digital sound (wav) files with the same filename, or to store a single audio clip (wav) *within* an image file (jpg). Multimedia message formats (MMS) are also now available in the telecommunication domain to encode a single voice message with an accompanying picture or video. However, these are a long way off supporting the kind of multi-layered audiophotograph represented in Figure 9.4, or any of its extensions suggested above.

One initiative within the digital storage industry, promises to deliver a better solution in the form of a new standard for combining photographs, audio and video on DVDs. This standard is called MPV (MusicPhotoVideo). It provides an advanced hypermedia design language based on XML to represent the temporal and semantic connections between related digital media clips. This allows complex multimedia material to be created, stored and played back in a synchronised form. Hewlett Packard is a leading partner on the MPV standards committee, where we have fed in some of the insights on multi-layered audiophotos. We are also applying these standards in our photo album creation tools, which now support the intermixing of multiple sound clips, images and video. This includes the ability to bring in ambient sound photographs from our digital audiocameras, and mix in multiple voiceover or music tracks with groups of photographs in a set.

Once a suitable multimedia format exists for complex audiophotographs, individual devices can be designed to capture, manipulate, print and share such material. The format is the enabling technology, because there is limited use for an individual device that creates audiophoto material that other devices cannot use. This is really the status today of many audio-enabled photography products. For example, some digital cameras support the capture of individual sound clips with an image, but many photo viewers cannot playback the associated sounds. They are

simply not yet designed to playback sound clips embedded in the image files or contained within image directories. This means that it is not easy to send a digital audiophoto to someone who doesn't have the viewer supplied with the camera. Furthermore, most photo websites do not support audio, ruling out use of the world-wide-web for archiving and sharing audiophotos. Other anomalies include the fact that some digital cameras support the capture and playback of individual sound recordings or MP3 music tracks as well as photographs, but cannot handle audiophotos. A similar anomaly exists on certain camera-phones where it is possible to record voice messages and photographs, but impossible to combine them into a talking photograph. Finally, although a variety of cards, albums and frames are available for the playback of sounds from prints, none of these can accept audio from a digital camera.

The lack of an end-to-end solution for audiophotography is currently limiting the steps people can take to capture and playback sound with their photographs. Another barrier is the current legal restriction on music sharing. However, the above research suggests that this behaviour will become more widespread if the solution improves or the restrictions relax. (You can test this prediction on yourself by considering how much you have enjoyed listening to the audiophotos in this book, and whether you would like to create your own).

What is required is a suitable storage format in which complex audiophotos can recorded and archived, and an accompanying suite of products to facilitate the capture and combination of audio throughout the life of the photograph. Digital technologies already accommodate the playback of audio associated with screen-displayed images, although different types of viewers could additionally be provided for different budgets and contexts. Analogue technologies also exist for the playback of audio with printed images, but these need to be improved in quality and made compatible with digital photography products and services. We have seen from our studies that people are willing to entertain new ways of handling photographs on paper and screen, if they provide significant benefits over conventional prints. In addition, these methods need to be backward compatible with the methods and systems used by family and friends, so that people can continue to circulate photographs as widely as usual while they upgrade their technology and behaviours.

PHOTOWARE AND NEW MEDIA DESIGN

These recommendations for audiophoto content and technology also have implications for more general technology for the support of computer-mediated communication with photographs. This area was referred to as groupware for photographs, or *photoware*, in Chapter 1. Some of these implications derive from the substantive findings on domestic photography and the role of sound summarised above, while others relate to the methodology of examining new media content in relation to technology.

Taking the implications of the findings first, these can be related to the four classes of photoware defined elsewhere (Frohlich et al 2001). These are:

- co-present sharing of photographs
- archiving of photographs
- sending of photographs, and
- remote sharing of photographs

Regarding co-present and remote sharing, it was found that photographs were used extensively as props for conversation rather than as prompts for an extended monolog. This is unfortunate for a large number of software tools today that use a slide show metaphor for the presentation of photographs, and often display each photograph for a short fixed duration. While users of these tools may be socially skilled enough to accommodate or subvert this regime, we suggest that other designs should be developed which allow users to work with a variety of visible images at a time, and bring one or other into focus collaboratively. A photo table metaphor might be more appropriate for this purpose, as demonstrated by a small number of recent research prototypes (e.g. Bederson 2001, Shen, Lesh, Vernier, Forlines & Frost 2002, Vroegindeweij 2002). It was also found that the introduction of audio into a photo-sharing situation can influence the conversation for good and ill. Recorded voiceover and conversation is likely to inhibit conversation while participants try to listen to what is said before responding themselves. Music and ambient sounds however, add atmosphere and life to the conversation, at least between people who share the memory of the photographed events. This suggests that future photo-sharing tools should incorporate multi-layered audiophotos, but allow the selective replay of sound clips at playback time.

Regarding the archiving of photographs, the findings on the value of multiple types of sound have the biggest implications. Users may want to store ambient sounds, music, voiceover and conversation separately on the same photograph. This leads to the need for a multi-audio data format for photographs as mentioned above. The audio should be searchable so that people can find an image by its associated audio clips. The audio should also be extensible over time, so that people can add further audio clips over the lifetime of a photograph, perhaps as part of subsequent photo-sharing or sending activities. This is a different model of annotation than is used by current digital photo archiving tools. These typically expect users to sit down privately with their photo collections and add textual annotations at a single level. A further finding is that audiophoto content should be transferable across paper and screen devices, to allow different playback technologies to be selected for different playback contexts (as expressed in Chapter 8). This means that researchers should stop trying to think up the 'ideal' photo-storing and sharing device.

Regarding the sending of photographs, it was found that voiceover adds considerably to the private interpretation of images by a remote audience. This implies that facilities for recording and playing back voice messages should be built into email and telephone systems for photo-sharing. On the whole, participants found it easier to record a voiceover with a particular recipient in mind. This might cause problems when distributing a talking photograph to multiple recipients or putting it up on the world-wide-web. However, they also expressed a desire to personalise their photographs for posterity, mainly through the handing down of albums to their children. This can be seen as another requirement for the design of

photo archiving or sending technology, which should consider how a photo collection or selection can be packaged as a rich media gift. The preference for tangible photographs as gifts discovered in Chapter 8 is relevant here.

Beyond these particular findings about the use of photographs and sounds, there are broader implications for the *research* of photoware requirements and computer mediated communication solutions from our methodology. Whereas conventional research has focussed on exploring communication *activities* and the *technology* to support them (e.g. Frohlich et al 2002), the approach in this book has been to explore new forms of communication *content* and its implications for both. This stemmed from an initial observation about the potential value of sound with still images, and a realisation that the development of content and technology has always been intertwined in the history of any new medium (see Chapter 2). It was consequently decided to explore the value of different types of audiophoto content, through a series of essentially creative exercises with ordinary families.

This approach threw up implications for changes in behaviours associated with photographs, and new questions for digital technology that might support them. It was through these implications and questions that we experienced for ourselves the interplay between content and technology. For example, the fundamental discovery that different kinds of sound have different effects on the interaction with a photograph itself demonstrates that content matters enormously in the use of audio technology. It was also found that families began to change their capture behaviours and attitudes with exposure to the technology, as they worked out what it was and wasn't good for. Finally, the different reactions observed to the very same content viewed on different paper and screen-based players, was a dramatic illustration of the interaction between these factors. It led participants to think of switching players for different content or authoring particular kinds of content for individual players (Chapter 8). All these findings suggest that content design should be made an integral part of any new media investigation, and that this may call for artistic as well as scientific approaches to the design of any 'mediating technology'.

A final example serves to illustrate this conclusion. It is based on my most recent attempt to explore multi-layered audiophotos through an audiophoto desk (see Figure 9.5). The technology is a digital desk with an overhead camera but no projector (c.f. Wellner 1993). The camera and software is used to recognise a photographic image from its print, and playback the associated audio automatically. It can do this on multiple prints placed face-up on the desk; resulting in the playback of multiple concurrent tracks. A further calculation in the software measures the position of each print on the desk and alters the volume and stereo-balance of its audio accordingly. As a print is pushed away from the user it plays more quietly, while moving it left or right across the desk shifts its playback to the left or right speaker. Users can therefore playback an audiophoto automatically with no other interface than the print itself, and physically mix a complex soundscape for a pack of photographs simply by changing the print arrangement on the desk.

Figure 9.5 The audiophoto desk

Although a single image cannot be associated with multiple sounds, a small group of photographs can be used to play a number of sounds related to the same event. An example of this is given in the multi-way sound track of Figure 9.6. This is derived from four photographs arranged as shown on the desk. The photographs, ambient sounds and voiceovers were recorded on a single trip to the Island of Jura in Scotland. The sounds from each photograph include a bubbling stream (top left), a highland jig (bottom centre), a bird singing (top centre), and a voiceover (middle right).

The design of the desk is interesting in relation to the support of multi-layered audioprints, but it is the *process* of design and testing that I want to emphasise here. The desk was conceived whilst I was writing the book as a visiting fellow at the Royal College of Art. This context was important because it opened my eyes to the possibility of asking artists to explore the expressive properties of audiophotographs in something like a design competition. It also legitimised my own personal experiments with audiophotos for our family albums over the past few years. The inspiration for the desk was the requirement to mix multiple sound tracks together and a belief that a tangible interface with prints could be used to do this in an

interesting and accessible way. The feasibility of the design was demonstrated by Tony Clancy, a photographer from The University of Central Lancashire, and John Robinson, a Professor of Electrical Engineering at the University of York. The software was based on the LivePaper system architecture developed in John's group (Robinson et al 2001). It was produced in collaboration with them, and an independent product designer, Paul Smith. I mention these people, not only to acknowledge their input, but also to stress the interdisciplinary nature of the project. It was this interdisciplinary mix that led us to discover a number of interactions between the content and the technology, and to adopt a more artistic approach to the desk's evaluation.

Figure 9.6 A four photograph mix playing on the audiophoto desk.

In preparing demonstration material for the desk we found that the photographs and sounds needed to relate to each other, as in Figure 9.6. Playing concurrent sound tracks from unrelated photos didn't make sense to listeners, while playing individual audioprints in sequence didn't utilise concurrent playback at all. Despite returning to all the audiophoto material recorded for this book, and a body of personal audiophotos, we failed to find any suitable examples and were forced to record new material. This led to a particular style of audiophoto capture, in which we would take a series of photographs and ambient sounds during an event, and augment these with voiceovers and music on particular shots. The allocation of sound types to photos could be arbitrary, but we found that some images lent themselves better to narrative, music or ambient sounds. We are now interested in how lay people and artists might design material for this particular piece of technology. Rather than conduct a formal user study of the desk, we are planning to put out a call for content to various groups and engage them in a discussion of the results. New content can be

entered simply by inserting a new CD-ROM into the desk, containing image and sound files with the same filename, and placing prints of the images on the desk.

Similar approaches are needed in the design of other new media technologies, so that those technologies can accommodate different sorts of content in the right sort of way. If audiophotos are anything to go by, the content will make a big difference to the experience of a new media technology, and both may have to be designed together to achieve the biggest and best effects on behaviour.

THE FUTURE OF AUDIOPHOTOGRAPHY

In the future, we may wonder why it took so long after the invention of the camera and the phonograph to bring both inventions together. It may even seem strange to take a photograph without the option of sound to go with it. Digital technology now presents an opportunity to support this in a way which goes beyond the analogue camcorder and the use of home video. Digital audiocameras and camera phones will lead the way in helping us to capture ambient sounds and voiceovers with our photographs, while MP3 players and digital music systems will make it easier to combine music and photo collections. Digital camcorders have a part to play in this future, not least as sources of audiophoto material as well as digital video clips.

While photographs and video are likely to persist as forms in their own right, I believe these will be joined by audiophotos of various kinds. These will occupy an increasingly complex middle ground between photos and video, in which people will learn to combine sound and image in radically new ways. We began to see some of the early experiments in this medium by participants in the studies. Working with individual sound types, they tried out various sound-to-image associations and effects, and began to adjust their capture behaviours to obtain more fitting sound and image material. With a wider range of sound types to choose from, and the possibility of combining them with printed and screen-displayed images, this kind of creativity is likely to increase further.

The end result may be a new kind of multimedia literacy for producing as well as consuming audiophotos. Since the spoken elements of audiophotos can be produced live in conversation, I include the 'performance' and sharing of photographs as part of this new skill. This can be seen as another kind of computer-related literacy to emerge alongside others such as email, instant messaging or interactive games (Snyder 2002). And like those literacies, audiophotography will be both creative and social; producing new social artefacts and relationships. One of the most intriguing of these will be a very long term communication across generations. The ability to contextualise photographs for future generations will allow them to see into the lives of their ancestors in more intimate ways than ever before. This in turn may encourage them to speak into the lives of their own descendents in yet more powerful ways, through a more common form of oral history.

The extent to which this literacy is supported by technology, will determine how widespread the practice of audiophotography becomes in the future. The presence or

absence of easy-to-use audiophoto capture, editing, archiving and sharing facilities will make all the difference in its adoption as a new photographic practice. This is because participants in the studies were sensitive to the time, effort and financial cost of doing audiophotography, despite expressing strong preferences for audiophotos. This is a modern challenge for computing technology, as indicated in the opening quote of this chapter. Computing now needs to be as much concerned with the design of tools for human creativity, as it has been with the automation of human activity (Shneiderman 2002). This book can be seen as a user requirements study for one new form of creativity. What happens next depends on how well these requirements are met, either by the creative use of existing technology or the better design of new technology. As with most new things, true innovation will probably require a little of both.

References

Adler, A., Gujar, A., Harrison, B.L., O'Hara, K. & Sellen, A. (1998) A Diary study of work-related reading: Design implications for digital reading devices. *Proceedings of CHI '98*, 241-248. New York: ACM Press.

Atkinson, J.M. & Drew, P. (1979) *Order in court: The organization of verbal interaction in judicial settings*. London: Macmillan.

Atkinson, J.M. & Heritage J. (Ed.) (1984) *Structures of social action: Studies in conversation analysis* Cambridge: Cambridge University Press

Balabanovic M., Chu L.L. & Wolff G.J. (2000) Storytelling with digital *photographs. Proceedings of CHI 2000*, 564-571. New York: ACM Press.

Barthes, R. (1977) *Image, music, text*. Essays selected and translated by Stephen Heath. New York: Hill & Wang.

Barthes, R. (1981) *Camera Lucida: Reflections on photography*. Translated by Richard Howard. New York: Hill & Wang.

Bederson, B.B. (2001). PhotoMesa: A Zoomable image browser using quantum treemaps and bubblemaps. *UIST 2001, ACM Symposium on User Interface Software and Technology, CHI Letters*, *3*(2), pp. 71-80.

Benjamin, W. (1931) A brief history of photography. Reprinted in A. Trachtenberg (Ed.) *Classic essays in photography* (pp199-216). New Have, Connecticut: Leete's Island Books.

Berger, J. (1982a) Appearances. In J. Berger and J. Mohr, *Another way of telling*. London: Butler & Tanner.

Berger, J. (1982b) Stories. In J. Berger and J. Mohr, *Another way of telling*. London: Butler & Tanner.

Berger, J. & Mohr, J. (1982) *Another way of telling*. London: Butler & Tanner.

Bolter, J.D. (1991) *Writing space: The computer, hypertext and the history of writing*. Hillsdale, New Jersey: Lawrence Erlbaum Associates.

Boltz M. (2001). Musical soundtracks as a schematic influence on the cognitive processing of filmed events. *Music Perception 18 (4),* 427-454.

Brady, E (1999) *A spiral way: How the phonograph changed ethnography*. Jackson, Mississippi: University Press of Mississippi.

Brown, B.A.T., Geelhoed, E. & Sellen, A.J. The use of conventional and new music media: Implications for future technologies. In Hirose M (Ed.) *Proceedings of INTERACT 2001, 67-75.* Tokyo, Japan, IOS Press.

Burgin V. (1982) Photography, phantasy and function. Chapter 8 in V. Burgin (Ed.) *Thinking photography*. London: Macmillan Press.

Campbell Slan J. (1999) *Scrapbook storytelling: Save family stories and memories with photos, journaling and your own creativity.* EFG Inc., F & W Publications.

Cavalcanti, A. (1939) Sound in films. Reprinted in E. Weis and J. Belton (Eds.) (1985) *Film sound: Theory and practice* (pp98-111). New York: Columbia University Press.

Chalfen R. (1987) *Snapshot versions of life*. Bowling Green Ohio: Bowling Green State University.

Chalfen, R. (1998) Family photograph appreciation: Dynamics of medium, interpretation and memory. *Communication and Cognition 31 (2/3),* 161-178.

Cohen, G. (1996) *Memory in the real world*. Second Edition. Hove, East Sussex: Psychology Press.

Conot, R. (1979) *A streak of genius*. New York: Seaview Books.

Conway, M.A. (1990) *Autobiographical memory: An Introduction*. Milton Keynes: Open University Press.

Cosden C. & Reynolds D. (1982) Photography as therapy. *The Arts in Psychotherapy 9*, 19-23.

Csikszentmihalyi, M. & Rochberg-Halton, E. (1981) *The meaning of things: Domestic symbols and the self.* Cambridge: Cambridge University Press.

Cusack P. (2000). *The horse was alive the cow was dead: Sounds stories and people from the Lea Valley*, East London. Audio CD. London: London Musicians' Collective.

Cusack P. (2001) *Your favourite London sounds*. Audio CD. London: London Musicians' Collective.

Daguerre, L.J.M. (1839) Dageurrotype. Reprinted in A. Trachtenberg (Ed.) (1980) *Classic essays on photography* (pp11-13). New Haven, Conn.:Leete's Island Books.

Dillon, A. (1992) Reading from paper versus reading from screens: A critical review of the empirical literature. *Ergonomics 35 (10),* 1297-1326.

Drew P. (1985) Analyzing the use of language in courtroom interaction. Chapter 10 in T. A. Van Dijk (Ed.) *Handbook of discourse analysis. Volume 3: Discourse and dialogue* (133-147). London: Academic Press.

Drew, P. (1994) Conversation analysis. Entry in R.E. Asher el at.(Eds.) *Encyclopedia of Language and Linguistics, 749-754.* Oxford: Pergamon Press.

Duck S. & Pittman G. (1994) Social and personal relationships. Chapter 17 in M. L. Knapp & G.R.Miller (Eds.) *Handbook of interpersonal communication, Second Edition* (pp 676-695). London : Sage.

Duck S. (1994) Steady as (S)he goes: Relational maintenance as a shared meaning system. Chapter 3 in D. J. Canary & L. Stafford (Eds.) *Communication and relational maintenance* (pp 45-60). London: Academic Press.

Edison, T.A. (1878) The phonograph and its future. *North American Review 126* (June), 527-536.

Edwards D. (1997) *Discourse and cognition*. London: Sage.

Edwards D. & Middleton D. (1986) Joint remembering: Constructing an account of shared experience through conversational discourse. *Discourse Processes 9,* 423-459.

Edwards D. & Middleton D. (1988) Conversational remembering and family relationships: How children learn to remember. *Journal of Social and Personal Relationships 5*, 3-25.

Edwards D., Potter J. & Middleton D. (1992) Toward a discursive psychology of remembering. *The Psychologist 5* (10), 441-446.

Frohlich, D.M. & Murphy, R. (2000) The memory box. *Personal Technologies 4*, 238-240.

Frohlich, D.M., Adams, G. & Tallyn, E. (2000) Augmenting photographs with audio. *Personal Technologies 4*, 205-208.

Frohlich D.M., Chilton K., & Drew P. (1997) Remote homeplace communication: What is it like and how might we support it? In H. Thimbleby, B. O'Conaill and P.J. Thomas (Eds.) *People and computers XII: Proceedings of HCI'97*, 133-153. London: Springer-Verlag.

Frohlich, D.M., Kuchinsky, A., Pering, C., Don, A. & Ariss S. (2002) Requirements for photoware. *Proceedings of CSCW '02*, 166-175. New York: ACM Press.

Fryrear J.J. & Corbit I.E. (1992) *Photo art therapy: A Jungian perspective*. Springfield Illinois: Charles C. Thomas Publisher.

Gibson, J.J. (1979) *The ecological approach to visual perception*. Boston: Houghton Mifflin.

Godoy, R.I. & Jorgensen, H. (Eds.) (2001). *Musical imagery*. B.V. Lisse, The Netherlands: Swets & Zeitlinger.

Goffman E. (1981) *Forms of talk*. Oxford: Basil Blackwell.

Grice H.P. (1975) Logic and conversation. In P. Cole & J.L. Morgan (Eds.) *Syntax and Semantics 3: Speech Acts* (pp41-58). New York: Academic Press.

Haight B.K. & Webster J.D. (Eds.) (1995) *The art and science of reminiscing: Theory, research, methods and applications.* London: Taylor & Francis.

Harvey J.H. (1996) *Embracing their memory: Loss and the social psychology of storytelling*. Needham Heights, MA: Simon & Schuster Co.

Hawley, M., Poor, R.D. & Tutja, M. (1997) Things that think. *Personal Technologies 1*, 13-20.

Hesse, C. (1996) Books in time. In G. Nunberg (Ed.) *The future of the book*, pp21-33. Berkeley, California: University of California Press.

Hirsch M. (1997) *Family frames: Photography, narrative and postmemory*. Cambridge MA: Harvard University Press.

Holland P. (1991) Introduction: History, Memory and the family album. In J. Spence and P. Holland.(Eds.) *Family snaps: The meanings of domestic photography.* Virago Books.

Hoshino, Y. (1959) The talking book. In A. Delafons (Ed.) *The Penrose Annual: A Review of the Graphic Arts, Volume 53,* 57-60. London:Lund Humphries, 1959.

Hoskins, J. (1998) *Biographical objects: How things tell the stories of people's lives.* London: Routledge.

Hough, J.E. (1910) Letter to the editor of the Sound Wave Edisonia Works, Peckham, June 21, 1910. Reproduced in O. Read and W.L. Welch (1959) *From tin foil to stereo: Evolution of the phonograph,* pp 414-416. New York:Indianapolis.

Ireland, C. &Johnson, B.(1995) Exploring the future in the present. *Design Management Journal,* Spring 1995, pp57-64.

Ishii, H. & Ullmer, B. (1997) Tangible bits: Towards seamless interfaces between people, bits and atoms. *Proceedings of CHI '97,* 234-241. New York: ACM Press.

Jabbour, A. (1984) Preface to the introduction and inventory, Volume 1 of the Federal Cylinder Project: A guide to field cylinder collections in federal agencies. *Studies in American Folklife No. 3,* p1. Washington D.C.: American Folklife Center, Library of Congress.

Jefferson G. (1988) Preliminary notes on a possible metric which provides for a 'standard maximum' silence of approximately one second in conversation. Chapter 8 in D. Roger & P. Bull (Eds.) *Conversation: An interdisciplinary perspective* (pp166-196). Clevedon, Philadelphia: Multilingual Matters.

Johnson, E.H. (1877) A wonderful invention (Letter to the editor). *Scientific American 37,* 304, November 17, 1877.

King (1986) *Say cheese.* London: Harper Collins.

Kozloff S. (1988) *Invisible storytellers: Voice-over narration in American fiction film.* Berkeley:University of California Press.

Lacey N. (2000) *Narrative and genre: Key concepts in media studies.* London: MacMillan Press.

Lambert J. (2002) *Digital storytelling: Capturing lives, creating community.* Digital Diner Press.

Lambert J. & Mullen N. (1998) *Digital storytelling: The creative application of digital technology to the ancient art of storytelling.* Institute for the Future report.

Lawley S. (1990) *Sue Lawley's Desert Island discussions.* Hodder & Stoughton General Division.

Lieberman H. & Liu, H. (2002) Adaptive linking between text and photos using common sense reasoning. In *Proceedings of the 2nd International Conference on Adaptive Hypermedia and Adaptive Web Systems,* Malaga, Spain, May 2002.

Lombard, M. and Ditton, T. (1997). At the heart of it all: The concept of telepresence. *Journal of Computer-Mediated Communication (on-line serial) 3 (2).* Available: http://www.ascusc.org/jcmc/

Luff, P. & Heath, C. (1992) Tasks in interaction: Paper and screen based documentation in collaborative activity. *Proceedings of CSCW '92,* 163-170. New York: ACM Press.

Luff, P. & Heath, C. (1997) Mobility in collaboration. *Proceedings of CSCW '98,* 305-314. New York: ACM Press

Luff, P., Hindmarsh, J. & Heath, C. (Eds.) (2000) *Workplace studies: Recovering work practice and informing system design.* Cambridge: Cambridge University Press.

Manguel, A. (1996) *A history of reading.* Knopf Canada

Marggraff, J. (1999) *Leap into learning.* Knowledge Kids Enterprises.

Maur K. (1999) *The sound of painting: Music in Modern Art.* London: Prestel.

McLuhan, M. (1964) *Understanding media: The extensions of man.* Cambridge, Massachusetts: MIT Press.

Metz, C. (1990) Photography and fetish. In C. Squires (Ed.) *The critical image: Essays on contemporary photography.* Seattle: Bay Press.

Meyrowitz J. (1986) *No sense of place: The impact of electronic media on social behaviour.* Oxford University Press.

Mountain R. (2001) Composers and imagery: Myths and realities. Chapter 15 in R.I. Godoy & H. Jorgensen (Eds.) *Musical imagery* (pp271-288). B.V. Lisse, The Netherlands: Swets & Zeitlinger.

Norrick N. R. (1997) Twice-told tales: Collaborative narration of familiar stories. *Language in Society 26*, 199-220.

Nunberg, G. (Ed.) (1996) *The future of the book.* Berkeley, California: University of California Press.

O'Hara, K. & Sellen, A. (1997) Comparison of reading paper and on-line documents. *Proceedings of CHI '97*, 335-342. New York: ACM Press.

Pasupathi, M. (2001) The social construction of the personal past and its implications for adult development. *Psychological Bulletin 127* (5), 651-672.

Plomley R. (1975) *Desert island discs.* London: William Kimber & Co Ltd.

Plomley R. (1982) *Plomley's pick of Desert Island Discs.* Weidenfeld and Nicolson.

Poe, E.A. (1840)The dageurrotype. Reprinted in A. Trachtenberg (Ed.) *Classic essays on photography* (pp37-38). New Haven, Conn.:Leete's Island Books, 1980.

Polanyi, L. (1985) Conversational storytelling. Chapter 13 in T. A. Van Dijk (Ed.) Handbook of discourse analysis. Volume 3: Discourse and dialogue (pp183-201). London: Academic Press.

Pomerantz, A. (1978) Compliment responses. Notes on the cooperation of multiple constraints. In J. Schenkein (Ed.) *Studies of the organization of conversational interaction.* London: Academic Press.

Proust, M. (1982) *Remembrance of things past.* Translated by Scott-Moncrieff & Terance Kilmartin. Knopf.

Read, O. & Welch, W.L. (1959) *From tin foil to stereo: Evolution of the phonograph.* New York:Indianapolis.

Robinson, J.A. & Robertson, C. (2001) The LivePaper System: Augmenting Paper on an Enhanced Tabletop. *Computers and Graphics 25* (5), 731-743.

Rossell D. (1998) *Living pictures: The origins of the movies.* Albany: State University of New York Press.

Russell M. & Young J. (2000). *Film music screencraft.* Crans-Pres-Celigny, Switzerland:RotoVision SA.

Sacks H. (1968a) Second stories; 'Mm hm'; Story prefaces; 'Local news'; Tellability. Reprinted in Jefferson G. (Ed.) *Lectures on conversation Volume II Part I,* 3-16. Oxford: Blackwell.

Sacks H. (1968b) Second stories. Reprinted in Jefferson G. (Ed.) *Lectures on conversation Volume I Part VII,* 764-772. Oxford: Blackwell.

Sacks, H. (1970) On doing being ordinary. In J. M. Atkinson & J. Heritage (Ed.) *Structures of social action: Studies in conversation analysis* (pp413-429). Cambridge: Cambridge University Press.

Sacks H. (1974) An analysis of the course of a joke's telling in conversation. In R.Bauman & J. Sherzer (Eds.) *Explorations in the ethnography of speaking* (pp337-353). Cambridge: Cambridge University Press.

Sacks H, Schegloff E.A. & Jefferson G. (1974) A simplest systematics for the organization of turn-taking for conversation. *Language 50,* 696-735.

Schafer, M.R.. Ed. (1976) *European sound diary. No. 3 The Music of the Environment Series. World Soundscape Project.* Vancouver: ARC Publications.

Schafer, M.R. (1977) *Tuning of the world.* Random House/University of Penn. Press.

Schaverien, J. (1991) *The revealing image: Analytical art psychotherapy in theory and practice.* London: Jessica Kingsley Publishers.

Schilit, B.N., Price, M.N., Golovchinsky, G., Tanaka, K. & Marshall, C.C. (1999) The reading appliance revolution. *IEEE Computer,* January 1999, 65-73.

Sekula, A. (1982) On the invention of photographic meaning. Chapter 4 in V. Burgin (Ed.) *Thinking photography.* London: Macmillan Press.

Sellen, A.J. & Harper R.H.R. (2002) *The myth of the paperless office.* Cambridge, Massachusetts: MIT Press.

Shen, C, Lesh N.B., Vernier, F., Forlines, C. & Frost, J. (2002) Sharing and building digital group histories. *Proceedings of CSCW '02,* 324-333. New York: ACM Press.

Shneiderman, B. (2002) *Leonardo's laptop: Human needs and the new computing technologies.* Cambridge: MIT Press.

Sonnenschein D. (2001) *Sound design: The expressive power of music, voice and sound effects in the cinema.* Studio City, California:Michael Wiese Productions.

Snyder, I. (Ed.) (1998) *Page to screen.* London: Routledge.

Synder, I. (Ed.) (2002) *Silicon Literacies: Communicaiton, innovation and education in the electronic age.* London: Routledge.

Spence J. (1987) *Putting myself in the picture: A political, personal and photographic autobiography.* London: Camden Press.

Sprecher S. (1987) The effects of self-disclosure given and received on affection for an intimate partner and stability of the relationship. *Journal of Social and Personal Relationships 4,* 115-127.

Squires, C. (1990) *The critical image: Essays on contemporary photography.* Seattle: Bay Press.

Star, S. L. & Griesemer, J.R. (1989) Institutional ecology. 'Tranlations' and boundary objects: Amateurs and professionals in Berkeley's Museum of Vertebrate Zoology, 1907-39. *Social Studies of Science 19*, 387-420.

Stevens, M.M., Abowd, G.D.,Truong, K.N. & Vollmer, F. (2003) Getting into the living memory box: Family archives and holistic design. *Proceedings of 1AD, 35-41.* First International Conference on Appliance Design, Bristol, England, May 6-8th 2003.

Stewart, D. (1979) Photo therapy: Theory and practice. *Art Psychotherapy 6*, 41-46.

Thayer J & Levinson R. (1983) Effects of music on psychophysiological responses to a stressful film *Psychomusicology 3*, 44-54.

Truax, B. Ed. (1978) *Handbook for acoustic ecology. No. 5 The Music of the Environment Series, World Soundscape Project.* Vancouver: ARC Publications.

Tversky, B. & Marsh, E.J. (2000) Biased retelling of events yield biased memories. *Cognitive Psychology 40*, 1-38.

Vroegindeweij, S. (2002) My pictures: Informal image collections. *HP Labs Technical Report No.* HPL-2002-72R1.

Want, R. Fishkin, K.P., Gujar, A. & Harrison, B.L. (1999) Bridging physical and virtual worlds with electronic tags. *Proceedings of CHI '99*, 370-377. New York: ACM Press.

Weiser, M. (1991) The computer for the 21st century. *Scientific American 265 (3)*, 94-104.

Weldon M. (2001) *Writing to save your life: How to honor your story through journaling.* Minnesota: Hazelden.

Wellner P.(1993) Interacting with paper on the digital desk. *Communications of the ACM 36 (7),* 86-96.

Wellner, P. Mackay, W. & Gold, R. (1993) Computer augmented environments: Back to the real world. Special Issue of *Communications of the ACM 36 (7).*

West Briton (2002) *Hymns are fading from charts for funerals.* Thursday August 8th, 2002, page 15.

Wollen, P. (1989) Fire and ice. In J. X. Berger & O. Richon (Eds.) *Other than itself: Writing photography.* Manchester: Cornerhouse Publications.

Zwick, D.S. (1978) Photography as a tool toward increasing awareness of the aging self. *Art Psychotherapy 5*, 135-141.

Glossary

Ambient photograph A photograph with ambient sound

Ambient sound Sound occurring around the time and place a photograph is taken

Audience A person who does not share the memory of a received photograph

Audiocamera A camera which is capable of taking audiophotos

Audiograph A sound clip with sentimental value

Audiopaper Paper from which sound can be played back

Audiophoto An audiophotograph

Audiophotograph A photograph with associated sound

Audiophotography The practice of taking and using audiophotographs

Audio-portrait A sound clip which captures the character of its subject

Audioprint A printed audiophoto from which it is possible to playback the sound

Conversation Spoken dialogue between two or more people in an informal setting

Conversational photograph A photograph with recorded conversation about it

Diamond framework A new framework for understanding the relationships between four key 'actors' in photography (hence 'diamond')

Feedback group A group discussion of experiences and new product reactions following a field trial

Field trial A study in which participants are given the chance to use new technology in uncontrolled conditions

Interpretation of images Making sense of an image whose capture you were not involved in

Journalling The practice of writing an autobiographical journal or diary

Music Musical compositions

Musical photograph A photograph with music

Photographer The person who takes a photograph

Photo outing An act or session in which a photograph is shared

Photo-talk Conversation around photographs

Photoware Groupware for photographs

Recognition of images Recognising a past scene and event from a photograph you took of it

Recollection of images Recalling the past from an image of yourself

Reminiscing Discussing a past event with others who share its memory

Reminiscing photograph A photograph with recorded reminiscing conversation about it

Reminiscing with photographs Using photographs to discuss a past event with others who share its memory

Retropresence The feeling of being back in the past

Scrapbooking The practice of creating personalised photograph albums

Self-reflection with images Considering how others see you from an image of yourself

Silent photograph A photograph without associated sound

Solitary sound clip A sound clip without an associated photograph

Storytelling The act of telling a story to an audience

Storytelling photograph A photograph with recorded storytelling conversation about it

Storytelling with photographs Using photographs to tell a story to an audience

Subject The human subject of a photograph

Voice signature The effect of personalising a photograph with a voiceover

Talking photograph A photograph with recorded voiceover about it

Textural video Stable video footage of a relatively static scene

User research Research into the needs, values and behaviours of potential customers for new products and services

Voiceover Recorded narration over a photograph

Index

A

affordances, 169, 171, 191, 192
ambient photo playback, 172–74
ambient sound literature, 50–51
anthropologists, 14
art therapy, ix, 41, 42, 136, 215
attunement, 61
audience participation, 139, 140, 148, 149, 152
audio annotation trial. *See* music/voice annotation trial
audiocamera trial, 51–53
audiographs, 2, 60
Audiophoto card, 173, 180, 181, 182, 185, 189, 190
audiophoto desk, 208, 209, 210
Audiophoto frame, 173, 180, 182
audiophoto technology, 203–6
audiophotography defined, 7–9
audiophotos defined, 3–5
audio-portrait, 96, 99
Audioprint album, 183, 188
Audioprint player, 182, 183, 189
Audioprint scanner, 173, 178
augmented reality, 170
autobiographical memory, 43, 198

B

ballad, 88

C

CD album, 173, 175, 186
celluloid film, vi, 24, 25
choral, 94, 97
chronophotographer, 24
classical, 68, 87, 88, 90, 94, 101
collaborative storytelling, 139, 140, 149, 198
collective remembering, 43, 139, 198
Computer Supported Cooperative Work, 8
conversation literature, 137–41
conversational storytelling, 137, 140, 164

D

dance, 88, 90, 104
data format, 205, 207
Desert Island Discs, 80, 105, 217
diamond framework, 43–46
digital storytelling, 111, 112
domestication, 193

E

e-card, 20
electronic books, 168
empathy, 42, 107, 198
ethnographic, 14, 15, 28